MONOGRAM

THE MACMILLAN COMPANY
NEW YORK · BOSTON · CHICAGO · DALLAS
ATLANTA · SAN FRANCISCO

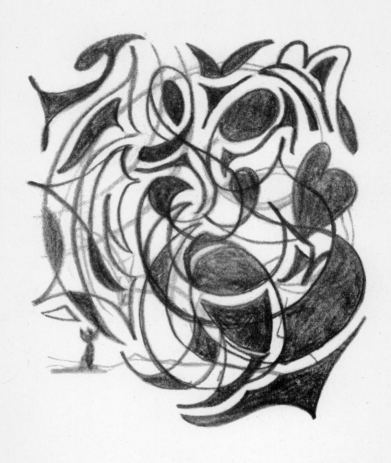

Conscious Drawing

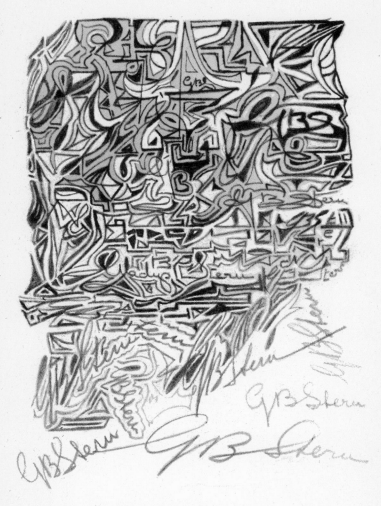

Subconscious Drawing

MONOGRAM

BY G. *Gladys* B. STERN

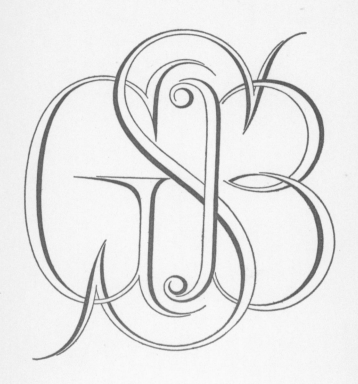

NEW YORK

THE MACMILLAN COMPANY

1936

To

DICK

"It's my opinion that the missing picture is hidden in the house next door."

"But there isn't a house next door."

"Then we'll build one!"

(Dialogue from a Marx Brothers film.)

PART ONE
King Charles's Head

Part One

KING CHARLES'S HEAD

A STRAIGHT line, so I have been taught, is the shortest way between two given points. This book will probably prove to be the longest possible way between three given points; objects picked up at random from my own sitting-room; from the rubbish heap of a garden in the South of France; from anywhere. A straight line cannot enclose anything; but if you join three points, you have a triangle, and something exciting may or may not be discovered, afterwards, enclosed inside a triangle, wherever and however you happen to draw it. Something exciting, though barely visible. A voluptuous star, in a legend called Hollywood, went to see the "Invisible Man" film, and was so delighted with the acting of the lead that she asked for an introduction. Several months later (in a legend called Hollywood) she was seen walking down Sunset Boulevard, wheeling a perambulator with absolutely nothing in it.

When you know an author's works fairly well, and you ask him if he really believes this or that, quoting some oddity of opinion expressed in his writing, he may easily say, and, in fact, usually does: "Why should you suppose that what I put in the mouth of one of my characters, need necessarily be personal to me?" That is true and reason-

able; if it should only occur once, it can be discounted; but if you find the same motif cropping up again and again in his work; read it in more than one of his novels, appearing not always relevantly; recognise it in a digression in an essay, hear it suddenly during a bit of dialogue of his new play, then you may know that this is something of his own that he cannot keep out.

In other words, here is his King Charles's Head. It is likely that he will not himself be aware of having thus betrayed himself so often; and if I were you, I would not tell him.

"King Charles's Head" has passed into common use in the English language as a phrase meaning some whimsical obsession.

Whimsical, we may gather from the dictionary definition, did not always have that winsome woodland air of quaintness which it now wears like a peaked cap; "whim" derives from the Scandinavian "Lvima": to wander with the eyes. And that is how Dickens saw Mr. Dick; not mad; certainly not mad; Aunt Betsey Trotwood was angry with David for even suggesting it. But there was an episode in his life too painful for him to contemplate; so he wandered with the eyes, whenever he thought of it, and fixed them on King Charles's Head, which had been a matter distressing for King Charles, but not so bad for Mr. Dick.

I had already some time ago made a discovery of literary importance: that Dickens was the creator of the first P. G. Wodehouse young man; in fact, that Mr. Toots was the ancestor of Bertie Wooster. And now, as I wanted to use King Charles's Head for the title of a section of this book, I thought I had better look it up again in "David Copperfield," to be quite sure that I had got what I wanted. When I re-read the passage, I was amazed; for here is that psy-

chology, clear and complete, which has been so often of late years denounced by old-fashioned people who love their Dickens, as "modern nonsense," far-fetched and morbid; here, in the sad case of Mr. Dick, is the exposition of the complex, and the use of the symbol. Aunt Betsey Trotwood reveals herself as Freud's own disciple, and one he would have delighted in!

"Well, child," said my aunt, when I went downstairs. "And what of Mr. Dick, this morning?"

I informed her that he sent his compliments, and was getting on very well indeed.

"What do you think of him?" said my aunt.

. . . "Is he—is Mr. Dick—I ask because I don't know, aunt—is he at all out of his mind, then?" I stammered; for I felt I was on dangerous ground.

"Not a morsel," said my aunt.

"Oh, indeed!" I observed faintly.

"If there is anything in the world," said my aunt, with great decision and force of manner, "that Mr. Dick is not, it's that."

I had nothing better to offer than another timid, "Oh, indeed!"

. . . "He had a favourite sister," said my aunt: "a good creature, and very kind to him. But she did what they all do—took a husband. And he did what they all do—made her wretched. It had such an effect upon the mind of Mr. Dick (*that's* not madness, I hope!) that, combined with his fear of his brother, and his sense of his unkindness, it threw him into a fever. That was before he came to me, but the recollection of it is oppressive to him even now. Did he say anything to you about King Charles the First, child?"

"Yes, aunt."

"Ah!" said my aunt, rubbing her nose as if she were a little vexed. "That's his allegorical way of expressing it. He connects his illness with great disturbance and agitation, naturally, and that's the figure, or the simile, or whatever it's called, which he chooses to use. And why shouldn't he, if he thinks proper?"

I said: "Certainly, aunt."

When my publishers deliciously suggested that I should write a book about anything I liked; anything I jolly well liked; anything I damn well pleased; in fact, about anything, I swaggered for days across these boundless prairies before I began to suspect that they were altogether too boundless, and that what I needed were a few horizons laid down here and there. They had not only put me outside the pale, but they had even removed the pale when I was put outside it (as a child, I believed that "pale" was spelt "pail," which led to all sorts of puzzled speculation on the phrase).

Finally, having been given all heaven and earth and the bottom of the sea to choose from, all the past, present and future, all abstraction and fantasy, all history and geography, I ended in the only predictable way, when one is given no restrictions, by accepting every restriction and choosing myself as a subject, with as much as possible of myself to be left out.

Some people are inarticulate and complain of being so. They say they have the greatest difficulty in putting their thoughts into words. They say that that is where authors, and especially autobiographical authors, have the pull on them.

Our own great difficulty, it is true, lies more often in

putting our words into thoughts. Words we have spoken; words we have written; words by which we have excused ourselves, explained ourselves, bluffed and deprecated; words by which we have confused confusion; words used in our attempts to convey our idea of beauty instead of leaving it well alone; words by which we cut a long story short; words by which, far likelier, we stretch a short story long; a Lodore of words; an ever-open sluice of words; an equipment of words for camouflage and prevarication; arrangements of words by which one steadily earns a living; words tumbled out loosely, fluently, eloquently; words that were lies and words that were accidentally the truth; words that expressed convictions you never had, and words that were utter nonsense but went swaggering about in small groups, answering to the name of wit. Words: an avalanche, a concentration, a superfluity, a redundancy, a profusion, an exuberance, an inundation, a surfeit of words. Life and Roget's Thesaurus arm-in-arm.

So let us try, for a change, to put our words into thoughts. Surely this should be what they call autobiography?

Autobiography must naturally include dates, events, places and people. Therefore any person whose life has been crowded and sensational, would have a harder task in writing a good autobiography than one whose outward life has been gentle and leisurely, with plenty of pauses and very few ups and downs. For events are such hustlers; they push out thought, send it reeling off the pavement. If you have to recount how the whole world acclaimed you as the greatest operatic star that Milan, Covent Garden and the Metropolitan have ever known the likes of, and then a week later stoned you into the street, let you starve on the quays, bundled you off to China as an immigrant, you will have very little opportunity to sit on a garden bench and

make a record of your feelings and impressions while all this was happening to your person and your fortunes.

So that a full and violent career is discouraging material for a would-be autobiographer. He will need all his art, all his will, to keep events from getting uppish. For very much the same reason, extroverts rarely write the best autobiographies. A natural introvert, on the other hand, would probably produce a fine fastidious piece of work, every line of it against the grain. His temperament will compel him to criticise and eliminate; his temperament will guard him from exuberance and indecent revelation. But an extrovert, by writing autobiography, would be succumbing to sweet temptation all the time; letting runaway horses run.

Indeed, by the time one has decided on all the things that most certainly will have to be avoided in writing autobiography, nothing is left but blank pages or a masterpiece. For one must avoid, to begin with, dullness, crowding, bad taste, anecdotes, a cargo of *I*'s whimsicality and over-intimacy.

Dullness, in a book of this pattern, can only be avoided by accident; it would so obviously be foolish to try and divide up your life into two heaps; one heap of all the things that can only be interesting to yourself, and the other of things that just may be interesting to those who read of them. For no one can emphatically state: In this heap are jewels, but this is the rubbish heap. At least, they may state it, but they have only a most fantastic chance of being right. What is there to guide your selection, as you help yourself from the large heap on your right, the small heap on your left? No prayer, no instinct, no advice. Pepys did not care, in his journal, what was of interest and what was not. Samuel Butler did not care either, in his "Notebooks"; nor Proust in his glorious pages of neurotic

self-examination streaked with descriptions of French So-
ciety. The fear of dullness may attack you a dozen times
on every page, but it is a fear that has to be left to look
after itself.

Jane Austen never asked if she were being dull when she
engaged Mr. Woodhouse and his son-in-law in that un-
fortunate discussion on the rival merits of their physicians,
Mr. Perry and Mr. Wingfield; Mr. Perry having a very
poor opinion of Southend for little Bella's throat, but Mr.
Wingfield, who "thoroughly understands the nature of the
air" highly recommending the place. "We never found the
least inconvenience from the mud," said Isabel. It could
hardly have occurred to the author that one hundred and
twenty years later, in *The Times* yearly General Knowl-
edge examination paper, would be a question respecting
the rival qualifications of Mr. Wingfield and Mr. Perry.
It is possible that had Miss Austen stopped to ask herself:
"Can people possibly be interested in what my heroine's
fussy old father thinks and says and invents about the effect
of sea-air and mud on a delicate child's throat?" she would
never have written that passage; for though indeed her
passionate admirers could not spare one word of it, it has
no actual bearing on the theme of her book nor on the
fortunes of her heroine.

Yet still that small self-conscious question: "Am I being
dull?" clings like a burr round the ankles.

Many years ago I had a long letter from a woman, a
stranger, living in one of the small Western states of
America. She wrote: "I wonder how you would handle a
real life story such as mine," and then gave me a detailed
account of all that had ever happened to her, adding: "or
is my story too wildly improbable, or is it uninteresting
to anyone but myself?"

Now from my point of view, and I was temporarily "the reader," nothing of it was interesting except a minor detail slipped in probably by chance. She starts by telling of the love-affair of herself, a little girl aged six, with a little boy aged six, and says: *"Little boy hires another little boy to kiss little girl, since he is afraid to do so himself."* And then, no less extraordinary, her own comment: *"It is a pretty, ingenious way of showing he loves her."* After that follows page after page of drama and suffering, which were, callously speaking, of no value at all. That letter seems to me a fair proof that we are incapable ourselves of making any sort of a choice.

Next, this matter of "I." Self-consciousness causes a morbid panic that the pages will be "I" and "I" and "I," over and over and over again. Self-consciousness, and a fear of being accused of insensitive egoism, will suggest the uses of "one," of "you," of "we," in place of "I." Or, going even further, of writing autobiography in the form of biography, about a woman called "Mary." But directly I tried to externalise myself as a woman called Mary (she insisted on being called that and nothing else) Mary immediately did a wayward metamorphosis into a person so priggish and sententious and generally horrible, that I had to abandon the idea. After all, it is of little use pretending that I, whoever I am, can pass a sentence of banishment on myself, while writing an autobiography; that is modesty unduly pampered.

Introverts are inclined to generalise. You may notice it in their conversation as well as in their writing. Directly a matter becomes personal they cut, so to speak, its navel cord. To generalise is not a sign of wisdom and detachment, but only another weapon in the armoury of self-preservation. A reticent person is more acutely conscious of the first per-

son singular than any of our more obviously intimate, garrulous friends, robust and confidential. So reticence had better be violated, within limits, and I remain "I" till the end of the book.

Too much intimacy, however, leads to what I would call the "joy-plank" style of autobiography. Down comes the revue chorus singing, with made-up faces and engaging smiles, past the footlights, over the orchestra bridge, and right into the stalls, mingling with the audience. The audience is supposed to be flattered by this collaboration. But in autobiography, too much collaboration must prove embarrassing; though it is certainly a relief to take gentle reader into our confidence and whisper to him of our difficulties. In writing fiction, a conspiracy exists to pretend that there is no gentle reader and no writer, hardly even a publisher, but just a story floating about loose in space. Autobiography releases us from the conspiracy and we are apt to enjoy freedom too friskily.

Another danger in the same category, is to anticipate objections and criticism and try beforehand to take the wind out of the critics' sails; to throw up your arm, shield your eyes from the coming blow: "Don't say it, sir, for Gawd's *sake* don't say it. I've said it myself first, so you can't."

Yet all these snags are as nothing, in my own case, compared with the peril of being whimsical.

As a child, I think I may be said to have had naturally bad taste. And in adolescence, it went from bad to worse, perhaps influenced by the fashion of the period. For I had a strong pierrotic tendency.

The pierrotic period extended from about fourteen to twenty, and can be seen curling and uncurling all over my first novels, stories and poems. I was beguiled into the tilted

kingdom of pierrots and pierrettes, minstrels and dark red roses and round silver moons, mischievous elfin laughter, quaint tricks and wistful symbolism, along the star-shiny trail of Ernest Dowson's "Pierrot of the Minute"; J. M. Barrie's "Pantaloon"; a jolly little odd volume called "The Harlequin Set"; Richard le Gallienne—I am not sure that he was not more responsible than all the others put together; surely "The Quest of the Golden Girl" was something more than merely graceful and shocking? Laurence Housman's "Prunella"—all of these I read, shivering with ecstasy. The real "cher maître" of our harlequinade mood wrote his "Carnival" a little later; and of the whole collection, I believe this novel of Compton Mackenzie's might still hold glamour like rose-coloured wine (the old style dies hard) in a silvery chalice. On my walls hung pictures by a painter called Kay Neilson: elongated pierrots shivering outside a locked door, gazing forlornly at a rusty moon, while a few dead leaves drifted across a wan sky. This formula filled my soul to the very brim. In a pierrotic miming play called "L'Enfant Prodigue" and in a song "Au Clair de la Lune, mon ami, Pierrot—" I found the same emotion.

The Pierrotic influence glittered in every tinsel harlequinade of every pantomime; an influence so powerful that even now I have to take the greatest care not to mix up fauns and moonlight and little men with pointed ears sitting on mushrooms, stricken punchinellos and big white ruffs and capital letters and dots and whimsical metaphors, with the more sober, more seemly style that I have acquired (I hope) in these latter years.

"Symbolical" plays were a side-line of my pierrotic phase; plays where you hang your hat on a peg which isn't there; plays that are not built on gravel soil; bluebird plays. Blue Bird means happiness, you know. Once I lay on the beach at

Santa Monica on the Pacific Coast; and because it was very hot, I took off my wool cardigan and flung it on the sand beside me. Then I turned over and meditated for an hour or two. The sun began to drop and I grew colder. I turned round again, picked up my coat to put it on, and there, *believe me or not*, half buried in the sand under the coat, was a Blue Bird, a brilliant blue baby lovebird.

There are times when severe statement is more acceptable than comment.

I see no necessity, now, for looking back on this phase of my youthful taste with the same tender tolerant half-indulgent smile with which one watches a puppy eating one's sequin evening-shoes. On the contrary, I am inclined to write a Hymn to Middle Age, valuing the companions of my maturity, their austerities and astringencies; their palate for life; their subtle understanding of what need not be said and of what can be taken for granted; varied by their sudden agreeable frankness, so far removed from mere juvenile crudity of blurting out the truth; their taste, mellow, fastidious, that has learnt by experiences, good and bad, to reject a diet of satin and sequins. One cannot be as critical and bored as one could wish, over the tender youth of others, or one would be charged with jealousy; but at least one has the right to be properly harsh about one's own.

I am grateful, deeply grateful, to those who are responsible for hoicking me out of that morass of whispering reeds and glamour and elfin enchantment, and putting my feet on the hard uphill road. Of course the correction of bad taste is a slow process, and it is difficult to say exactly when mine began to improve. Nevertheless, there may be latent within me what doctors call "a tendency"; and auto-biography might easily, dangerously, prove the Prince Charm-

ing to awaken this sleeping beauty, this Princess Winsome. Too many whimsical autobiographers have shown the way to make boon companions of their bedroom slippers; or with a tolerant smile, introducing Signor Cameo to Mademoiselle Vignette. . . .

Can one draw a stern dividing line to separate "cameos" and "vignettes" from episodes of any worth? I wonder. When I sat on a headland in Brittany and watched the Breton fishing fleet come home to harbour in the warm evening light, and wrote pages about it, that, I think, is an example of a "vignette," and must be kept out. If you find it later on, anywhere in this autobiography, it will be for you, ungentle reader, to pity, not condemn; for simply temptation will have overcome judgment.

Let us try to find an item for the other side of the dividing-line:

It was Silver Jubilee week. I was coming up to London from the country by an early train, about nine-thirty a.m. At the station after mine, two ladies scrambled into the Pullman; buxom joyful ladies with pink faces and golden hair; they may have been about fifty; they wore leopard-skin coats and wreathing smiles. The leopard-skin coats may have accounted for the Bacchanalian atmosphere they spread around them even before they sat down, rang for the Pullman attendant and ordered champagne. Their talk, while they waited, was rich free talk, plummy talk, no harm in it anywhere; they were bubbling with the holiday spirit. And when the champagne arrived and the pop of the cork loudly defied early morning propriety, they smiled at me, sent for another glass and invited me to join them. Then the plummier of the two (though there wasn't much in it) rose to her feet and, swaying, gave us the toast: "The King. All this week, the King!"

All this week. . . . All that week, now that it is over, I was able to conjure up a vision of these jolly, loyal women in their leopard-skin coats, perpetually ordering champagne before ten in the morning, perpetually drinking the health of the King. All that week. They were darlings; they were Polly and Moll, Prohibition's Terrors; they were the best subjects King George could have found in the latitudes and longitudes of his kingdom; they were——

Now is this just another vignette, or is it permissible for me to have set it down?

I did not want, and still do not want, to write a "proper autobiography." To begin at the beginning of one's life and go straight on and on and on, with occasionally an airy little bridge thrown over an abyss, and then on again, conscientiously noting down milestones and landmarks, till one reaches the point in one's life five minutes before one ends the book, those are the obvious straight lines which drive the shortest way between three given points; the shortest way, even if it should cover five hundred thousand words. And apparently there is not a straight line in my mental system. How do I know? Easily. If you will take a look at the frontispiece, you will see what you might at first take to be a not very professional design for a carpet or wallpaper. It has indeed been suggested that I might make a sale of the million designs of this nature, each slightly different from the other, like finger-prints, which cover all the blotting-paper I have ever had and the margins of all the manuscripts and note-books. I swear that I have honestly given for reproduction a genuine example, and not artificially prepared to be as effective as possible. Every time I am stuck for a word, every time I am feeling lazy and would rather day-dream than get on with my work, every time I am nervous or bothered or irritated or wonder-

ing how to extricate myself from a difficult situation, my
pencil wanders round and round, and produces these, to
me, deeply soothing emanations.

My friends who have accidentally caught sight of them,
for thus do I often spoil their blotters at week-ends in the
country, tell me that it denotes my subconscious to be in
a most irascible state, and that I would do well to show
the patterns to a psycho-analyst. Like Timon, I lightly flung
at these flatterers the dishwater out of a soup-tureen, but
otherwise paid no attention. But when a friend who was her-
self a famous scenic artist, exclaimed with some excitement
that I had a real sense of form and balance, and that I should
show my patterns to a manufacturer of carpets or wall-
papers and turn them into good money, I instantly took her
advice. There is no delight like the illegitimate pleasure
of suddenly marketing what is not quite one's own job. So,
puffed up with pride on getting a professional opinion, gen-
uine and favourable, on what I knew well was no more my
work than writing sonnets was Raphael's, or painting angels
Dante's, I dragged this baroque subconscious of mine into
more conscious areas, and said sternly: "Now then, you,
function up here, not down there."

You will immediately see the difference. The conscious
pattern is certainly worked up from one very involved
monogram, G.B.S.; but in the more elementary production,
my own name occurs over and over and over again, as a
signature; as initials; as "Gladys Stern," the name I was
known by at school ("Now then, Gladys Stern, if you
have nothing better to do than draw while you might be
learning your algebra——"); as though I were seeking some
conceited relief from obscurity; as though the arbitrary
handle put to my identity were a matter of the most in-
tense gratification to the psyche.

I submitted my patterns to the heads of several whole-
sale firms; and while waiting for their verdict, planned a
carpet for myself of which I could reasonably say to
friends, entering: "Tread softly, for you tread upon my
dreams."

I doubt if I should have said it often and still retained
my friends, but the matter was never put to the proof; for
the manufacturing house of carpets and wall-papers, while
allowing my designs a certain merit, declared that they
were much too intricate to be of any trade value, and could
I do two sides alike?

Of course I could not do two sides alike. Are one's
dreams on two sides alike? Is one's subconscious to be so
mathematically adjusted and turned into a wall-paper? I
gave up the idea, and my weaving of patterns continues,
unchecked by monthly payments.

And having got as far away as that from my point, you
will begin to understand the subconscious force which im-
pels my patterns.

I believe set to the same rhythm in my system is a love
of vast family trees, of the weaving sound of Bach fugues,
and of kaleidoscopes.

Anyhow, it was obvious that my natural line of auto-
biography was not to travel straight from one given point
to another.

Xavier le Maistre has written a book called "Voyage
autour de ma Chambre."

His formula expressed a conviction that everything is
linked to everything else; it must have been the greatest
fun to follow. For there is hardly an object, however re-
cently acquired, however sharply free from cobwebs and
memories, that would not start an association with some
incident, some person, that would lead on to another and

another; honestly allowing the line of the pattern to take whatever twists and curves and backward looks, angles and zigzags and convolutions it wills; honestly; not forcing it in this direction nor in that, simply because this or that direction might make the prettier or the more rhythmical pattern. Suppose I started with——

Will this do? The little blue and white glass dragon who has got herself christened Lorelei, standing in the centre of the mantelpiece? And go on and on from there till we find out whether this theory of mine happens to be true: that whereas one thing undoubtedly leads to another, all roads will eventually lead to one's own particular King Charles's Head.

And next, pick up casually a second and a third object. What shall they be? Anything from anywhere. The mosaic paper-weight that my parents brought back from their honeymoon in Venice? or the bit of the Grand Canyon which I brought back myself, loot on my return journey from Hollywood? or the painting of a little dog on wood, splintered, blistered and faded, which I picked up from the rubbish-heap under the olives of a villa I had rented furnished in the South of France? or the brocade curtain from the Paris Exhibition of 1889, hanging over the door? the curtain which my Rakonitz uncle presented to the Matriarch, and was given by her to my mother, and was draped over our piano at home when I was a child and mother used to play for me Viennese tunes from "Vogelhändler"; or "La donna é mobile"; or sometimes: "I have a song to sing-o!"

And from this second chosen point, and from the third, travel along the same spontaneous expedition, the same looping, twisting, curling, single-line routes, and see where they lead. If eventually, as I now believe, they also lead to

the same King Charles's Head, then our three objects are linked, and the book is finished.

I was born under Gemini, and therefore they fascinate me, the Heavenly Twins. It seems to me that I should be a twin myself; and I used to question mother, hoping to be told that a dear little brother or sister had also been born on June 17th and had died early. Apparently not.

Judge then of my surprise (this is one of the phrases I have always wanted to write; another is "the clicking of the jalousies") judge then of my surprise, after an operation for an ovarian cyst, when I was told by the doctor that they had discovered in me, unexpectedly, a little dermoid cyst at the same time. A dermoid cyst, he told me, answering my eager inquiries, was a dermoid twin. In fact, I should have been twins if all had gone well.

When I was in Hollywood, I went to the top of Mount Wilson to the great observatory there, and looked through the hundred-inch telescope. I requested that it might be swung round so that I could see Castor and Pollux at close range. Astronomers will smile when I confess my surprise and resentment at being told this was not possible, they were too far apart, and I must choose either one or the other; too many million miles, I suppose, since astronomers despise space or time which is not a matter of millions.

Still, it was exciting to see even a lonely Castor wheeling, a saucer of white flame in the blackness.

Here are my rough notes made directly after that visit to the Mount Wilson observatory:

"Great blocks of snow on top, piled carelessly like forgotten masonry left over from winter building. Sudden appearance of two startled deer with soft eyes and slim shapes, that spring on a piece of high ground within a few feet of us, and then spring away again. The squirrel with huge grey bushy tail. Our austere walk through blackness and snowchunks, under the stars, from the hot primitive dining-room of shack hotel (forlorn swimming-pool with no water, very muddy bottom, wheelbarrow standing in it. Huts with radios) toward the Observatory of the 100-inch telescope (they are getting a 200-inch telescope soon). Looking back, against the skyline, two stark silvery outlines of other thin observatories, a few tall black pine-trees, nothing else. Received at O. by little Von M. with his eager childish alert face under peaked woollen hood, like a kindly gnome. "Tom," who lives at the bottom of the shaft, and works the telescope by buttons (leverage?). Tom is invisible, and usually only growls. One feels he doesn't particularly care for the human race, but serves his master, the Hundred-Inch. Up here, domination by the Hundred-Inch; down there, in Hollywood, by Mickey Mouse. Standing on the little moving rimless platform, while the telescope swings slowly down towards us, and the wheel-ladder swings grimly into the high dark away from us, and the dome itself revolves in one direction and the floor in another, Von M. remarks chattily that once when the monster instrument had been swinging down within a few inches of his chest, there had been a mistake . . . though he had applied the emergency brakes, it had been quite unpleasant!

We saw, through the small eyehole, first Orion and the Nebulæ, like streaming white fire-balls. Then Castor of the Gemini, which in itself splits up into two stars. Then Jupiter,

with four moons visible, one quite close, as though he had just that minute given birth to it (*only* 33-year-old light). Before looking, we were afraid that we might see nothing at all, but would have to exclaim with conviction: "Oh, *yes!*" Everybody has that feeling over huge telescopes.

The strange look of the observatory dome, with the square light cut out, and the dark sharp air flowing in, as we looked back at it after we had crossed the wooden bridge again, when our visit was over. One could just see the outline of the telescope, and imagine little Von M. spending his night up there, contemptuous of mere planets and stars, but observing accurately tiny refractions of light, etc.

Then the view from the top and all the way down, of Los Angeles and sixty other towns, like grains of sand flung in a luminous shower over the land; luminous as diamonds. Or like numerous problems and theorems of Euclid worked out in millions of lights.

I am glad Gemini is my sign of the Zodiac, though it encourages those alluring regions of softness and self-pity where one may not dwell too long; the region where one says the word "lonely" aloud in an empty room, or smothered into one's pillow. "Lonely" is a hit-below-the-belt word, a cadging word that whines and tugs at your hand and can't wipe its own nose; a word that should never be used except about prairies, and even then not too often. I have, however, succeeded in wheedling myself into a persuasion that two is my lucky number, all because of Gemini and that little matter of my lost dermoid twin. I wonder how I should have been influenced had I been born under that whimsical godparent in Zodiac, the Man with the Watering-Pot?

And the "M" perpetually woven into the warp (or is it the woof?) of my patterns must be an indication of a woofed mind; for if the mind were not woofed, surely all or none of the letters of the alphabet would have twisted themselves in? Or simply "G" for Gemini as well as for Gladys? And furthermore; "How is it?" a friend asked me suddenly, "that you use the name Maitland so often in your books?" I asserted indignantly that I had only used it once. I was mistaken. She had found four separate Maitlands in four separate books. I have been waiting, ever since, for a Maitland to turn up significantly in my life.

It is true that in these subconscious scrolls I recently found stuffed away in a drawer, I find the letter "M" boldly recurring, and wonder whether this preoccupation can be traced to Mother (says Professor Freud), to May, my elder sister's name, or even to "Me"? Or perhaps, a more recent admiration than Mother, May, or Me, to Mister Max Beerbohm? Or to the contents of Alice's well: "such as mousetraps and the moon and memory and muchness"? Or to the Marx Brothers? Or to the Maitland family?

It *is* funny, about the Maitland family. I have never known anybody called Maitland. I give names to characters in my books in the same way, I imagine, as all authors do, from maps, from any copy of *The Times* Births, Marriages and Deaths that happens to be lying near, or from the telephone book, or using a name seen perhaps at some time or other over a shop or in an advertisement and retained for future use: Petit-Pierre or Juby; or from just throwing one's mind about, vaguely saying: "Names? Let me see, what names *are* there?" aware that it has to have a certain balance, a certain amount of syllables, a certain symmetry or lack of it, otherwise it will not do for just *that* character in *that* place in your scheme.

Neither must names be too appropriate or too suitable, unless you are writing a Morality Play; or too euphonius; yet you should not choose a casual name for a serious character; nor a Scotch name if the character of your book hails from Dorset. And names must not be too grand. I was once roughly commanded not to call my hero Kevin St. Erth; and yielded, though not without a wrench, and rechristened Kevin by a name so severely plain as to be hardly convincing. And then to my disgust I found that Galsworthy had not feared to tread where I had not been allowed to rush in, and had named a character in "Loyalties," Lord St. Erth, a respected member of a first-class club in St. James's. That was very bitter.

The letter "H," and not "G" for Gemini, not "M" for Max, Marx Bros., Me or Maitland, should have been the controlling arabesque in my subconscious scrolls. It can still be seen as I saw it during my childhood, on walls and railings: a diamond-shaped plaque, sapphire-coloured, and on it the letter "H" in white, clear and unexplained. "There it is again!" I would say to myself, thrilled at every fresh encounter with the mystery. Once only did I ask what it meant, and was briefly told: "Hydrant." That conveyed nothing, and I did not look it up in the dictionary. Being a dreamy child, a little beast, I wrote instead about fifty pages of a symbolic epic poem called "Edelweiss" in the Hiawatha metre, but I did not look up Hydrant. The mystical letter H remained a mystical letter. "There it is again!" suddenly, high up on the wall of a house in Holland Park, in Kensington, in Campden Hill, wherever I took my walks. I do not think I was guilty of any elfin interpretation of what lay beyond this recurring flash of excitement, white on sapphire blue. Indeed, it seemed more like

a solemn statement of the things that were all about us but which we did not understand, than any whimsy to the effect that it had been put there to mark how behind it was a little door through which children could pass into fairy-land. . . .

"There it is again, Nannie——"

H for Hydrant.

What was a hydrant? I did not know. So many things one did not know, queer, disturbing, rather frightening; but the richness of that sapphire blue as it glowed through the murk during a bleak afternoon walk with Nannie, in winter, made it to a degree that I can only call sensual, my favourite colour. And if ever a rajah should wish to load me with superb jewels, which is improbable at my time of life, and he should tenderly inquire my favourite, and learn the answer was star sapphires, he would be surprised if I followed back, link by link, as far as the railings of the walls on my early walks in Holland Park, London, West, what had flashed and fixed the colour of my choice.

And now I must confess and apologise: A few weeks ago I met a well-known writer of our time who has to carry the word "whimsical" before him, a banner with a strange device; probably, to him, a strangely boring device. It is easier for a rock to get rid of its limpet than for a writer to shed what has been dealt out to him as an appropriate adjective. I suddenly longed to hear what whimsy that whimsical mind would make of my whimsical recollection of the letter "H," so whimsically seen and not understood in childhood. So I mentioned it, luring him on; and waited for the twists of quaint embroidery, the dancing fancies that the theme might well have been expected to inspire in him of all people. His reply, though he was not aware of it, was the perfect snub:

"It stood for Hydrant," he said simply.

And I could not even say that by now, having achieved more than half my three-score and ten, I knew that; for what should I have replied to what would have been his next, most natural query?—"Then why, my dear Madam," (or: "Then why, you bloody fool") "did you ask me?"

There was a sculptor. I cannot remember our first encounter, nor our last, nor indeed the social geography of the matter. In appearance he was long-drawn-out, with hungry eyes, side-whiskers and a pallid complexion. His eyes could look a little crazy. He was going ahead of me up a rather dusty wooden stairway, vaguely part of some converted mews; there must have been studios there, with little blue doors where the paint blisters had been peeled off by passing urchins. I was just behind him on the stairway, and I can clearly remember this, if nothing else: that at that period I was finding life so unbearable that only the plain fact that there was no alternative, enabled me to go on bearing it at all. And the sculptor (I wonder who he was, how I knew him, or why I was following him up those stairs?) stopped and turned round and said: "Have you ever noticed how things happen to you that people call coincidence? only they're not coincidence; they're not, they're *not!*" he asserted passionately. By the time he had calmed down, we were in a large dusty unfurnished studio: "There *is* no coincidence. But where you notice the linking-up, the whole world with a web flung over it, a web of tiny curling filaments, *that's* what the fools call coincidence. Once you begin to notice, it's fascinating; you *have* noticed, haven't you? They mention a woman—I'm just giving you one instance; you can do all the rest for yourself— they mention a woman called, let us say, Eve, who's just

gone to Finland. And that very evening you pick up a
book, and the word 'Finland' is on the page. The 'phone
bell rings, interrupting you, and you answer it and a voice
says gaily: 'Why, it's Eve!' Your cousin, Eve; not the
strange Eve on her cold way, her ice-blue way to Finland.
You have not seen your cousin for years; she's been in
Greece. You dash round to her hotel; she's wearing ice-
blue; it reminds you of the dress she wore at a dance ten
years ago on Christmas Eve. You talk of it, laughing. She
had given you a book, that Christmas, long ago. *It was the
very book* you had picked up accidentally, an hour ago,
and seen the word Finland on the page. One day, you think,
one day for certain you are bound to meet that other
Eve——"

He broke off. His eyes were what normal people would
call "queer."

"——that other Eve. So you see how exciting it is, once
you've discovered these are connecting messages, and that
they're over everything, like invisible writing in milk.
Learn to read it, and you can never be unhappy again. You
cannot be unhappy again. . . ."

I am not sure about the never-being-unhappy-again part
of it. And irony is supremely overstressing its point in this:
of the man who first tried to make me aware that every-
thing in life is linked, and on the rope of association you
can, so to speak, haul and haul in, till if you continue
long enough you have got all there is on a line, of him, to
begin with, I can remember absolutely nothing. Absolutely
nothing, except that detached moment on the wooden stairs
of a building in a converted mews. No amount of search-
ing for association will help me to place him or to link him
up with my own life; he floats forever in a vacuum; to the
North, South, East and West of him is space and mist.

Among my books, as a child, I had four bound alike in dull green: "Home Influence" and "A Mother's Recompense" by Grace Aguilar (of the same school as "The Wide Wide World" and the Elsie books which still give me such extraordinary pleasure) "The Swiss Family Robinson," and "Mansfield Park." Why those four should have been linked together by the same binding, I do not know. I accepted "Mansfield Park" as rather duller than the Grace Aguilars; except the acting part, when Sir Thomas Bertram was away and they performed "Lovers' Vows" in the billiard-room: an enthusiasm begun by Mr. Yates having come straight on from Lord Ravenshaw where they had been going to act "Lovers' Vows," only Lord Ravenshaw's grandmother had died inappropriately the day before, and the whole event had to be cancelled.

". . . 'To be sure the old dowager could not have died at a worse time; and it is impossible to help wishing that the news could have been suppressed for just the three days we wanted. It was but three days; and being only a grandmother, and all happening two hundred miles off, I think there would have been no great harm, and it was suggested, I know; but Lord Ravenshaw, who I suppose is one of the most correct men in England, would not hear of it.'

" 'An afterpiece instead of a comedy,' said Mr. Bertram. 'Lovers' Vows were at an end, and Lord and Lady Ravenshaw left to act My Grandmother by themselves.' "

For about thirty-five years I thought "My Grandmother" was an invention of Tom Bertram's. Last night I was reading Jane Austen, as I nearly always do at odd moments; then I put it aside for a volume of Hazlitt's "Conversations with Mr. Northcote" which I was reading for the first time, and came across this: "My Grandmother, too, was a laughable idea, very ingeniously executed; and some

of the songs in this had an equal portion of elegance and drollery."

It took thirty-five years for Jane Austen to make her point with me.

That was one of the moments when I understood what that sculptor with the feverish eyes had meant: one of all the tiny filaments that invisibly bind the world and time together, suddenly became visible and iridescent.

And again:

I was walking beside a stream in the Austrian Tyrol, and passed a broken-down châlet with a brilliant fall of nasturtiums from the balcony; and a dark Celtic woman with a handkerchief knotted round her head came out and stood on the balcony and yawned, hating the quiet valley. Why did the incident remind me first of Massine's dance, the dance of the Tipsy Barman in the ballet "Union Pacific"? And then on a surely even more irrelevant tangent, why did it further remind me of a group of skaters doing their turn, exquisitely confining acrobatics within the space allowed for cabaret, and a remark from Mr. H. G. Wells, sitting beside me: "Now do you know, I suppose we are seeing just this one thing being done as perfectly as it can be done or ever will be done"?

A châlet with nasturtiums on the balcony; the Russian Ballet; some professional skaters in a cabaret at Monte Carlo. What was my brain about, to link up these?

And then I realised I had seen the date carved over the door of the châlet, and the date was 1888. It is a curious date to look at, with those three eights. But the sight of it was familiar to me, for John Van Druten had given me a fan which he had bought in the Caledonian Market; an amusing fan with a map on it of Europe, which was apparently the fashion for fans at one time. The man who

had drawn this particular map was a little unbalanced in his sense of values: he must have been a German or an Austrian, from his spelling of "Canterburg" and "Scheffeld." He marks very few towns in the British Isles, but Merthyr Tydvil is marked and printed with such size and emphasis that we must tenderly hope that the romance which surely happened to him during his brief stay at Merthyr Tydvil, had turned out a happy one.

I had had that fan with me at the Russian Ballet; and again on that evening when I dined at the Sporting Club. 1888 on the fan; 1888, as it happened (and why not?), over the door of the châlet. An invisible pattern which links everything to everything, and suddenly, in one place, for one moment, it comes up clear like a bit of a message written invisibly in lemon or milk. Eighteen-eighty-eight and eighteen-eighty-eight. This was pattern, not coincidence. ("They're not coincidence; they're not, they're *not!*") Coincidence is a much more arbitrary matter than association. And though coincidences do strangely happen in life, they have always an air of clever fiction about them. If the discontented woman on the balcony in Austria had turned out to be the daughter of the woman in Merthyr Tydvil who had been loved by the Austrian who drew the map on my fan, *that* would have been coincidence.

So, glancing round the room, and making my choice as laconic as possible, for deliberation here would make of it a weighty and boring matter, let us pick up Lorelei and see what comes of it.

Lorelei (as I have said before) is a small dragon of thin modern glass, formalised with blue and white stripes into being an even less natural dragon than dragons wontedly

are. She has a long neck which loops and then goes on
again, an engaging mouth, open, with tiny blue beading
round the rim of it, and a red glass tongue, thin and
forked; flat blue glass feet (but it may be that among
dragons flat feet are esteemed a beauty) and a blue glass
cockscomb on her head.

I bought her in Berlin when we dashed over from Paris,
a quartette of the dramatist's friends, to be present at the
First Night of a play called "Journey's End" in German.
At the same time, rehearsals were going on in Paris, of
"Journey's End" in French. But this German production
could not be accepted as placidly, and as a normal corollary
to a long and successful run in its own language. Trans-
lation into French, yes, of course; and into Swedish and
Dutch and Danish and Italian and Chinese and Japanese
and Hebrew and Erse. But was there any more pungent
comment on the utter silliness of wars, than that on this
night it was going to be played in *German*? For this was
no ordinary play. There were scenes of real happenings in a
dug-out in the English front line during a war with Ger-
many a few years before. The Germans, perhaps recognis-
ing the peculiar irony, had not literally translated the title,
as had the other nations, but called it, instead: "Die Andere
Seite." Die Andere Seite. The Other Side.

So this was more than a mere First Night; it was an
occasion; and, if you ask me, a damned queer occasion. How
would they take it? That one scene, for instance, where
Raleigh and Osborne make a raid into the German lines
and bring back a German prisoner?

We were only three days in Berlin. I had never been
there before. A heat-wave helped to put the haze of un-
reality over those three days. We saw the head of Queen
Nefertiti; we ate in shady wine-gardens or on roof restaurants;

we ate iced fruit-soup. Unter den Linden swerved away
at opposite angles from how my imagination had placed
it. Subsequently I had to fiddle round several times in my
head, between the image and the real, before I got it right.
We visited, at Potsdam, the house of a German Frau Baronin
to whom one of our party had an introduction. The others
burst out with "Isn't she charming?" directly we left the
house, at precisely the moment when I began: "Isn't she
awful?" And she was, not a doubt of it. Awful, not charm-
ing. I understood German better than they; understood
the arrogance, the ruthless persecuting quality that lay be-
hind every gay welcoming word; a woman with a thump-
ing superiority complex; luckily they are rare. Her serv-
ants and her children were afraid of her. She would have
assented to torture, with an inflexion that betokened she
had absolutely no doubt but that torture in many cases
was what the doctor ordered. If ever I am asked if there
be anybody in the world whom I hate or would wish to kill
quickly and painlessly, if I could do so without being
found out, I think and think, and at last I can remember
only this woman and a certain chambermaid on the South
coast.

On the First Night of "Die Andere Seite," I was in a
box with the author and the management. The house was
packed; not antagonistic, but prepared to control all emo-
tional responses. I knew the play very well, and had seen
several companies perform it. Yet it seemed now that every
familiar line of the dialogue was doubled in significance
when spoken in German by a German; doubled and trebled;
every line held a comment on itself. It was not a straight-
forward picture any more of a little group of Englishmen
just before a raid during the Great War. As the lines
could be spoken (and every moment was proving it)

without apparently any dislocation of the sense, did not that prove from a new angle (as though we needed proof) how supremely futile war was, is, and ever will be? If the words, the sense, the point of view, the acting, the characterisation, if anything had had to be altered and adapted even superficially before it could be played in German, one might have said "that does show a difference between the two nations; because of this difference, perhaps they fought." But there was no difference; nothing had to be altered. Played by the other side, it was as true as when played by our side; both sides were equally the Other Side; you could spin it round again and again.

The scene between Osborne and Raleigh, the gentle older man and the eager boy, in their last ten minutes before going over the top, was not as touching in German as it had been in English; nor did it affect the audience equally. But that, I think, was a matter of local colour: Osborne and Raleigh talked of "Alice in Wonderland" and of black pigs in the New Forest. In the German version, they quoted the "Midsummer Night's Dream" instead. It might have been adapted less sentimentally by allowing the German Osborne and Raleigh to talk of deer in the Schwarzwald and to quote those gorgeous nonsense verses of Busch: "Die Schöne Helena," and so forth. The scene which warmed up our cold German audience into much greater enthusiasm, enthusiasm which lasted for the rest of the evening, was the coward scene where Stanhope, young and weary and obstinately sticking it out, has to drive Hibbert, by scorn and by terror, out of malingering.

Roars of cheering at the end; feet stamping; applause like thunder. How queer, and yes, how nice!—they liked it. One had to cry because they liked it; though in England

and other countries one had cried at the play itself. This time, the effect of the play meant more than its performance.

Afterwards, a supper-party on the roof of the Eden Hotel, Germans and English eagerly agreeing that no better Stanhope had ever been seen. A sultry night; and the author could not settle down to his food because London newspaper offices kept on ringing up to hear what had happened. Again and again he was called away. It was a good supper-party, a queer supper-party. I was wearing an elaborate Chinese coat, and Anna May Wong, sitting a little way off, a well-cut and most European black evening-dress.

And the next morning the author appeared at my door with a pile of about thirty or forty German newspapers. "I say," in his usual modest fashion, "you know German, don't you? I wonder if you'd very much mind translating these? It would be awfully good of you." For the first time, I began to think I was a bit of a fool to have come. The compensation instinct, operating in all of us, sent me out to buy myself Lorelei.

I call my dragon Lorelei because of the twist and loop in her neck which meant undoubtedly the siren power to fascinate.

Lorelei is both siren and dragon, which is incompatible: dragons are not usually sirens, though sometimes they eat sirens and effect some sort of an identification. I have never wholly believed that dragons exist in the flesh, but it was only about three years ago that I learnt that unicorns were fabulous animals too, just as much as dragons and phœnixes. I was first surprised, then incredulous, and ultimately very cross. A few evenings later, I passed on this information to Ivor Novello, who also would not believe it at first. "No,

but look here——" we both kept on saying "—there *must* be unicorns!" And that remains one of the titles which I might have chosen for this book: "There must be Unicorns." They are linked in our minds with reality, with lions, with public-houses, with bootmakers under Royal Appointment, with fleetness and beauty and a pointed horn springing from the centre of the forehead; a horn so delicately and wittily equipped for attack. If this unpalatable News from Nowhere were true, if there were no unicorns and never had been any, who, forsooth, invented them? Somebody must have seen a unicorn once. Come on, these beasts are altogether too plausible to have been imagined out of the blue! if they had rosettes on their tails, like the Wallypug's sort-of-a-pet-dog Kis-mee—But unicorns! You have seen them in the centre of Central South America, perhaps? or in Thibet, or——

There *must* be unicorns. We know there are no dragons, curly and fantastic, as drawn for us in the corners of old maps; we will grant that the phœnix does not spring golden and radiant from the ashes of the fire that we forget to keep in over-night; we grant that the Centaur and the Chimera and Pegasus and the Sea-Serpent are mythological fantasies; did I not write an essay for an encyclopædia on "The Fabulists"? I will even allow that the Wallypug and the Mouldiwarp, adorable creatures both, do not really exist. But there must be unicorns. That there should not be is plainly silly. Who can deny that there are zebras? And zebras are even striped, which is absurd. Well then, there must be unicorns or how are we to manage?

And if there be none, there may not be Hong Kong either. I have had no guarantees, along with my birth-certificate, that I shall actually meet with unicorns or happiness or Hong Kong.

My host, for there is no need for me to bother you with his name which happens to have so brilliantly coloured itself that it might detract attention from our dialogue, my host was having breakfast in bed; and I, during a week-end spent at his country house, was sitting at the end of the bed entertaining him and being entertained. He suddenly said: "How do you imagine Hong Kong harbour?" for he had been to Hong Kong, and I had not. "When I say it quickly like this: 'Hong-Kong harbour,' what picture do you get in your mind?"

I told him the picture in my mind. He listened with attention. "You're wrong," he said (as usual). "Wrong from beginning to end. *This* is what Hong Kong harbour really looks like." He described it meticulously. "I had it differently in my mind, too, before I went; not differently but the same as you have it now; differently from you *and* differently from the real Hong Kong harbour."

By this time you will see there were five Hong Kong harbours floating about the room: The actual picture in his mind; my fancied picture of it; the picture which he picked up from my description of what I saw in my mind; my fancied picture corrected from his description (which cannot have been the same as the real Hong Kong harbour which he was trying to pass on to me); and a very faded Hong Kong harbour which he had seen in his imagination before he went there. And if it be true, as certain philosophers state, that everything exists which has once been thought of and thus launched into space, then there must be millions of Hong Kong harbours jostling each other in the ether, overlapping, all facing different ways, one superimposed upon the other; a crazy palimpsest of Hong Kong harbours. And millions of Berlins and Grand Canyons; trillions of Taj Mahals; quadrillions of temples of Ang-kor.

Photographs, we agreed, dizzily continuing the discussion, really did not help to put one right nearly as much as might be supposed; you mentally place them facing the wrong way. Presently, when you have been to the spot which you have imagined for a long time, after the first dazed refusal to accept such an imposition, you get used to the real Hong Kong harbour or whatever it may be, and forget the earlier mental pictures; but only while you are in the midst of it. When you have gone away, and for a long time afterwards, you will dwell in a curious contradictory no-man's-land: whenever you hear this place mentioned or read its name in a book, at once involuntarily your old habit of mind presents you with the earlier picture, the wrong one architected by fancy alone, with a few buildings and steeples thrown in lopsidedly and at random from photographs or rough hearsay. Then, suddenly, surprised, you remember: "Why, I've *been* there now; it's quite different!" and you juggle for a moment uncertainly with the two pictures, the old and the new, reluctant to surrender the old. Yet it must be done. With firmness you thrust it out, and replace it with that not quite so lovable print of what you have seen for yourself.

Datchet. A childish fixation in my mind, of Datchet as a gay City of Sin in the style of the Restoration Period, needed quite an amount of correction and readjustment when eventually, happening to be passing through that sober little town, I halted there for a cup of tea. "My mother had a maid called Barbara." So Desdemona sang, on the sorrowful eve of dying. "She was in love, and he she loved proved mad and did forsake her." I often thought I would write the story of my mother's maid, Nelly, calling it: "My mother had a maid called Barbara."

I must have been about eleven when I remember her in

the nursery, sewing and chattering about the two Charleses.
My sister was just "coming out"; the era of governesses was
over. One of them she had thrown downstairs and never
regretted it. Governesses had been terrible, after Fräulein
Sanders left. Fräulein Sanders was our first governess and
stayed with us for years; a stout, comical angel on whom we
all relied for cheerful affection, and who could pull her smil-
ing mouth suddenly downwards, put a bit of lace handker-
chief on her head, puff out her cheeks, and look exactly like
Queen Victoria. While Fräulein Sanders lasted, governess
was a word that had no sour associations. I had read "Jane
Eyre" with precocious enthusiasm and many morbid and
unholy thrills, sitting under the dining-room table hidden
by the drop of the velvet cloth, at an age when I should
still have been reading "The cat sat on the mat" (which
from Rochester's point of view, was the same thing). So
I grasped that there was a different kind of governess from
Fräulein Sanders. Yet ours was not a household like Roches-
ter's, so it did not seem likely that we should exchange our
capable Fräulein for any one as uncomfortable about the
house as Jane. Unluckily, Fräulein being an obvious darling
and an asset in the home, her own relations knew it too,
and never ceased plaguing her to give up work and retire
and come and live with them. Ultimately she did this. We
then had a long pageant of governesses (I often wonder how
or where mother found them), who clearly would never be
asked by their relations to retire and come and live with them
for the sake of their open morning faces. One of them,
not quite so near bitterness, nerves and lunacy as the rest,
the one who most resembled Jane Eyre in personality, bleak
and cool but not unpleasant, with white fire burning under
a sedate exterior, was a Roman Catholic, a native of Alsace,
and the niece of a Berlin chocolate manufacturer. She tried

hard to convert us; and though I remained puzzled about Ca-
tholicism, she succeeded in turning me into a desperate loy-
alist on the French side of the Alsace-Lorraine contest. And
I liked the hampers of chocolate her uncle sent her.

After that, we had several lunatics, one elderly nympho-
maniac (unsuccessful) and a prostitute. The prostitute was
sacked when a man was found in her bedroom. Cook told
us, or we would not have known. It might have worked
out better if the nymphomaniac (unsuccessful) had been
able to follow the example of the prostitute. She threw
herself out of the top-floor window, but considerately two
days after she left us and not two days before. (One is a
slave to the rhythm of a sentence, but I do realise that "and
not two days before" makes nonsense.)

At any rate, when my sister grew up and I went regularly
to school, Nelly the sewing-maid was substituted for the
spinsters and the un-spinsters from whom we had suffered
for so many years. Nelly was luscious and a pet; her head a
mass of ringlets, inside and out; her eyes blue; her figure
plump; her dimples all in order. Nelly had a daughter,
two years old, ringlets, blue eyes, figure plump, dimples all
in order, whom she used to bring occasionally to the house.
Otherwise Baby Nelly lived with Nelly's mother down at
Datchet. Datchet, therefore, has and always will have, for
me, an element of clashing swords in a duel, mystery and
romance; also of merry kings with long curly black wigs,
and a more shadowy, more melancholy king who lost his
head; a chaos of Royal Stuart impressions that began with
Nelly's nursery serial, in three hundred and sixty-five in-
stalments, of the two men who had loved her down in
Datchet, both called Charles; whom I, with a bias towards
clear narrative, christened Charles I and Charles II.

Nelly was a laughing heroine, in spite of many blows of

ships upon their little daughters. It may be, even, that they thought these delightful friends led lives that were merely slightly relaxed and informal; it may be that they did not know a tart when they saw one. However it was, of all the houses of the Rakonitz family, ours had the reputation for providing the most amusing entertainment. As for the ladies themselves, one can speculate now on what they thought of it all? of this atmosphere of extravagance, comfort, innocence and married faithfulness? Pleased but puzzled would probably have summed up their reaction; a shrug of the shoulders: "It can't last!" a great liking for my father, who had a Rabelaisian jolly streak in his conversation. "Where are you going?" I would say when I found him in the hall, putting on his overcoat, and he would answer with a shout of laughter: "To the Bodega for some sherry wine!" It must have been a gag of the 1890's.

Yes, the ladies of the town liked flirting with him. They must have smiled, too, but tolerantly, let us hope, when my pretty Viennese mother, with whom they were on the most intimate terms, used to tell them of her counter-flirtations; charming, cosmopolitan gentlemen who politely kissed her hand, paid her compliments, and sent her *Marquis* chocolates, bouquets of Parma violets and lilies of the valley. She was a tiny little bit of a rip without any harm in her rippery whatsoever. I think she enjoyed being shocked by the broader confidences given in exchange for hers. Once, one of these merry incongruous ladies had got a little mixed, and started confessing to me, by mistake, what last night had been like. Some of it got through to my understanding, and some emphatically did not. She kept on repeating one triumphant phrase that made no sense whatever to my fourteen years. Nowadays, when virtue and vice, Society and the stage, black and white, all swirl together

without question or comment or bother, it is not so easy to see how strange and irrelevant these odd friendships of my parents must have seemed to families safe, conventional, careful as those who mostly composed their set.

——Pastime with good company,
I love and shall until I die——

Irrelevant that one's parents, and oneself perhaps, should have anything in common with Henry VIII. But in this matter of gaiety he may have been better than his proto-type, Bluebeard. Bluebeard probably had a grim sense of humour, but one cannot feel that he inspired an atmos-phere of silvery laughter around him. Gaiety, when you begin to define it, becomes a little leathery. Translation does not help: "Allegra" the Italians would say; and the Austrians believe we cannot translate "Stimmung" into any other language. The ball of the eve of Waterloo must have been gay; Persephone was gay when she ran over the fields picking flowers, because her too careful, too omniscient mother Demeter was away from home. Yet gaiety, in senti-mental cliché, is "a sob choking through the laugh" and "tears at the end of the waltz"; perhaps that is why, seeking one example and then another, I can find no purer instance of gaiety than two so instantly corrected by their sequels: a ball on the eve of a bloody battle; a young girl picking flowers just before hell opened in front of her. But the word itself cannot remain iridescent and elusive unless you say it only once, swiftly, and then fling it away with-out analysis. Gaiety, of course, at its most orthodox, has the lilt of a waltz; the "Blue Danube" and Old Vienna, Mitzi and Franzi dancing with officers in blue cloaks.

My parents have handed on to me this same legacy of choosing my company for the gaiety it spontaneously pro-

vides; for that rare delightful quality of *lifting* the air whenever it arrives.

These warm joyous ladies who were their friends were not wholly rubbish; they built their gaiety on the foundation of honesty that Henry VIII demanded:

> *Company with honesty*
> *Is virtue; and vice to flee.*

We might overstress our love for company with honesty, for laughter and good company; too willing, perhaps, in gathering it round us, to sacrifice substitutes of more sterling worth, such as morality, industry, stability, chastity and thrift. But this instinctive longing for a "good time" cannot be checked by drawing up such careful estimates as these.

A "good time" crystallised into a few moments, I still visualise as a dark London lane between high blank walls leading to a group of studios; the snow lightly falling; the studio brilliantly lit because we were giving a fancy-dress party; the gramophone playing a foxtrot: "It's moonlight in Kalua," a tune like canoes slipping down a river through sliding ripples of black and silver water. Two of the visitors were expected late, for they were acting in "The Knight of the Burning Pestle," and were coming straight on in costume. Somebody sighted them from the doorway of the studio, advancing in full panoply down the lane, and called to the rest of us: "Here they are!" We all rushed to the door, thrusting out lit tapers to guide them, slender white twigs with crocuses of flame.

This was the quintessence of a good time, as the shout went up to welcome them, and "Kalua" still rippled on in the light and brilliant warmth behind us: the crowd, half in the light, half out in the dark, brandishing their

torches; and those two beautiful slightly absurd figures
moving slowly towards us hand in hand, clasp held high
as though in some formal dance. Laughter, and the dance
of lit tapers. "Pastime with good company.". . . It was
all over in a moment, but the moment had been complete,
high, encircled, cut off from yesterday or to-morrow; a
moment that did not flicker like a fairy-tale, nor burn it-
self away in a fever like love realised; just a group of people
lightly happy, holding out tapers to welcome two more.

Every one present was included. I think that may have
been the secret. One so hated, always, to be excluded one-
self or to see anybody else excluded from a good time; yet
one hated to include somebody who did not naturally
belong, but only happened to be there. But on this occasion
kindliness had not to be forced, and no little match-girl
was left sitting miserably on the door-step; no clown was
pretending to laugh with a miserable heart; no Pied Piper
vanished with his jigging procession although one child was
lame and had to be shut outside. Sentimentality and that
childish tendency to say "nobody loves me and I don't care"
on the slightest provocation, made one invariably cast one-
self for the lame child excluded from the good time that
the others were having. My yearning always to belong to a
fabulous band known as "the Rectory children" was asso-
ciated with the idea that the Rectory children were always
having just this sort of a good time, and that if you mingled
with them *hard,* you would be yourself identified with their
good time, and so escape the dire fate of being excluded
from whatever was going on. These mythical Rectory chil-
dren, later on, were to develop into a more sophisticated
group; but they would always be the group that looked to
me as though they were having the best time of all.

I do not think that it was sheer rowdiness that I coveted,

but I am afraid it was not hermitage either. It was privilege; it was tapers and a running tune, a group in a doorway leaning out of the warm brilliant light into the dark, laughing and calling out hospitality.

From a high balcony that overhung a village in the Austrian mountains, I saw one night a procession with torches march down the village street, and march straight into the mountain, so it seemed, that stood a dark shape at the end of the street; march on and disappear. Because of the darkness of the surrounding mountains densely covered with pines, that little street cutting through, became for a few swift moments a very parade of gaiety and brilliance; the torches flared; the band played; the men swaggered in Tyrolean peasant costume; and the whole town followed them in a swarm:

Did I say all? No! One was lame
And could not dance the whole of the way.

A curious list has associated itself pictorially with gaiety and a good time: meals eaten over water or beside water; on some outjutting structure like a pier, a balcony, a terrace, a boat moored up to the bank; on the terrace of a restaurant at Rapallo, over the Mediterranean; at San Francisco, sitting in a bow window thrust out on the very rim of the Pacific; in innumerable gardens, along the length of the Thames; breakfast on a balcony in Budapest looking across the yellow Danube to the Royal Palaces opposite; meals eaten beside lakes, beside streams, beside weirs and waterfalls; on a balcony in Venice; at a restaurant beside the lake of Annecy; lunch at the end of a little breakwater in Cornwall, looking back at the harbour and the fishing village. Nevertheless, let none believe from this, that I adore picnics; I have always the darkest suspicions that picnics are likely to involve discomfort, insects, and indus-

trious co-operation thinly disguised as "fun." Washing-up is "part of the fun," a statement that I bitterly contest. The only picnic I have ever really enjoyed was when the complete furniture of the house was unostentatiously sent on in advance with the complete staff and every kitchen amenity; and civilisation was fully established under the pines beside the sea, five minutes before the picnickers sedately arrived.

Balconies are for ever fascinating to me, and little crescents, and streets up flights of steps and down again, and shops on bridges. All these, in a perplexing sort of way, have connected themselves with gaiety; a psychoanalyst, rooting round among my complexes, might be able to divine why. And gardens belonging to coast-guard stations, with lumps of chalk edging their borders, and white flag-staffs, and cannon-balls. And, more obviously gay, orange-trees in shining fruit planted along a terrace.

Another moment of good time, encircled and lifted high and cut off from the rest of one's less confident existence:

Four of us, four friends, on a wine-tour through France. We were starting off that very day from Avignon, and, in fact, had already had the first lunch of the tour; an excellent and exciting lunch that promised success for the rest of our four inviolate weeks. Letters were not to be sent on. Rosemary and I were sitting at a table on the pavement under a thick canopy of planes; so thick that the sun could hardly force its way through; but it had been a hot afternoon, and the street beyond the shade was still vivid where a pageant of men and women paced up and down in front of us as we slowly drank our Tavel from the Rhone vineyards; they looked as though the mob of dark-eyed children who had followed the Pied Piper were now grown-up.

It was lazy and pleasant, sitting there sharing a bottle of rosy wine. Presently the sun would set, and globes of light would shine like huge yellow lemons tangled up among the dark leaves of the plane trees. And then Humphrey and Johnny came strolling towards us, dressed for careless summer, in cream tussore trousers and brilliant blue shirts. It was all there for the summing-up of pleasure; spots and freckles and gold pennies of light fell through the trees on to the pavement; the river Rhone flowed near by; our quartette was complete; no one excluded. We were in Provence, so to replace "Kalua" or the Piper's music, no doubt a troubadour would come along.

Yet as gaiety has called up a vision of troubadours lilting their joyous way along the sun-baked romantic roads of Provence, pausing now and then to flirt with a queen, La Reine Jeanne or any other, I must correct that vision by setting down in as plain, as dry terms as possible, in what circumstances I found the Last of the Troubadours. It is not I who have named him with such a romantic flourish; the name is inscribed over the sort of wooden hutch, the sentry-box, the booking-office detached from its station, in which he spends most of his time in winter on the edge of a pine-shaded road that runs round a cape in the South of France. I do not know where he goes in summer. He is very very old, and his knees are thin and very very weak. I noticed his knees particularly. He sits there shivering, wrapped round and round in the folds of a dingy cloak. On the outside wall of his sentry-box is advertised: "Chante sur demande"; but passers-by seem a little self-conscious about stirring up the troubadour's chant, so sometimes he strums a few bars on his mandolin to lure them to pause and listen and pay. His box is plastered with swaggering declarations of his renown and his achievements, and faded

photographs, taken years ago, on his tour of the world.
When there are no more passers-by, he totters out of his box,
and totters down the road towards the village; for food,
no doubt. He has rheumy swimmy eyes, this gay troubadour
of France. And again I notice his knees, how weak they are;
and his legs, how thin they are; and his hand, how it trem-
bles. We are used to the Pagliacci tradition of the broken
heart under the mask of white paint, and the wide grinning
red mouth; so used to it that we would find it almost impos-
sible to believe, now, that any clown could have a happy
married life and crack jokes at his own breakfast-table with
no cracked heart to conceal. But a Troubadour is a slightly
less hackneyed form of Pagliacci.

There are little dusty shops in side-streets of small towns;
nobody ever enters them, so you marvel how the owner
can survive and eat and bring up children and clothe them
and pay the rent and the insurance. Even if a customer
enters twice a day when you do not happen to be there
to see it, that could not be called a roaring trade. Still, they
do survive. They have mysterious side-lines. I have pon-
dered as to what the side-line can be, of the Last of the
Troubadours? He might give racing tips. The man who
wrote "Trilby," when he died, murmured to his son: "Si c'est
la mort, ce n'est pas gai." But sitting for twelve hours a
day in a sentry-box in a wind that swirls round the cape,
waiting for passers-by to ask for a song that apparently they
have no desire to hear, *si c'est la vie, ce n'est pas gai non plus.*

A troubadour of modern Italy, with an enormous grin-
ning mouth like a toad (I always like toads) used to wheel
his organ up the drive every Friday at four o'clock and play
under our window, when I was a child. Mother called him
"Norma" because of the tune he played. But I thought it

was "Norman," because I had learned about Normans and Saxons, and he was indubitably the opposite to Saxon.

"Here you are, Norman!," running out with his three-pence.

Norman: a lovely name; one of the fourteen children in Charlotte Yonge's "Daisy Chain": Richard, Margaret, Flora, Ethel, Norman, Harry, Blanche, Tom, May, Aubrey and little Gertrude whom they called Daisy. There ought to be fourteen; I must have missed out a few.

Mother's At Home day was on the first Friday in the month; and the drawing-room where she received was at the back of the house looking into the garden; not in front, like the sitting-room, looking on to the drive; so I suppose that Norman either learnt in time to eschew that particular Friday; or, though he missed his threepence, his broad toad-like mouth used to grin with enjoyment at the sight of the carriages arriving and the ladies alighting, wearing white kid gloves, artificial parma violets on their furs and hats, large sleeves and feathers, and gold mesh handbags.

The drawing-room cannot have been very different from the drawing-room of every other child who lived in a house in Holland Park or its equivalent address, during the 'nineties. A volume of Doré's engravings bound in yellow velvet with a gold clasp lay on the grand piano. I was allowed to look at this as often as I liked; and though the subjects were terrifying, even the fairy-tales of Perrault as illustrated by Monsieur Doré, they did not affect me except to wonder and rejoice over the great floods of light that he sent in shafts and ladders right across the page and down from heaven, in his illustrations to the "Paradiso." When I tried to imitate him, and paint light, I might squander nearly a whole bottle of gold paint, which cost my elders three shillings and sixpence and was proportion-

ately rare and precious, and even then I could not make the light shine and dazzle as Doré managed in terms of black and white. Through Doré, I learned also, though vaguely, about Don Quixote and Sancho Panza; and about Balzac's "Contes Drôlatiques"; about the voyages of some Latin poet called Virgil; and of a curious French couple called Paul et Virginie. Virginie apparently preferred to drown in a shipwreck than throw off the clothes which encumbered her rescue. I was very scornful of this; and continued scornful through adolescence and maturity, until I found myself in the '33 Earthquake in California.

I was naked when the first shock tilted and rocked the earth; naked and just about to step into my bath. Instead, the bath flung itself out on to me. One might have imagined that primitive instinct for safety and the open would have sent me flying out of the house and into the garden. Primitive instinct, however, did no such thing. Primitive instinct sent me rushing round and round my room in desperate search of a coat, a blanket, anything to cover myself before I escaped into safety. I shall never cease to be amazed at such chaste and modest response to the extreme test; and of course when I eventually meet Virginie in Doré's Paradiso, I shall immediately embrace her, apologise, and say that I know *exactly* how she felt.

These are my shorthanded notes that I wrote down two or three days after the earthquake happened:

A beige moth dies outspread on my beige canvas hat. Found it the next morning. Chorus of mocking-birds, early. The beginning: naked, stepping into bath. Head suddenly swaying and thought I was ill, giddy or going to faint. Then realised it was the floor and walls, heaving and bumping, swaying and toppling. Rushed through bathroom and Freda's room, naked; looked round for something to wear

so that I could get outside. Desperate barefooted feeling. Picked up blue blanket and draped it round. Ground still heaving outside like a seasick whale; household assembled. Niki reports, first the sun going pale as though it were dusk; then a growling sound like thunder, only beneath you instead of above. Then a rustling whistle of wind of which one could almost see the whorl as it moved through the two palm-trees. Then a green flash of light through the stuffy air. And then the quake itself. We thought of the fires burning in the bedrooms, and we thought of the bath-water running, and Jennings dashed in, turned it off, and brought out brandy and my fur coat and eiderdown. Long silence broken only by the wing-beat of the terrified humming-bird trying to force its way into a niche in the roof. Then the distant whine of police-cars. Tried 'phone in vain. Sent Jennings down to Clemence. Very cautiously, about half an hour later, after a few minor quakes, went in and dressed and went down to her. Managed to ring Diana. Arrival of the Roland Youngs. Towards end of meal, more heavings and windows rattle. They depart to calm their mother. 11 o'c. and another quake, so we rush out into the misty night.

Next day: wide ring round pale sun. Mocking-birds in great form. Account from the Clive Brooks of their night; very Cavalcade. Children and parents, trying to sleep in drawing-room, woken and rung up by London newspapers calling! Had Hollywood been wiped out by earthquake and tidal wave? He gave them information of what he had heard spasmodically over the Radio from Los Angeles.

President woken and told. Rather a shame, considering he had the whole banking crisis on his shoulders.

I ask Jennings, the following afternoon, to take us for a quiet country drive for shattered nerves, and he takes us

looping round and round the Hollywood hills (a black dog lying still in the road, aged beyond his years by earthquake) to HOLLYWOODLAND, where girls disappointed by their film careers, committed suicide by throwing themselves through the giant letters into the canyon beneath. Marmots whisking in and out of holes in the cliff. Down the rough canyon road, and across the smooth dam that restrains the grey reservoir. Then he says: "My God, I'm glad we're safely across that! I always wait for it to collapse one day while I'm on it." *Not* perhaps a very good day to choose, to take us across. On the way home, Gauguin impression of brilliant cherry-blossom tree and dark Jap gardener's face beside it. Sky like a Doré picture, grey and white, with a silver sun. Ladders of faint, shaking light spreading out in wide rays, and rushing mist. One small aeroplane. We suddenly remember the upward-pointing rose-coloured finger in the sky the week before, admonishing or promising or warning us, we didn't know which, during three sunsets. And my own queer over-excitement all day, though believing it to be because of some great personal good coming to me.

The sailors (gobs) came ashore to help, all along the San Pedro coast, carrying enormous bottles of gin.

Passed a signboard: "Do you Want Security?"

And a horrid feeling that one will never quite be able to trust the solid earth again.

The goldfish who swooned in the quake, and had to be revived with salt water.

Zuleika also stood on the piano in the drawing-room, with the Doré album. She was a musical doll who existed as far as the waist only; a dark-skinned creature with real hair, who, wound up by a key in the flat of her back under yel-

low silk drapery, played the harp, graciously moving her
wrist, her head and her eyelids. I think this treasure must
have come from one of those great Paris Exhibitions which
Max Rakonitz used to loot for the pleasure of his sisters in
London. Maximilian Rakonitz was the name I gave one of
my three uncles in those family chronicles, half truth, half
invention, which I have written round the personality of my
great-aunt, the Matriarch.

I was not very deeply attached to the Matriarch. She was
too despotic. I was able even in childhood to remain fairly
aloof and critical from what most of the family and all her
vast circle of friends declared to be her charm and magnet-
ism. I invented excuses to encounter her as little as pos-
sible. Of the dozens of children in our enormous family
group, her grandchildren were naturally very much closer
to her than myself; so that really she was not at all an
important figure in my répertoire. If any one had told me
then that a time would come when I would make her
heroine of three or four long novels, where she would give
me less trouble than any invented heroine of mine; that I
would know without the least shadow of doubt, know to a
certainty, exactly what she would do in any situation where
I placed her; what she would say and how she would say
it; so attuned to her slightest reaction that I simply could
not go wrong in it whatever other faults I might and do
commit in the exercise of my profession, I would simply
have exclaimed: "I don't believe it."

She stands, therefore, as an excellent example of that most
fascinating game called "Little did I think——" A game
which is fun to play, because we can give ourselves such
shocks of surprise; especially when we choose to throw our
minds back from the present and from whatever things or
persons are so important in our lives that we take their

stature for granted, and see how casually, with what boredom or reluctance on our own part, our knowledge of them began.

"Little did Emmeline think——" so the old-fashioned novelist used to attempt putting salt on the tail of a flying bird still beyond the horizon; "little did our Emmeline think, when she went tripping forth so gaily that morning, that e'er she returned to her beloved home——" and so forth.

Little did I think, then, when terribly unwillingly I used to allow the Matriarch to seat me in front of the dressing-table mirror in her own bedroom with the yellow brocade hangings; while her masterful fingers improvised terrible masterful constraints on my long thick hair, pulling it fresh ways, plaiting it, thrusting in combs and tortoise-shell pins; saying all the while: "There. But *much* better. Me you can teach nothing about *la coiffure*. So. That is the way. Now you look but much toaller! Now one can see the forehead a little bit, isn't it? When I was a young girl, at fifteen already one had elegance, one had a little style and *allure*, one attracted les Messieurs. Directly Toni is old enough, so I will arrange her hair, and so, and so a little bit, and not like your foolish English schoolgirl, hanging down till she is nineteen already, and twenty-one and ready for the marriage bed!"—Little did I think, then, that some twenty years later I would be standing in a theatre, dust-sheets all along the rows of stalls, charwomen knocking and banging with unnecessary emphasis up in the dress circle; on the bare stage, a young actress, slim and childish-looking according to the "Constant Nymph" fashion of the nineteen-twenties, playing a love-scene. And beside me the Matriarch. Not my own great-aunt Anastasia, but the Matriarch nevertheless; a dark magnificent woman with glowing eyes, a

wicked sense of humour, and an unparalleled knowledge of her job as an actress; saying to me, in a deep voice that tragically stressed every consonant, "Look at those girls. Look at that poor girl. Look at them all. How can they play love-scenes, flopping about with boy's hair and no breasts? They lean on men and call them 'darling,' even when they are not in love with them. They have no dignity. You do not know if their hair is up or down. How can they expect to *know* what love is, schoolgirls with no breasts? *When I was a girl, we were like young princesses.*"

Yes, it was Mrs. Patrick Campbell. And what a picture she gave me of the girls "like young princesses," tall, fierce and virginal. Girls from a Du Maurier illustration; heads proudly tilted under their weight of piled-up hair; hearts beating fast; tall shy girls; *des jeunes filles lointaines* . . . like young princesses.

And that would have been my great-aunt Anastasia at seventeen. My great-aunt Elsa was a different type: pink and cushiony and delicious, with coquettish eyes, a dimpled shrugging shoulder, and no shyness at all. But she, too, must have had *allure* for the gentlemen. I invited her to a studio supper party one day, when she was about seventy-eight. All the men made love to her, and toasted her, and she told them they mustn't be "nottee," and tapped them with her fan. They had been instructed beforehand to dress and behave like a third-rate performance of Vie de Bohème. She expected it in a studio: lots of absinthe and velvet jackets; and I told her that everybody who was married, wasn't married but just living together. It went very well with Aunt Elsa. At least half a dozen of them made sketches of her and gave them to her, and that went well too. She told them that she too had sketched when she was a young girl, flower-pieces very carefully shaded. She was wearing

her silver-grey chiné with a faint blur of rose-colour in it, and looked a sweet; her eyes bright and narrow because she had been crying.

Why? Let me tell you. She had arrived early for the party, and we got chubby and sentimental in the firelight, and she told me little family stories like a shower of pink petals softly falling, and some one slain under every petal. I thought the stories needed illustrating, so I produced my immense pack of old family photographs that I had collected for years. Aunt Elsa was so touched and excited that I "took an interest" in the family. I passed her the photographs one by one, most of them faded old cabinet size, the photographer's name and address from all odd parts of Europe and Africa. Naturally I did not know who half the people were. Great-uncle Daniel at thirteen in his Bar-Mitzvah clothes. There were even two or three whom she could not recognise herself. And she laughed and poked fun at their clothes: So old-fashioned, isn't it? And suddenly she gave a little startled cry: "Ach, it is Mama!" and burst into tears. I had had no idea, of course. It was all over in a minute, and we went on looking at the photos. And then a bearded man appeared in an oval, and she cried out again in the same startled voice: "Ach, it is Papa!" and burst into tears again. Easy tears, not wrung out, but as though I had just put my little finger on a spring. And then she explained: "You know I cannot help crying a little to think of all who were alive seventy years ago and are dead to-day. But come, there are plenty of nice people still alive. Yes, yes, yes, present company!" And she grew gay again, and gave me little digs and pulls, and we went on looking at the photos until the Murger characters began to arrive for the party.

Darling Aunt Elsa. Little did I think that with such

heartfelt sincerity she would become my darling Aunt Elsa, when as a child I used to sulk and wriggle and say: "Must I?" aloud, on being sent there to tea, and: "I hate her," in a rebellious whisper. For Aunt Elsa was hard on impertinent children who had always, isn't it, a little bit too much to say, and wore their hair so silly as if they had no forehead that the Herr Gott gave them, and no ears.

And little did I think—but this is not my own experience in the game; it belongs to R. C. Sheriff, the author of "Journey's End," so I must let him speak for himself: "It's funny, you know——" we were in Berlin, sitting in a box at the first-night performance of the translation of his play "—I don't understand what they're saying, of course, but last time I heard that language it was only a few hundred yards across; they were speaking it in the front line of the German trenches, and when the wind was blowing that way you could hear them talking quite clearly. It sounded just like this. Well, I suppose it would. It's funny."

I agreed that it was funny.

Little did I think, when the post brought me a fan letter, every line crowded with immature, rather touching cleverness, signed by a young man who had read my second book when he was in hospital, and liked it, and had lent it, he said, to another young man in the bed next to his; little did I think that the writer would one day write "Cavalcade"; and that his friend in the bed beside him, was to be my husband for fourteen years.

Little did I think, when my old cousin the French Rakonitz whom as children we called "Kruger" because he was pro-Boer and had a white beard all round the edge of his face, little did I think when he invited the children of the family to come and see Queen Victoria's funeral from his balcony in Oxford Terrace . . . that one day, my own hair rather

silver by then, I should be sitting in a deep armchair in Winfield Sheehan's luxurious private projection-room in Hollywood; on one side of me Diana Wynyard, whom I knew so well already in the flesh but had never yet seen on the screen; on the other side of me Clive Brook, whom I knew so well already in the flat, in black and grey and white, on the screen, but had just encountered for the first time in the flesh. And in front of me. . . . A group of children on a balcony in London; behind them their protective elders in the dresses of 1900, excitedly watching something going on in the street below, something that from their exclamations and quick descriptions was as curiously familiar to me as memory itself.

For they were, in fact, my own memories of Queen Victoria's funeral.

"That's Lord Roberts. He held up his hand to stop them cheering."

Just back from Pretoria, and he rode a too spirited horse who curvetted and reared when the people could not forbear from cheering him along the route. Lord Roberts had to hold in his horse with one hand, while the other he held up for silence because it was not right to cheer at a funeral: *"Look, look—one-armed Giffard. Oh, mother, look——"*

Yes, I remember one-armed Giffard, too. He was our hero; very pale because he had been wounded so terribly; his empty sleeve pinned across his breast.

"Five kings riding behind her."

It must have been about two years before that strange blend of reality and memory, film faces and real faces, the tiny faded past and the fantastic present, that I had gone down one late afternoon to see Noel Coward in his studio

in London and found him in a state of excitement, sur-
rounded by a litter of old illustrated volumes of reference:
"Peter, do you know anything about the Boer War?" for
he had just had the idea of writing a revue on a big scale
that would cover the events of the first thirty years of the
twentieth century. He was going to take one family, he
said, and their servants, and show the same people going
through it all. And I had ten years start of him, for he
was only just going to be born when the Boer War broke
out. I told him about newsboys down the street, about the
siege of Mafeking, about Bugler Dunne. I recited "The
Absent-Minded Beggar." I am afraid I sang "Dolly Gray"
and "Bluebell" and "A little Boy called Taps." "Remem-
ber that: Newsboys down the street," said Noel crisply to
Gladys Calthrop, who was to do the scenery and costumes
of the production, and gave us such a lovely backcloth of
Kensington Gardens and people in dense black mourning
passing slowly to and fro in front of the railings when the
old queen had died. And again: "Remember that: 'Blue-
bell,' "—which was a pity, because he told me long after-
wards that when he had incorporated it so deeply as a theme
song into the overture and the action of "Cavalcade" (we
found the title that same evening. I kept on saying: "You
want something like 'Pageant' or 'Procession' "—and then
Noel shouted: "Cavalcade!") so deeply that it could not be
picked out again, he discovered it was all wrong and had
been a pantomime song in London, not in association with
the Boer War but the Spanish American Cuban War in 1895.

We had an exhilarating evening, and before I left, Noel
remarked: "Look here, I've wanted to dedicate something to
you for a long time, only it had to be something good
enough" (modest little boy). "Would you like this?"

"Look, Gladys, that's the Kaiser riding next to the Prince of Wales; the one with the moustache twisted up!" How is it that Diana, on the screen in front of me (not Diana in the chair next to me) how is it she forgot to say it, standing behind the excited child on the balcony, one hand on Gladys' shoulder?

The significance of the Boer War for children in London was expressed in Generals and sieges. Generals, a long list of them, whose names and personalities were astoundingly clear, ever so much clearer than in the Great War fifteen years later: Sir Redvers Buller ("Buller has crossed the Tugela"), Sir George White, Lord Dundonald, Hector Macdonald, Kelly-Kenny, Kekewich, Plumer and French, Baden-Powell, Gatacre, Roberts and Kitchener. We wore generals' heads printed on little buttons covering our jackets; often eight or nine or a dozen buttons of the same favourite, in my case "Fighting Mac." We minded terribly about what happened to our favourites. On the other side were Cronje and Botha and de Wet. And the three sieges were breathless possibilities of defeat or victory: Kimberley, Ladysmith and Mafeking. "Kimberley is relieved!" "Ladysmith is relieved!" Finally, after months of waiting: "*Mafeking* is relieved!"

At last. We had been bracing ourselves for the phrases: "Mafeking has fallen!" "Ladysmith has surrendered!" Sieges sound romantic, surrounded by flushed and gallant phrases; banner phrases; whereas the reality cannot but be monotonous and stale. Sieges meant little in a more recent war; but all children played at relieving-the-beleaguered-city, in 1899 and 1900. It was an intimate war, although it was so far away. A little boy called "Bugler Dunne" was sold as a charm to hang on our bangles, because he was a hero; the

C.I.V. in khaki with slouched hats marched through London on their way to Table Bay; we often recited "The Absent-Minded Beggar," and we could buy china "absent-minded beggars" dressed in khaki, with a badge over one eye, to stand on the mantelpiece.

At the beginning of the Boer War, one used to hear the newsboys bawling out bad news as they tore like rejoicing goblins along the street; usually after tea; distant first, then nearer and nearer: " 'Orrible disaster at Colenso." " 'Orrible disaster at Spion Kop!" And all the servant-girls rushing up the area steps from their underground kitchens with halfpennies and pennies to buy the bad news: " 'Orrible disaster". . . nearer and nearer till they clamoured under our very windows; then died away down the street, round the corner . . . till presently the shouts would swell again with another 'orrible disaster.

The books of Joseph Shearer: "Moss Rose," "Album Leaf," "Forget-me-Not," treat of a sinister type of heroine-villainess who repels me with the same queer horror as the sound of these goblin newsboys coming down the streets; they all form part of a horror pattern, with illustrations in the *Police News Gazette,* of women with enormous black eyes, pictured crudely lying in all sorts of distorted shapes, knocked over, murdered, black-stockinged legs sticking up stiffly from their white flounced dresses. A peculiar sort of stuffy smell seemed to come up from those pictures; an emanation of life in the raw; areas nearly invisible in the fog; a High Street with gas triangles flaring over barrows where lumps of red meat were sold.

At angles to those raw and busy thoroughfares are more silent streets, where beggars stand on the kerb, in the fog and rain. Most beggars of one's childhood are sinister figures. It is right that they should be; right that we should never

become unresponsive to the horror of things that drag themselves about, maimed or blind, muttering, tapping with a stick; singing in cracked voices through the bleak air; squatting all day long in the same hopeless position on the pavement; leaning hour after hour motionless against a wall, drearily offering matches or boot-laces for sale.

When I first went to Vienna after the war, the beggars there were so macabre, so fantastically thin, so obviously damned and starving, that they escaped the fate of the permanent beggar in our midst: you suddenly saw them and were startled and shocked. You *saw* them. In the same way that, as a child, I *saw* the man who leant against the railings of Norland Square in whatever weather, holding a small pillow in front of his face. "He's got lupus," they told me, when I asked about the pillow. That did not help. I understood only that he might not drop it or— Suppose one day he dropped it just as I was passing? This was worse than the blind man; though I could hardly bear to hear the monotonous tapping of his stick down Holland Park, and whenever I was told to give him a penny, did so hastily and in shame because I was frightened.

Pictures by Hogarth jarred me with the same nausea, the same desire to look away. So did the illustrations of Cruickshank. So did the beggar who, laughing, ragged and venomous, dragged himself on to the stage for the preface to the "Beggar's Opera"; and the beggars in "Hassan," dancing with their crutches.

"H" stands for this sort of underworld; for the things, the lives we do not understand because we cannot bear to approach near enough. And still I cannot understand, when for discipline I force myself to concentrate on what life must actually feel like for those who squat and limp and tap their way along, what it must feel like if it were myself

living that life? if it were to-day, now, at this minute and
for the next ten minutes and for the next hour, and multiply
that by more hours and then by weeks and so on into the
years? Surely there must be a way of digging down to
knowledge of how they do it, and how they go on, and
why they do not end it? After all, their lives are lived in
the same dimensions as ours. If we have to do something
for half an hour that we hate as intensely as they must
loathe standing there drearily against a wall, squatting on
the pavement, tapping or dragging along the street, we can
barely get through it. Is it enough, the hope of a penny or
of sixpence? It must be, or there would be a general suicide
of beggars. I wonder whether I somehow miss seeing in
the papers, among the smaller items of news, that yet an-
other beggar has committed suicide, making nine thousand
and seventy-three since yesterday? I can remember read-
ing of suicides, but hardly ever of a beggar's. Or am I still
instinctively averting my eyes? Is there in reality a nightly
pageant of beggars leaping into black water, only this hap-
pens not to be of the same news value as film-stars leaping
to death because their lives, unlike the beggars', are too
sharply coloured, too bold and brilliant and feverish in
variety. Or, incredibly, do beggars with their ghastly mutila-
tions and epilepsies, lead quite a jolly life, hobnobbing with
other beggars, comparing the day's experiences, rolling in
tipsiness, having loud jokes, ʼdespising us, all somewhere
down under the arches of a Cruikshank illustration? some-
where down there, behind and under the letter "H" on the
wall?

I might, of course, try to settle the terror and the ques-
tion, by stopping and talking to them, asking straight out
whether and how they find compensation. But I have not
the courage to force this contact; my voice would become

unnaturally breathless; or, worst of all, might even sound in my own ears, if not in theirs, condescending. Beggars in the sun frighten me less, though I once saw one of them swing his crutch above his head in some flourish of hate against law and society, and his shadow did the same, longer, thinner and more menacing. And beggars who are musicians also matter less; one can always sentimentally hope that they love their own music even if we do not; at least they do not bring up my imagination against a wall of blankness, like those who merely shuffle or squat or stand all day long while we go about on merrier business; stand with a pillow pressed to the face.

You need to pass them every day to get this horror, this conviction of a procession of beggars always winding on; otherwise you contrive to slide yourself out of horror, on a soothing hope that all the rest of the time, when you are not there, they are not there either, but are having a better time elsewhere.

On Sunday morning, I could not see the letter "H" which was nearest my home, on the railings of a garden wall just beyond the drive and down at the first corner, because the one-legged crossing-sweep stood there covering it. He, however, looked well and prosperous, with a stout, bearded air which reminded me of Professor Bhaer in "Little Women"; therefore I was not frightened of him. Which is fortunate, for I had to pass him every morning twice, going to school and returning home to the house where I lived for the first fourteen years of my life, in Ladbroke Road, Holland Park. After I had passed Professor Bhaer, I used to stand for a moment and watch the first Twopenny Tube being built; a mysterious construction at the corner, in brownish yellow stone. Twopenny Tube: the syllables conveyed the same thrill of something going on underground,

full fathom five, something wholly outside experience, beyond
nursery questions and answers, as my symbolic letter "H,"
white on a diamond-shaped sapphire. The Tube, we were
told, ran in a straight line from Shepherd's Bush to the
Bank. We might have found it hard to learn by heart the
dates of the Kings of England or the German prepositions
which govern the genitive; but the names of the first sta-
tions on the first Twopenny Tube were memorised for ever:
Shepherd's Bush, Holland Park, Notting Hill Gate, Queen's
Road, Lancaster Gate, Marble Arch. . . . A bush and a park,
I used to count, conceiving the daring notion of spelling the
station surnames with a small instead of a capital letter; and
two gates and an arch; oh, and a circus. And at the end
of the procession, a postoffice and Bank. Bank, that hard
monosyllable without a prefix, slammed the door. We never
went as far as Bank. After Marble Arch was unknown coun-
try.

"Why do they call it the Twopenny Tube?"

"I told you, Gladys dear; because it's only going to cost
twopence however far you want to go."

"Yes, but however *un*far you want to go, will that be
twopence too?"

"Yes, that will be twopence too."

Sagely I shook my head. It would not do. If people could
go the whole way from our private and particular Holland
Park to the Bank for twopence, nothing, surely, would
make people get out at Queen's Road, only two stations
away, even if people wanted to go to Queen's Road? As it
happened, my juvenile psychology was right. "Twopence
any distance" did not work; and passengers who were pay-
ing twopence to ride for only two or three stations, resented
those luckier passengers who wanted to go much farther
and could do so for the same price. It wasn't fair. It was

nobody's fault, but it wasn't fair. And quite soon they arranged a scale of payments that slid up or down in the usual way.

At the corner opposite Holland Park Tube, another building was started at about this time of my childhood, of which the framework towered like a skyscraper; a London version of a skyscraper in the 1890's. Little did I think then how lightly I should one day dismiss the Empire State Building as: "Too squat." The Lansdowne Road building must have been at least eight or nine giddy stories high, and my mother and father spoke of it contemptuously as "flats." "Flats" was a new word; all my friends and cousins lived in houses; usually with a drive in front and a garden behind; or, lacking a garden, with the key to a shady square. Because our own house had a garden, I held squares in much higher esteem. You had to cross the road and unlock a gate to go into them, and it was all highly privileged. One's own garden was a matter-of-course and a universal matter; almost I would have said that there was no such thing as not having a garden. Our garden had other private gardens to the right and left, and more gardens beyond that; and the gardens, too, of Lansdowne Road guarding the far end. So that it had not that faintly exciting air of some London gardens, of being scooped out of space and barely held against fearful odds, with battalions of grim walls marching down on it, North, South, East and West. These pleasant Ladbroke Road gardens were nearly the country.

It is far gayer to have unrighteous access to the flowering end of a tree or a bush, than legitimate control of its roots. The gardens on either side of us rejoiced in the roots of many may trees, laburnam trees and lilac bushes. The cliché: "rejoiced in" is here used sardonically, for waving over our walls was all the blossoming wealth we could desire; the

branches wayward enough to lean over so far that the
owners of the roots had to ask permission to come round
into our garden, please, if they wanted to pick a spray of
their own lilac.

I was allowed to pick as much mint and as many mari-
golds as I liked, in our garden; which naturally left me
with a strong contempt for both marigolds and mint. Now,
when I am shown round any strange garden and bidden
with pride to look at the bright flowers, I find the greatest
difficulty in checking myself from carelessly pulling off the
heads of the marigolds as I pass. A monstrous act, that
might easily lead to unpopularity.

We were moderately friendly with our neighbours; on
the right-hand side they were religious, and sang hymns on
Sunday while we played croquet. On our left, two small
children, son and daughter of the new residents, leant over
the wall and said hoarsely: "Give us a bit of cike, lidy,"
while we were at tea under the apple tree. Later on, when
they knew us a little, but not much, better, they said still
more hoarsely: "Pa tried to shoot Ma last night." The
demand for cake might not have meant that they were
starved; only greedy. And naturally the winsome bit of
information about Pa and Ma, who, we can be sure, would
not have been pleased had they overheard, led to a certain
amount of discussion between *my* pa and ma, wondering
if they could prevent themselves from looking aware when
Mr. and Mrs. K. came in to bridge that evening. They sus-
pected already that Mr. and Mrs. K.'s domestic life might
be a little sinister and sensational, but those children were
almost too enlightening:

"Pa picked up a big pistol and Ma screamed, but he
locked the door. And Sally screamed too, but I didn't.
And Pa said, 'I'll shoot you dead, I'm sick of it.' It was the

middle of the night——" their voices got hoarser and more Cockney. English children so often had these voices, before careful Norland nurses with exquisite articulation became the custom. Little French children heard chattering to their elders in the parks or down on the beach, really do produce those innocent chirruping sounds associated more with pictures of children than with children themselves; associated with gay little nursery rhymes; children in sashes, hand in hand, tripping to and fro, bowing, curtseying: "Sur le Pont d'Avignon——" Unreal French children, clean and *délicieux*.

A real child, I naturally took more interest in the garden hose than in the pretty flowers. Father used to water the garden in the summer when he got in from business at seven o'clock every evening. He went into the billiard-room in a wing on the first floor; and opening the window, began to pay out one end of the hose so that it tumbled into rings and coils on the grass just below; the other end was fastened to a tap in the billiard-room. Only a few days ago I suddenly realised why these lines out of Ralph Hodgson's "Eve" always reminded me of billiard-rooms:

> *Out of the boughs he came*
> *Whispering still her name,*
> *Tumbling in twenty rings*
> *Into the grass.*

Then he—father, not the Serpent—turned on the tap, and came down into the garden. There was time, however, during the brief interval before his arrival, to do many pleasant things with the running water from the nozzle. By lifting it and putting your finger partly over the hole, you could direct a hard, solid shoot of water in any direction you pleased, such as in at the pantry window; or you could wave the thin arch of water high into the air towards the

sky and all around you, as though you were writing your own monogram: G. B. S. or the letter "M" perhaps, iridescent in the evening sun; breaking and falling on you in cool flashing loveliness: "making fountains," that was called. Or you could bore a fierce hole beneath the plants with the jet of water thrust down as deep as you could into the earth, to give yourself the thrill of an underground spring welling up; or you bathed the tops of the lilac in spray flung towards them by graceful play of the wrist. But by that time, father had completed the journey from one end of the hose to the other; and you had to explain innocently, that you wished to help and might you go on helping oh might you might you if you promised not to stand on the hose and flatten it and then suddenly leap off again but *real* helping I do so love helping you and no one else does it so well as me do they you said so last week once and that tiger-lily broke itself at least I honestly think it was broken before I began and anyhow I've watered its roots lots so there'll be lots and lots of others.

Innocence is a touching quality to contemplate in sentimental retrospect. I mean, if it be your own that you are retrospecting. It is perfectly true that when I used to go into shops with my mother, and saw her take possession of this or that article and say, "Put it down," and they then made it into a parcel and gave it to her without further question of payment, it is perfectly true that I really did believe "put it down" to be some sort of abracadabra which would work equally well if I tried it in the same shops and in the same voice. I understood that not every shop would do. She never said, "put it down," when (rarely) she bought something in the sweetshop where most of my own purchases were made and paid for painfully in cash: one penny, two or at the most three at a time. But

then mothers got their sweets and chocolates illegitimately. Gentlemen sent them because they had dined at the house: *Marquis* chocolate, slender brown *langues de chat* powdered with gold. "Quite right," mother would say, pleased but not surprised when the box arrived; for it was the custom then for entertainment to be repaid politely, lavishly, by flowers, chocolates or even sometimes long white kid gloves up to the elbow and beyond, with little pearl buttons.

So when I started going to school by myself, at about seven years old, on passing the stationer's shop going and coming, I went in; chose whatever I wanted in the way of paint-boxes, chalks, pencils, india-rubbers and other fascinating objects; said: "Put it down," a little shyly to the girl—usually Mr. Woodstock's daughter—in charge, who had seen me often with my mother; and went out rather pleased with this easy way I had discovered of extending the buying power of sixpence a week. During that term, I possessed more than forty pencils; pencils were my passion; and also I gave the whole class, except two or three girls whom I disliked, presents of luscious fourpence-halfpenny Lightning Erasers. They were very pleased. The stationer's shop at first must have thought it was bound to be all right; they had seen me so often with mother. Gradually, so I heard later, they became uneasy, but still continued to give me enough rope to hang myself with. Gorged, myself, with stationery, I distributed more and more largesse to my lucky companions: generosity became power, and power became intoxication.

One day I went home, and found that Woodstock's account had come in. I was told I should not be sent to the Coronet Theatre Christmas Pantomime those coming holidays. I cried. I declared (to myself; not aloud) that it was

unfair and that justice was not anywhere. But justice was in the house all the same; for I was allowed to go, after all. So I think that mother or father or both realised that it was more innocence than sin which led me to swagger so often into the stationer's shop, and come out laden, and say, "Put it down."

Queer that I should never have wondered why other people did not use this convenient means of obtaining hundreds of chalks, thousands of pencils, millions of india-rubbers. Nor have wondered, if really these things did not have to be paid for, what was the stationer's gain in keeping his shelves and counters and windows laden with tempting articles that any one could have by merely using whatever was the word to open the magic gates. It happened that "Ali Baba" was the Pantomime that year; but I had to wait half my threescore and ten years before I linked up my experience with Open Sesame in the fairy-tale.

The Coronet Theatre is a picture palace now, but for the first ten years of its existence, it was my heaven. Mother and father went often in a brougham at night to the Gaiety, to His Majesty's Theatre and the Haymarket; but they apparently saw no harm in sending "the children" regularly to matinées in the dress circle of a theatre so conveniently near as the Coronet.

My pantomime fixation and my attachment to Principal Boys, though it began at Drury Lane with Dick Whittington when I was four

> —(*You stick to the boat, boys,*
> *You save your lives!*
> *I've no one to love me,*
> *You've children and wives!*)

was renewed and doubled at the Coronet Theatre. Christmas Eve at the Coronet Theatre; Boxing Night at Drury Lane. Drury Lane was a family tradition: the three Rakonitz Uncles used to take a whole row of stalls and the stage box, every year.

Have you ever tried to tell an "intelligent foreigner" about the English Christmas Pantomime? Earnestly and conscientiously giving you his full attention, he tries to understand the peculiar formula of this extraordinary blend of fairy-tale, topical politics, spectacular ballet, mediæval Italian "Commedia dell'Arte," and Shakespeare's swash-buckling boy-girl heroines.

In Shakespeare's time, when the stage had its peach-complexioned young actors but no actresses, a sound practical reason existed for those heroines, Viola, Rosalind, Imogen, to change into doublet and hose. But the origin of the Principal Boy's popularity in pantomime, no slender page, but a dashing female, tall, swashbuckling, with a ringing voice, opulent hips, and brisk, high-handed way with all Demon Kings and King Rats, remains shadowy. The Intelligent Foreigner will supply dark hints linking it, probably rightly, with some obscure sexual significance and the discoveries of Professor Freud. A panorama of absurd little invisible bridges in the pantomime landscape rather startlingly connect Dick Whittington with the borough history of the City of London; Robin Hood, with Richard I and King John, and Now girls I want you to read for our next lesson the chapter on the strife between the King and the Barons; Robinson Crusoe, with the necessity for a seventeenth-century Scottish sailor, one Alexander Selcraig, "to be gone away to the seas," when summoned for indecent behaviour in kirk; Beanstalk Jack, with the mediæval fables of the world, the need of a playground for expressing the Com-

pensation Complex; and Ganem, Aladdin, Prince Charm-
ing and Selim, with Rosalind, Viola, Julia, Portia and
Imogen.

One of the charms of pantomime is its defiant, its fan-
tastic irrelevance: the boy is a girl, the Dame is a man;
the scene is set in China, yet nobody raises objection if
Aladdin, in kilts, sings a sentimental war song called "Blue-
bell":

> *Midst Camp fires gleaming,*
> *Midst shot and shell*
> *I will be dreaming*
> *Of my own Bluebell.*

A piece of information that affected me monstrously at the
time, for it was only later it occurred to me that he could
not have been an altogether useful type of soldier; the
verse could well have been illustrated by Bairnsfather: the
soldier sitting on an overturned packing-case in the very
thick of the battle, death and explosion all around, while
with his chin propped up by his hand and a soft, abstracted,
mopey gaze, he yielded to the charms of reverie.

The irrelevance of pantomime goes merrily on: a circus
element introduces elephant, horse or cat with a rolling eye
and a lively kick in the hind legs; yet not wholly circus,
for the animals are composed of a skin drawn over two
serious-minded gentlemen. One moment we are in fairy-
land or under the sea or among the clouds, and the next
the famous Knockabout Bar Act is set up in the Baron's
Kitchen, and a topical ditty introduces the English political
obsession of the hour. Scheherezade and the Russian Ballet of
the future are potential in the Transformation Scene, slowly
unfolding in iridescent loveliness through curtain after
curtain of misty gauze. Then the Pageant form of enter-

tainment is represented, when the principals swagger in procession across a background of supers; Principal Boy wearing a not unstriking costume that combines satin hose and trunks and diamond network brassière, with three feathers in his hair; dressed, but for certain differences, as it might be to attend one of His Majesty's Drawing-Rooms. And so that nothing shall be lacking, Dan Leno, as Sister Anne, steps forward and declaims:

> *Now give a cheer for Bluebeard and his whiskers,*
> *I ask you each and every one, promiskers.*

And all in a moment, a backcloth is run down; clown and pantaloon and policeman leap on to the stage, swinging strings of sausages; lithe Harlequin and delicious Columbine spring and flit from the right wing and the left wing, bringing before us the mediæval Italian "Commedia dell'-Arte"; and nobody minds and nobody questions, because it is an English Christmas pantomime. The final incongruity of the word Christmas, preceding pantomime, is neither a matter for eloquence nor print, but for silent browsing of the spirit in meadows of perplexity.

That is the whole point, you see; not the irrelevance, for any country can string together revue with elf-land and pageant and circus, if they wish; but that it should be so placidly accepted as a British Institution. Because it is an institution, it is never weakened by apology, explanation, or any sense of anxiety as to its success. The usual ingredients are flung together, the clown cries: "Here we are again!" and nobody asks "Why are we?"

No doubt but that Drury Lane and the Coronet pantomimes, blended with my early love for Imogen and then Rosalind, are fundamentally responsible for much of the worst that I have written and admired. A touch of swagger,

false panache, tripping elves, quaint incongruities; these must
be uprooted from one's system if reality and honesty are to
have a chance. Yet when I am old and grey and babble of
green rooms, no doubt Pantomime will return again and
kiss me on the brow, like the play in which Beethoven's
Nine Symphonies tripped across the stage at His Majesty's,
and kissed Mr. Beerbohm Tree.

Here, anticipating my senility, is an extract from these
babblings:

"Ada Blanche! Ah, there was a Principal Boy for you.
And Madge Vincent was it, or Madge Titheradge? And
Cressie Leonard, bless her, with her dashing looks and fine
figure: Selim, she was, at the Coronet. Ah, we had some
fine upstanding pantomimes there. Lily Elsie, she can't have
been more than a girl of seventeen with a long golden plait
and a fluffy pale mauve chrysanthemum behind each ear;
don't talk to me of 'The Merry Widow,' you'll never find
a sweeter Morgiana than what she was. And the year before,
it was 'Babes in the Wood,' and *who* do you think were the
babes? Why, little Vera Vere and little Phyllis Dare. And
who do you think played Maid Marian? One of our finest
actresses: Ethel Irving. And Winifred Hare as Robin Hood
—Now, now, now, little Wilhelmine, you mustn't ask Granny
too many questions—Maid Marian was governess to the Babes
in the Wood, and some do say as how they was meant to be
the little Princes in the Tower that got themselves stran-
gled. . . ."

When there was no pantomime, the programme changed
each week; an amazing repertory; nearly every well-known
actor and actress of our time, foreign as well as English,
nearly every interesting play and West End success, must
have passed through the invisible "Gate" at Notting Hill:
Lewis Waller, storming Harfleur in "Henry V," storming

it with all that glorious conviction and valour which made
his flamboyant reputation. "If I were King," by Justin
McCarthy, with Suzanne Sheldon in green tights, waif of
Paris, dying for love of François Villon, Paris gutter-poet;
and Martin Harvey in "The Only Way"—my young heart
was terribly inflamed by Sidney Carton and François Vil-
lon; and could any stage hero hope to get away with it un-
less he were a ne'er-do-well and a drunkard and died for
others?

Forbes Robertson in Kipling's "The Light That Failed":
"Bilked, Mr. 'Eldar, bilked"—and frightfully did Bessie
slash at the picture of the Melancholia, painted by Dick
Heldar just before he went blind; one of these stage pic-
tures carried carefully so that no audience shall see it; until
an enterprising picture gallery gives a show for these alone:
for Dick Heldar's picture; and the one they dispute over,
through three acts of "Christopher Bean"; and the one
Ina Claire paints in "Biography"; and the masterpiece painted
by Henry Ainley as the artist in "Buried Alive"; and many
many more.

John Hare in "A Pair of Spectacles"; Laurence Irving in
"The Lily"; H. B. Irving in his father's parts: "Charles the
First" and "The Lyons Mail," and, presently, in Pinero's
"Letty" ("We're all bad, we Letchmeres. Rotten to the
core!"). The Kendals in "The Elder Miss Blossom" and
"The Ironmaster"—I was intrigued by the plot of "The
Ironmaster"; and clamoured for that bedroom business to be
sensibly explained to me. All the Tom Robertson comedies:
"School," "Caste," "Ours." Julia Neilson and Fred Terry
in "Sweet Nell of Old Drury"; (and that cleared up a lot
of contemporary bewilderment about our sewing-maid,
Nelly, and her two Charleses). "Bluebell in Fairyland," the
first children's play that was not a pantomime. "A Gentle-

man in Khaki," with Esmé Beringer, Haydn Coffin and Vera
Vere in the company; I was reminded of it during the Boer
War scenes in "Cavalcade." Vera Vere was a ragged paper-
boy, and sang a patriotic song of the moment:

> *Some one's gaht ter do the shahting,*
> *Some one's gaht ter cheer 'em as they pass!*

"Veronique," with Ruth Vincent; Charles Hawtrey in "A
Message from Mars"; Lena Ashwell in "Diana of Dobson's";
"Pete"—dramatised from Hall Caine's novel "The Manx-
man"; clothed richly in a fur coat and cap, but with his
soul in sackcloth and ashes, the hero sat negligently, all
through the last act, on a redhot stove.

Mrs. Langtry. La Loie Fuller, dancing in a swirl of rain-
bow scarves; Miss Horniman's Repertory Season—what a
good play was "Consequences," by Harold Rubinstein.
Jeanne May, miming deliciously as one of those dear-to-me
bad-for-me Pierrots in "L'Enfant Prodigue." In 1904, Mrs.
Patrick Campbell. Little-did-I-think that in another the-
atre she would one day impersonate that very Matriarch
who might, you never know, be in the sitting-room when
I got home to tea, laying down the (Rakonitz) law to
mother.

The procession went on; a stimulating education for a
stage-struck child. Should I ever cease to be grateful to
Mr. Saunders and his Coronet Theatre? Here were those
queer little, quick little players, the Japanese: Otogiro Kawa-
kami and Madame Sada Yacco. And a touring company in
Barrie's "Little Mary." What a sensation that had been,
when the carefully guarded secret was let off, like a bomb,
under the noses of the first-night audience, Little Mary?
Why, she wasn't a character in the play, at all! Little Mary
was a synonym for—oh, hush!—*for the stomach*. The arch-

ness that followed this shocking discovery! The naughty
jokes! The sly references, even in the politest, auntliest
circles. And Miss Gertie Millar's killing song about it, in a
contemporary musical comedy, I forget which:

> *Mary, Mary, dainty little Mary,*
> *She's a fickle but a fascinating fairy.*
> *When you go across the Channel*
> *Mind you wrap her up in flannel—*
> *Oh, take care of Little Mary!*

Has Sir James repudiated this child of his? There is no men-
tion of it in the Collected Edition of his Plays.

A little while after the Coronet Theatre was opened, I
had a legacy of a Theatre Book from my elder sister; she
had got tired of writing up the log, after the first three or
four pages were filled; and so passed it on to me. I wish I
had kept that Theatre Book, crammed so full of immature
arrogance, enthusiasm and blots. If my feelings could have
coloured the pages, they would have been dabbled, like
ancient illuminations, with vermilion and silver, blue and
purple and gold. It was arranged in diary form; that is to
say, you entered up the name of the theatre, the play, the
cast, the dramatist, the date, and your seats. The lower half
of the page was left blank to fill in, under the heading:
"Criticism." I did not bother much, in criticism, with the
dramatist or even the play itself. Plays grew haphazard on
trees, as far as I was concerned. I concentrated almost
entirely on the acting; and I am sure that many actors of the
day could have wished that I had been appointed dramatic
critic of the *Saturday Review,* shall we say, in place of Mr.
Bernard Shaw or Mr. Max Beerbohm. "Simply absolutely
splendid," I used to write, desperately wishing there were
more superlatives in the language. "So-and-So is well-nigh

the very best actor in the whole world" . . . "In the last act he was too utterly wonderful for words" . . . and so on.

The Bird is dead that we have made so much on.

The first time I ever acted myself, I played Imogen in this one scene from Cymbeline:

> While summer lasts and I live here, Fidele,
> I'll sweeten thy sad grave.

I was seven. It was in my first term at school. Three of my older companions had been chosen by the elocution mistress to play the "speaking parts": Belarius, Arviragus and Guiderius, in the public performance at the end of the term. And if there had been a fourth, she said, appealing to the class, who would it have been? It would apparently have been myself. They chanted my name in chorus, and Miss S. agreed. "If there had been a fourth——" and much good that was! However, I was allowed to be Imogen and lie quite still on the ground; dead, they thought; though only fast asleep from the strong potion she had swallowed. Dead, they thought, fortunately, for had they not believed the boy dead, Shakespeare would not have written that most haunting, most tender lament:

> *Fear no more the heat o' the sun,*
> *Nor the furious winter's rages;*
> *Thou thy worldly task hast done,*
> *Home are gone, and ta'en thy wages;*
> *Golden lads and girls all must,*
> *As chimney sweepers, come to dust.*

In the same spirit as the conscientious actor who blacked himself all over though only his face showed, I insisted on

playing my part lying quite still on the ground, entranced, excruciatingly uncomfortable, not moving an eyelash lest I defeated all Shakespeare's purpose, every time they rehearsed; which was about twice a day for the whole of one term. So I grew to know these lines and care for them better than for all other poetry or rhyme.

Then came the night itself. I lay on the boards of the school stage, hearing for the last time:

> *No exorciser harm thee!*
> *Nor no witchcraft charm thee!*
> *Ghost unlaid forbear thee!*
> *Nothing ill come near thee!*
> *Quiet consummation have;*
> *And renowned be thy grave!*

Not for the last time. If ever I want to lull myself, soothe myself, drug myself, speak a dirge of quietness over my soul, I repeat these cadences, slowly, as though I were the three schoolgirls from the Upper First, standing over the prone figure of a child of seven who had longed to play Belarius, Guiderius, and Arviragus all rolled into one, but had to be content with a non-speaking part, after all. Some lines as they grow more familiar, lose their potency; never these. I believe during all that term's rehearsing, I had not the faintest idea of what they meant.

When Shakespeare becomes youthfully sentimental in one of his later plays, we know well that there is no flaw in his own maturity, and that it is the character he has created, not himself, who is having the fun. Arviragus was divinely sentimental, and Arviragus was very very young:

> I would rather have leapt from sixteen years of age to sixty,
> To have turned my leaping time into a crutch,
> Than have seen this.

Though his grief for Fidele was sincere, it could yet console itself with these exaggerations; with wistful promises:

> While summer lasts and I live here, Fidele,
> I'll sweeten thy sad grave.

But in the creation of a character who is not in essence sentimental, like Rosalind, Shakespeare shows how easily he can shed these floating scarves. In the loveliest scene in "As You Like It," Sylvius describes simply, sincerely, sentimentally: "what it is to love." At the end of each sad heartburst, the other characters on the scene chime in one by one: "And so am I for Phœbe." "And I for Ganymede." "And I for Rosalind." "And I," says Rosalind, disguised as Ganymede, "and I for no woman." She and Shakespeare are both enjoying that ironical game of telling the truth to make it sound like a lie; which is, indeed, the very art and definition of flippancy.

Suddenly, Rosalind's humour revolts; something in the way that they all stand there, one by one sighing out their plaints, appeals to her as irresistibly funny; funny, but nevertheless an indulgence that must be stopped: "Prithee no more of this; it is like the howling of Irish wolves against the moon!"

We all have moods that are like the howling of Irish wolves against the moon; the best way to split them is to pick up irony's blade. Though Irony is usually an accident that forms independently of our assistance, all we need do is to recognise it instantly when we see it, as Rosalind did.

Once there were three famous people: an actor of forty and a very young actor, and an actress without age (also an author, myself, who swore there would be no anecdotes in this book: so call this a lesson in irony, rather than an anecdote). The actor loved the actress, but the very young

actor presently took her away from him. They were all
three married, though not to one another, and so six people
were in a very storm and turmoil of passion and agony and
remorse. Forty years later, when all the characters were still
alive (but forty years older) at a party, the name of the
actress, then away in America, was mentioned in a group
of her friends; and a very old actor, turning to an elderly
actor who had once so ringingly supplanted him, said,
with the idea of courteously drawing him into the conver-
sation: "Let me see, do you know Mrs. Asterisk?"

Had he not genuinely forgotten, it would have been
sublime. He *had* forgotten, so it was merely such irony as
to make love itself ridiculous.

A cynic does not deserve to be placed in the same cate-
gory as a man of irony, or that flippant, dangerous, delightful
species of man whom I, before I learned that I was wrongly
pronouncing half the words in the English dictionary,
used to call a "septic." A cynic is one who may have a
justified grudge against the world, for its follies, its mean-
ness, its ingratitude, its stupidity, its treachery, its incon-
stancy, its inconsistency; but never realises the rueful truth,
that he is not himself exempt from these disabilities.

A prize for the most ironic moment the theatre can
provide, should be awarded to its supreme sentimentalist:
"Mary Rose is coming across the fields!" What should
have been a cry of pure joy from the parents and husband,
bereaved for so many years, was not joy, but terror and
apprehension. Mary Rose was coming across the fields;
nothing could stop her. Mary Rose. And we thought she
was dead; we mourned her as dead. Mary Rose. And will
she be old now, and goblin, with blank forgetful eyes?
That Mary Rose should be coming across the fields!, was
once their only desire.

Mental collections can be as dearly prized as those we keep behind glass, like snuff-boxes, fans or china cats; or the collection of a man who assembled everything that happened to be the size of a fist. I have a mental collection of moments on the stage, moments of horror, irony, beauty or tension; and that moment from "Mary Rose" may well lead the rest. Though in point of time, the first occurred to me in a curtain-raiser called "Ib and the Blue Wolf," played at the Coronet Theatre during the 'nineties, in front of a queer operette called "Chilperic," in which early Saxon princesses wore long conical hats, veils streaming from the points, and had names like Galswinthia and Fredegonda.

Mother and father had supposed, from the name Ib and dim memories of Hans Christian Andersen, that it would be a charming and suitable story for children. They could not possibly have foreseen that it would provide a horror that has never since wholly faded away. Ib was no child, but a Scandinavian woodcutter. He and his brother were at the last gasp of poverty and hunger. Ib played the violin and his brother did not. Ib had feverish, hunger-stricken fantasies that waiting for them in the forest was a gaunt blue wolf, and unless they could keep the blue wolf from the door, it would enter and devour them. Moonlight discouraged the blue wolf, and violin music depressed him frightfully. The brother went into the nearest town on a sleigh, in a desperate quest of provisions, and Ib, left alone, thought he saw the blue wolf actually in the room. He was found by his brother, squatting in a circle of moonlight, fiddling, and screaming that the wolf was scrunching his bones. The curtain fell, and I was removed, howling.

Hunger, to me, will always remain incarnated as a blue wolf. That being the case, it was surely impracticable that I never learned to play the violin.

More moments: Young Stanhope saying, across the dug-out (but how queer, saying it in German): "You think there is no limit to what a man can bear?" when Osborne has been killed. And Young Woodley's sudden smile upwards at a kind, lenient father, at the very end of the play, when he sincerely thought his next sixty odd years of life disillusioned, hopeless and broken.

Yvonne Printemps as the youthful Mozart, making his first abashed appearance in a salon in Paris; breathless, too thrilled, too shy to say a word; it might well have been Mozart himself at eighteen, so intense was our pleasure at seeing him at last where he had so longed to be, in Paris.

Mädchen in Uniform. A schoolgirl, her face irradiated with tears of happiness, translated, tremulous, unbelieving, coming out of the room of her beloved schoolmistress with an absurd present in her hand: a chemise.

And the little boy, Skippy, lying across his bed, twisted into heartbroken sobs over the death of a dog; another child's dog, his friend's, not even his own. His grief reminded us uncomfortably of a familiar sound. What was it? Anyhow, we do not wish to be reminded, and it is a positive relief when the curtain goes down; for we have perhaps recollected, and hastily forgotten again, that that is the sound we may have heard—yes, from ourselves, once or twice in a lifetime.

Diana Wynyard in the film of "Cavalcade"; at Victoria Station; when she has just said good-bye to her son; the wounded from France are carried past her on stretchers; she pauses by the bookstall to light a cigarette. And you see her face.

Mrs. Patrick Campbell, not on the stage, but in private life, being approached with the idea that she should play the Matriarch for us. And her argument that she could *not*

play the Matriarch; how *could* she play an old Israelite woman who should speak her lines like this—and instantly she spoke them, to prove the impossibility; and instantly she *was* that old Israelite woman, so miraculously that one gasped and could not believe it.

H. B. Irving in his father's part, King Charles the First. His entrance, just before the execution, with that curious "white look" stamped on his face, as though already he had died and were removed somewhere beyond death.

Marie Tempest, also, on a last entrance before death, as Empress Catherine, a very old old woman, trying to chuckle, to coquette and domineer; the moment in my collection was just before she spoke: that ghastly acceptance-after-battle on her face: she was finished, and she knew they knew it.

Cedric Hardwicke in the Dreyfus film; alone after he has just been told by his guards that he can leave Devil's Island and return to France.

The door of his hut has been left open for the first time. He does not at once seem to grasp he is free. He is dazed; numb; old and vacant. He wanders slowly to the doorway and stands looking out at the sea.

Suddenly he realises. Crumples up against the side of the door; buries his head on his arm.

Ina Claire, using her flippant hands, her sorrowful hands, during a moment while the dialogue was covered by laughter in the audience, to give us a fluent illusion that we were still hearing her, not one word lost. Ina Claire, with her divinely light touch on life, her shower of moods that are neither as sad as silver nor as brilliant as gold, but blow across the stage like misty spray from an invisible fountain, can at all times do more with her hands, a ripple of the shoulders, a shrug, a turn of the head, than many other

actresses with twenty-horse-power energy of lungs and
body.

The style, the *panache* and suddenness with which Alfred
Lunt leapt over the sofa at the end of that love-scene
danced on a narrow tight-rope in "Design for Living":

OTTO: What small perverse meanness in you forbids you to walk
 round the sofa to me?
GILDA: I couldn't move, if the house was on fire!
OTTO: I believe it is. To hell with the sofa!
 *He vaults over it and takes her in his arms. They stand
 holding each other closely and gradually subside on to the
 sofa.*
OTTO (*kissing her*): Hvordan starr det til!
GILDA (*blissfully*): What's that, darling?
OTTO: "How do you do?" in Norwegian.
 The curtain slowly falls.

Celia Johnson, at a rehearsal only (for the scene was cut
out later), summoning up all the desperate conviction of a
girl's lifetime, to say: *"Of course* I'll be happy with you,
Mummy. Perfectly happy. Perfectly happy" . . . when,
like Young Woodley, she thought her heart was broken
and she could never never be happy again.

The entrance of "The Breadwinner" at the end of Act I.
 The door is opened and CHARLES *strolls amiably in. He is a
 man in the early forties, quiet and of rather distinguished ap-
 pearance; he is very neat in his black coat and grey striped
 trousers. He wears a top-hat.*

His top-hat shone; he smiled. A moment to mark the
epitome of serene happiness only to be found in a guilty
conscience.

The poignant last words of the imprisoned king, in the
play: "Richard of Bordeaux": "How Robert would have
laughed!" thrusting home the truth that we miss a dead

friend not so much in moments of stress, but when we
have a joke tilted at such an angle that only he would have
seen how it was funny.

And again John Gielgud, and again as Richard II, but
Shakespeare's Richard, appearing in crown and gold armour,
for one assembled moment of thrilling royalty, on the walls
of Flint Castle after his hopeless defeat by Bolingbroke:

> We are amazed; and thus long have we stood
> To watch the fearful bending of thy knee,
> Because we thought ourself thy lawful king.

The ignorant Welsh servant, played by Edith Evans in
"Christopher Bean," saying: *"Me* dislike artists? Oh, no,
I *like* artists." Such love distilled in her voice that for a
moment of comparison, Verona's Juliet, poor child, poor
baby, hardly seemed to have known the meaning of the
word.

The moment in "Dear Brutus" when Harry Dearth comes
in from the garden and remarks casually to those assembled
that he has only a moment to spare, for he has left his
daughter outside in the garden. And gradually realises that
he has no daughter, that the child in the garden is a dream-
child, a might-have-been.

Now this was a moment beyond acting. Acting would
have realised that the night had cheated, with one sudden,
stricken look:

> . . . I—(*he tries to smile*) I didn't know you when I
> was in the wood with Margaret. She . . . she . . . Mar-
> garet . . .
> (*The hammer falls.*)
> O my God!

But the actor who played this moment for perhaps the
five hundredth time, realised the truth gradually, not in a

flash. He was mixing up his own reality, with what he had to play; and his genuine deep sense of loss offers a strange paradox; for in the world of reality he had three flesh-and-blood daughters, loving and loved. In the world of reality, he was not the father of Barrie's play discovering that what he had hoped was a real daughter, was only a dream-daughter; he was discovering that what he had hoped was a dream-fatherhood, was solid and real.

For this man, you see, was Peter Pan. And Peter Pannery is such a terrifying phenomenon that it is easier to reveal it in the person of one man, than in a whole race of husbands and fathers.

There are two popular conceptions of character which control us from our earliest years: one is a picture of a little girl, precocious in maternal instinct, fussing over her dolls, eager to lavish the same tender touches on whatever little boy may be handy. While he, already an embryo man, sturdy, adventurous, self-reliant, will do anything to escape her coddlesome affection. The name of one of these pictures is "Wendy"; the other, of course, is "Peter."

The Englishman has a curious innate reluctance to become adult. "He's such a boy at heart," is a term of praise in this country. Perhaps also in other countries? I am not quite sure: "Ce n'est qu'un grand garçon" may be said indulgently in France as often as in England. Except that garçon also means bachelor or waiter. Either puts the sense wrong.

This phrase in Peter Pannery: "I don't want to be grown-up, Wendy's mother. I don't want to be a man and have to go to the office. I want to be a little boy always, always," is, interpreted in the Freudian sense, an example of the will-to-die. It states, in so many words, that life is

too difficult and complicated; life and growing-up take you farther and farther and too far away from the womb. If you become a man, you marry and have children, and life goes on, and responsibilities accumulate; you are head of the family, and your sons have to grow up too, active and rebellious; and your daughters are not dream-daughters, jolly little playmates in the wood, understanding and whimsical and adoring; they, too, grow away from you and marry and have sons and daughters of their own. All this is life, but it is not fun. And it violates the sense of possession, as well; that sense of possession that desires your mother to be your own exclusive property, your wife to turn into your mother as and when required; your daughter to remain a jolly little dream-daughter. If this cannot be arranged, then plant your feet obstinately and stay a boy: Peter Pan, leader of the other boys who wouldn't grow up; eternally playing games in the Never-Never Land, among the tree-tops; inventing pirates and other picturesque, unreal dangers; meeting them gallantly, conquering them.

"Peter Pan," the play, as an exposure of Peter Pannery, is an asset in the drama and psychology of the nation; as an exposure, an attack and a satire, it is a work to be proud of. Unluckily, it has instead become popular as an entertainment; a charming fantasy and just the play for the kiddies, grown-up kiddies as well; rows and rows of old gentlemen in stalls, clapping heartily to show they believe in fairies. And we smile indulgently: "They're just boys at heart."

So Peter Pannery has been made to look romantic and attractive, whereas Peter Pan is nothing but a shirker. And that type of man can now, with a sigh of relief, adopt this romantic attractive excuse for shirking (and thank you, Sir James, for providing it!).

The matter is serious for women. In the fantasy, Peter Pan actually does in physical appearance remain a boy; or an illusion of a boy. Outside the fantasy, he has to grow up and become a man. We cannot afford to let this legend stand, this legend that we do really exult in mothering our fathers and husbands and grown-up sons; that we find in it our deepest satisfaction.

With a few exceptions, it quite simply is not true.

Boys hate to be fussed over . . . men hate to be fussed over. Behold, therefore, another picture in the same tradition: the male, sturdy, self-reliant, very pleasing in a rough old shooting-jacket and smoking a stumpy black pipe. The manly male. Yet only-a-little-boy-really, wanting his mother all the time. Without her, he will invariably forget to take his medicine, he will run into danger, he will have no one to whom he can show his grazed knee. . . .

The pictures seem incompatible. Men have to reconcile them, somehow. They stick to their idea of the man who hates to be fussed over; in fact, they dare not abandon it. Or what would other men say? The shooting-jacket and the stumpy black pipe, the impatient twitch of the shoulder as the sound of the words: "Have you taken your medicine, dear?" All these belong to a visualisation of manliness too effective to be discarded.

So that Wendy has got to be very clever. An obvious fusser is no blessing to him, for he dare not acquire a character for feebleness, in his own eyes and in the sight of other men, by yielding to her ministrations with any sign of complacence. Yet if she accepts as a final statement of preference, his brusque command to stop fussing over him, and therefore simply pulls herself together and does stop, he will be extremely displeased.

She must be more ingenious than that; she must beauti-

fully accept his expressed wish that she would not, with his unspoken desire that she should. Then she will always have plenty to do, and moreover, he will discover a quality about her of "intangible charm."

The point is, of course, that the male quite rightly hates unskilful fussing; the kind that too obviously advertises what we all know but prefer to conceal! What men require, and are grateful for, is subtle collaboration in the legend of their independence: "Oh, Peter, I'm so dreadfully anxious about your cold, I'm sure you must be feeling much worse than you say. Now here are your clean handkerchiefs, and here's another cushion, and your matches and pipe handy. Yes, and the whisky. I'll come in in five minutes and see if there's anything else you want. Yes, yes, Peter darling, I *know* you hate to be fussed over, especially when you're ill. Do forgive me. It is, I expect, because you're so big and strong. And after all, you haven't got a mother."—Then he slings his boots at her, and an enjoyable time is had by all.

"A man," he growls, "does like to be let alone."

Peter Pan, you see, gets it both ways. He has double fun, and the conventions have been properly observed.

Often Peter Pan will leave his Wendy because she fusses too much. He will leave her for another woman, a fascinating *intelligent* woman who will understand that man is adventurous, that man must be allowed to look after himself. Heaven help her if she believes him! Presently he will be letting her know that "somehow" she is a disappointment to him. She may wonder why, for years.

Let her take it as an indisputable solution of her bewilderment that our insatiable Peter Pan must find, so to speak, his Wendy at both ends; equally in his wife and in that glorious creature who symbolises his escape from his

wife. Perhaps she, that glorious creature, must be rather readier with mental than with physical fussing. She must "understand" him. When you understand a man for hours on end, you are mentally fussing over him. Unless, indeed, you carry understanding a stage too far. Then you have "no charm."

One is curious to know why women have submitted? Why they have adapted themselves for so long to this boring Wendy rôle? For the whole picture is false, and psychically inconvenient to women. The longing to be fussed over, is not a question that rests on sex; it is a fundamental craving of the eternal child in us all, which we eventually learn to conquer directly we realise that we are not going to be encouraged. The Girl Who Wouldn't Grow Up is just as true as the Boy Who Wouldn't Grow Up. If allowed, she too would dodge and evade this bothering business of becoming adult, of taking on responsibility. If the boy has a formidable mother-fixation, she has a father-fixation which might have proved just as handy: "I want to be a little girl always, always, and play among the tree-tops in the Never-Never Land."

Had woman been able to impose her secret wish on man as blandly as he upon her, had she been the first to capture that advantageous arrangement whereby she could accede to all the pleasures of being free, gay and attractive, all the convenience of evading responsibility, and gain in addition the credit of being "Just a little girl at heart," then we would have had the comic predicament of the Peter Pan instinct equally rampant in both sexes.

"The Doll's House," of course. But Ibsen compelled her to abandon her childhood, instead of providing a delightful excuse for her to remain in it:

Who left him in?
Little Jamie Thin.

Peter Pan has no right to go on all his life expecting his mother to fuss over him. It imperils any promise of happiness in a marriage with him. Besides, his real mother is usually, by paradox, the one woman from whom he honestly refuses to accept fussing. It is in the perverse nature of things that he likes to seek a mother where she is not; not find her where she is. Here is Peter Pan's subconscious creed:

"I have remained a boy at heart because it is the most convenient idea that has ever occurred to anybody; moreover, it has been sanctioned by the most successful play of the century, revival every year and no sign of flagging. *You* haven't a chance of having a successful story, a successful play, written about you, proving that women don't want to grow up but like to remain little girls all their lives, because we got there first and refuse to be hunted out of our happy playground. Possession is ninety-nine points of the law."

Yet convenient, expedient, fundamentally satisfying as this Peter Pannery would seem to be for Peter Pan, it has not worked out so well. You can see middle-aged and elderly Peter Pans wandering about in this world of uncompromising reality, with a forlorn look, a restless spirit; the fact of their years ruthlessly contradicting the scheme of their days. They have sold their birthright for a mess of pirates. Futility creeps in; first an uneasy sigh in the distance; then stronger, like the saddest of all phrases in the last movement of the Eroica. There is little comfort anywhere for a Peter Pan of forty or fifty or sixty. They are

fanatically attached to the playing of aimless practical jokes; they revisit scenes of childhood far too often; they squander affection on old tunes, old photographs, old bits of furniture. They do not lack physical courage; often they are happy in war, provided they are not in a position of too much responsibility; for war becomes a union of their favourite childish games, blessed at the same time with the noble sense that they are being as grown-up as other men and doing what is demanded of them. Existence, during war, is thus robbed of its faint sense of reproach; day and night are gingered up again; the salt regains its savour.

Even business, even travel and a career, need not be wholly incompatible to Peter Pannery. These can ingeniously be twisted into some semblance of a juvenile game.

Yet one thing cannot be turned into an irresistible game, and that is normal family life. It is in family life, then, that Peter Pannery is most devastating. For the ultimate and logical result of having a husband who is still a delightful child about the house, may easily be that there is no child about the house except the delightful husband. The fundamental will of procreation is lacking; because procreation is a responsibility; and children may rob him of his childish privileges. Therefore Peter Pannery will gradually turn a man from wishing for a wife except to mother him. And this can eventually develop into sterility and extinction of the race.

I once knew a very sweet woman who had been the youngest of three sisters, and a great favourite with her father. He died; the middle sister married; and the youngest lived with the sister very much older than herself, who petted and idolised her. She was between thirty and forty when she married a charming, masterful personality who, though younger than herself, was able without any effort

to reverse the actual fact of their years, and be the auto-
crat of the household, spoiling, admiring and commanding
his wife. They had a little girl, and procured for her an
excellent nurse, one of those trained young women from
the Norland Institute.

Presently the husband became very ill.

I can never forget the voice, not of present bewilderment,
for she had accepted her position by now and understood
it, but the voice of bewilderment remembered, in which
my friend told me: "You see, I suddenly realised that I
was the oldest person in the house!"

It was probably the most significant thing that had ever
happened to her. Little daughter, little sister, little wife.
And suddenly, through circumstances, left with every one
coming to her for orders; no one to interpose, saying that
"the youngest" must not be worried or burdened with these
heavy, dreary matters: child, servants, invalid, as a mat-
ter of course turning to her for sustenance and authority.
She was the oldest. And though of Wendy's sex, no less
was she Peter Pan compelled to grow up and take it all
on.

Yet how one yearns for that comforting bulwark of older
people, grown-up people, wage-earning people, even of
cross, domineering, unreasonable people, to interpose between
you and responsibility. The dreariness of being able to do
as you please, because you are head of the family. If you
are the youngest, if you are Peter Pan, if you are Harry
Dearth, or Charles Strickland, you may run away to the
Never-Never Land, to the woods with your dream-daughter,
to a South Sea island without your top-hat. The man who
pays the piper may call the tune, but there is one tune he can
never call: the hilarious care-free infectious tune of *not* be-
ing the man who pays the piper.

Plays about families sort themselves out quite naturally into two species: the real and the fabulous. Bernard Shaw originally pinched the fabulous family out of the empty air, as a conjuror pulls coins. The family life of the fabulists exists only in some curious Fifth Dimension imagined by the dramatist. The characters have a harlequin quality; they gleam and flicker, they shimmer and caper as no real family has ever been known to do. And they have such fun, even in the mornings, even before breakfast.

The chief difference between fable-family dialogue and real-family dialogue is that the former are unbelievably, exquisitely, fluently and persistently insulting to one another, and are never hurt by it. But real families are often inhibited and usually sensitive. They rarely indulge in swift verbal duels, because they have taken for granted for years the things that must never be said; sensitive areas have long ago been marked red on the family map. If wounding things are finally spoken in the course of the play, after long conflict and emotion, we get our Big Scene. But members of the fable-family are goblins and change-lings; they cannot be hurt; so the witty disconcerting flick-and-cut can persist through three entire acts.

They have a funny sort of servants, too, in fable-family plays. As fluent as their employers, they also are apt, at any moment, to burst into carnival irrelevances, quite astounding if we compare them with our own normal and inarticulate [sic] staff.

People are apt to make a mistake in their classification of real and fabulous families; they divide them, instead, into "old-fashioned" and "modern."

The old-fashioned slogan, "Papa knows best," was, I imagine, based entirely on the fact that Papa was the only person in the house who had money to pay the bills. In

Victorian days we submitted helplessly to the man who paid, as though he were God. The "man" in question was then of the male sex. In Edwardian days came the Great Rebellion. Everybody, young son, wife, hot-headed daughter, spinster sister, passionately desired to be the man, to leave home, to earn a living, to vote, to acquire all the prerogatives attached to the liberty-and-latchkey period: passions fading almost to a daguerreotype quaintness as we gaze back upon them. The Ann Veronica period. The back-to-the-wall period.

Then the War.

Since the War, a curious reaction is just beginning to be visible. Certainly the modern sons and daughters do not dream any more of submitting to the man who pays; but nor do they fight him any more. They either ignore him, or else they are flippant and condescending at his expense: "No, thanks, we don't want to leave our comfortable home. Strike out and be independent? How sweet! Fancy your digging up a mediæval notion like that! Why, we *love* our homes!" Sentiment of a sort has come round again, and, as in all social history, the whiting solemnly bites its own tail. The solemn, pontifical, awe-inspiring figure of Papa and The Breadwinner, has become humorous; and the man who pays finds himself with status diminished, laughed out of the way, pushed into perplexing isolation.

It is curious that it never occurs to him how much ultimate and bedrock power he really possesses; or rather, that it has not occurred to him recently that this power can be used. The heavy father of the Albert Memorial era most unchivalrously over-used it, and owing to him, the Jove-and-thunderbolt attitude, the attitude of "You can take it or leave it," the "Never darken my doors again" or "While you live beneath my roof" attitude, is miserably discredited.

And the man who pays nowadays (frequently it is a girl; sometimes not much more than a child) must in addition pay the price for his predecessors, who enjoyed themselves too much, though never honest enough to acknowledge enjoyment of their privileges and their reverberations.

It is intoxicating at first, to be an autocrat. A relief, too, to overstrained nerves. To the woman who for centuries has come nowhere near this particularly dangerous type of intoxication, nor been able to seek that particularly dangerous way of relief, the present temptation is most insidious. She swings between the longing to indulge herself by using this delicious new form of cheque-book potency ("One would think when I'm all day long at work . . . heavy burdens . . . worries . . . naturally when I come home in the evening, I expect . . .") and consciousness that just because these things are true, they ought not to be said.

Men ceased to be chivalrous directly they became head of the household by material instead of physical justification. Women, going to the other extreme, are inclined nowadays to be too chivalrous. They fiddle with the psychological pros and cons of their recent accession to the throne. They realise this potency within them, and how it may grow, and where it may end. They are frightened to let it dominate them. They hold all the weapons, and that may easily be the weakest of all positions. A very big man dares not use his full punch against a very small man, because he knows it would knock him out.

Of course, there is such a thing as ruling a household by friendship and affection, tolerance and reason, all the civilised qualities. Yet walk into a family and note which is the most isolated figure of the group. Nine times out of ten, it will be Augustus Cæsar, who has tried to be "civilised"— until that one occasion of domestic crisis when he is sud-

denly forced to drop friendship and use power instead. After
that solitary betrayal, Augustus Cæsar is neither admitted
as a friend nor respected as a despot. He is the loneliest man
in the house. And if he be a girl, then lonelier still.

Because, under post-War conditions, there is not much
money about, and every one is in debt, we have temporarily
adopted this curious self-protective-colouring attitude that
money matters less than anything else; except, of course,
just to buy things with, to keep ourselves alive. "One must
have it, but one needn't be grateful for it," is the general
assumption. We are always grateful for anything that rids
us of the obligation to gratitude; that is an instinct old as
praying, and as universal. To resent the head of the family
who pays for us, is but one instance of it.

So if the master of the house, man or woman, must
inevitably be resented, he or she might as well be feared.
Certainly it is illegitimate to be enthroned as Mr. Barrett
of Wimpole Street; but if you abdicate, after conscien-
tiously analysing the bad sense and bad manners of a
domineering position, you will still have all the toil and
responsibility, and no reward at all. For money, from being
a subject breathlessly taboo except in the family circle, has
so lost its taboo that we drink cocktails with our bank-
managers, and joke about our overdrafts at dinner-parties.
So when the head of the family says: "We're broke. We're
ruined. We can't pay. We can't possibly go on. I've no
money. I'm worried to death about business," these, from
being common phrases in common use, produce no such
consternation, no such stricken tableau as was once revealed,
for instance, in Martineau's "Last Day in the Old Home"
painted in 1862. Nowadays: "Ruined? Are we, darling?
Isn't it *too* dreary! Oh well, something will turn up. For
heaven's sake don't walk about like Mr. Barrett of Wimpole

Street!" . . . And life goes on, seemingly the same as before, under the paradoxical tyranny of being flippant about everything, while the man who pays has nothing left except a stale thunderbolt and an overworked weapon.

If he persists, if she persists in looking bothered, or pleading for economy, she will become even more than she was already, the most unpopular member of the household. She has been for a long time the most conspicuously forlorn. She is not there all day, and so there are bound to be, among the non-paying members of the family, perpetual little knots of plot and conspiracy, to be kept secret from the breadwinner; petty plots for wangling petty cash; grievances; smouldering indignations; knots of two and three and four. If there be any sort of crisis in the family, the wage-earner never gets the full case put before her. She always has it specially edited and re-arranged, because the fact that she pays is supposed to complicate her judgment, so that they cannot even trust her answer to a simple question, like "Which hat shall I buy? This one is the cheapest."

Once, when Papa was still the bugaboo figure, his return from business was a solemn event. He had his sacred hours for rest, his sacred study, his sacred privilege of reading the newspaper first. These were his compensations for being thrust out from the warmer, more companionable niches. Years ago, he breathed smoke and fire and rattled a scaly tail. But now, a family dependent on the wife or daughter of the house is apt to feel that her whole nature has become warped and arrogant and incapable of imagination, simply because once or twice weariness may have sighed or frowned at sudden unexpected levy.

If domestic history could be mechanised so that, irrespective of health, talents, or disposition, every one earned

exactly the same; if every little pig went to market, and no little pig stayed at home, then every little pig would have roast beef. As it is, the one who earns the money to pay for the sirloin, seems in danger of getting less roast beef than any of the others.

See the breadwinner of to-day, about to let herself in with the latchkey, at evening. Not elderly arrogance and side-whiskers and the voice of Savonarola in the market-place, but just as often, since so many husbands and young fathers and elder brothers were killed in the War, a tired girl with drooping shoulders; smartly dressed, because one has to dress smartly in business; rouge and lipstick, but, under their camouflage, pale, overstrained, burdened with the modern handicap of terror: "I mustn't be thought heavy or a bore. I'm done if I lose my sense of proportion . . . but it's been a blackish day—business *is* bad, and there *is* a crisis and a slump. . . . One can't smash a fist on to the table because it isn't decent. . . . One can't call in allies from the rest of the family because they're enemies to the man-who-pays. . . ." A pause before she uses her key and lets herself in. She wants to hear some one say: "Don't worry, dear!" in the firm voice which she herself has so many times used to them, meaning that they're *really* not to worry; that she *really* will see to it all. To any one who has ever shouldered responsibility for any length of time, the most beautiful words in the language will always be: "Don't worry. Leave it to me," if said with a ring of truth behind them, a ring of efficiency.

The breadwinner is very unlikely ever to hear those comfortable words. She is up against the denseness which has thickened from the easy habit of putting it all on to her. She is up against the antagonism created by her position. She is up against the fact that there is perhaps one

strong nature to twenty weak ones; and that wherever she goes, her destiny goes with her, and the twenty weak ones will arrange themselves on her back and her shoulders and round her knees and hanging on to her hands. They pile themselves on to her till the impression is of a picture by Heath Robinson. There is a special hymn of joy, twanging and persistent as the hymn of a mosquito, which sounds almost audibly in the weak nature directly it finds a strong one.

The fight is now for freedom *for* the head of the house. The fight for freedom *from* the head of the house has resulted long ago in victory; though here and there, Ann Veronica still stands with her back to the wall, not realising there is no more a wall to put her back against.

I wonder if the wife and seven daughters of Atlas remembered from time to time that it was not fun carrying the world as a burden for ever pressing upon the shoulders. I can easily imagine Celeno, his pert pretty youngest daughter, being the first to minimise his endurance by the eternal argument: "Well, he wouldn't do it if he didn't enjoy it!" The answer to that is: "Somebody's got to do it." And then with a careless laugh that ripples down the ages, she replies: "Glad it isn't me!"

If you look up at the Pleiades on a clear night, it is easy to see that her twinkling brilliance is still unabashed, and that she continues to agree with herself and with the seventy-seven million daughters-of-Atlas who have since thought in the same milky way, that it is *fun* to run about in the Garden of the Hesperides, and afterwards to sequin the heavens; and leave the tiresome job of carrying the world to Atlas, to Papa, to the elder sister, standing forlornly at the door, her latchkey in her hand.

The conflict, now, lies between these survivors and the

very young, the very new generation, who are being brought
up to believe that there is no hope save in them, their
health and sanity. They seem strong enough; cool strong
young bodies, hygienically produced; calm, cool, intolerant
young brains. Youth is always intolerant; but it used to be
hot intolerance, storming the Kingdom of Heaven. This
very young, very new generation—is it my fancy, or are
they . . . a little bit too pleased with themselves? They
keep aloof, not mixing much with us, not letting us in.
They go about in droves, always in droves, without form-
ing violent, glorious, mistaken friendships. They are good
to look at. It is early to tell, but there does not seem to be
must genius about, nor personality, nor flame, nor fanati-
cism. They are self-possessed; they are efficient; they will
not make friends with us. They are not iconoclasts, for
most of the idols inconvenient to youth are smashed al-
ready. They do not rave for freedom, and run away from
home. Why should they? No one in the home is hindering
them from doing anything they please; nobody dares. Are
they not our salvation, untouched by war or plague? Hands
off the sacred younger generation even if they are behaving
a trifle too sacred!

The best unexaggerated satire on this topical theme, of
the sacred new generation behaving a trifle too sacred, was in
the play, "The Breadwinner."

I wanted my impressions verified, of the golden lads
and girls of this generation, the modern generation. So I
asked a father how he thought his two children compared
with his own contemporaries of thirty years ago. And then
I asked a friend who had herself only recently stopped
being the younger generation; but she had passed through
that phase directly after the War, and was therefore, as

classified by Noel Coward and Evelyn Waugh, a special
type; because of the War, more restless, more discontented,
wilder than modern youth usually is; their pleasures more
fugitive, their experiences snatched more desperately, a
"between" generation isolated from the rhythmic sequence.
Finally, I asked Micky and Liz to lunch; together they might
unconsciously help me to see for myself what was going on,
nowadays, before you were twenty.

Father-of-two told me confidentially that though his boy
and girl were a good boy and girl, he could not quite under-
stand their mania for speed: that appeared to him the
most characteristic and surprising difference between his
own youth and his children's. He had been prepared to find
that as they grew up, they went out a lot, found their
home dull and their parents a bit stodgy, all in the normal
way; but it surprised and worried him that, having gone
out, they did not stay in the same place. No, they kept on
moving round, quickly, as though the most desirable party
in the world lost its charm if it remained static for more
than half an hour; as a matter of course, they had cock-
tails in one place, a meal in another, a further gathering
somewhere else; no host was offended when his guests pre-
maturely packed into cars and "whizzed off"; perhaps he
went along too. They had radio talk in their cars mostly
about speed, as they speeded along. And all their reading
was about speed, said the father-of-two; and all their heroes
were speed heroes. Their table-talk, with or without a table,
was entirely of speed records and who was beating them and
how; their ambitions, to achieve speed for themselves by
car, aeroplane, or boats. What was it all about? their
parent asked me, oblivious of the fact that I was asking
him. His brows were puckered in an honest effort to

sympathise. He had been prepared for wild oats; he had arranged himself to be broad-minded over wild oats; to tolerate extravagance, late nights and love scrapes; but he received no confessions along these lines; and you cannot easily acquire a streamline mind when you are over fifty. I comforted him by quoting the Arab's reply to an English visitor who asked him if he were not pleased that now, by terrific exertion, a railway had been built between two villages in the desert, which would take him from one to the other in a day, whereas formerly, by riding, he had had need to take six days for the same journey? Calmly he replied: "But what do I do with the other five days?"

The girl of the immediate post-War generation, whom I consulted next about her successors, did not bother to denounce speed mania; she had known it herself while she, in a crazier, less regularised degree, dashed round in the three or four years before she came of age: during the era when strange fevers alternated with a lethargy that found nothing worth doing; the "Limehouse Blues" era; the "Dance-Little-Lady" era; the "Vile Bodies" era; the bored, horribly bored set, who had been too young to do anything but look on and see too much sorrow, too much waste. They did not achieve much, this set. Literally, they had been in at the death. It was not worth while to be ambitious. War hung about in the air even after war was over, and they could not get properly started; and then everything was too late; they were suffering not from shell-shock, but from the echo of shell-shock. Nonchalantly they lived, sometimes dishonestly, it did not much matter. Only their restlessness had been genuine: some inexplicable petulant despair goading them on, wasting and spilling emotion as they went, to tear round the next corner and the next and the next but one, looking for the peace, the

romance, the good time and the long stretch of years to enjoy oneself, which had belonged to the young generation before theirs; before the War.

But to-day restlessness has become a formula; to-day it is normal to go on from place to place. Everybody does, nobody doesn't, unless they are old or tiresome. To-day you are slim because you have to speed, and you speed because some day you will have to break speed records, on land, in the air or under the water. To-day can be no strangeness or defiance or desperation in going the pace, for the pace is the correct thing.

But this same friend to whom I went for my second consultation, called special attention to the modern rage for crooning. In her time it had been rag-time and then jazz. Now, crooning was so necessary for the young if they were to survive a day and live on till another, that Liz even took the gramophone and crooning records with her into the bathroom; lying back in her bath while the crooners crooned like hell. Men, seemingly, are attractive to Liz and her like, just because they are crooners. Once, a handsome tenor had been a young girl's dream. I suppose in the Middle Ages, maidens of seventeen and eighteen used to lean out of barred windows and worship the troubadour. We know that the young girl in Spain yields her heart to the thrumming of a guitar in the courtyard, but she has to lean this heaving heart against a grille of iron bars. She could not take him along in a box to the bathroom.

The crooner may very well be a romantic reaction from speed mania. Perhaps, growing up from their clear-cut, eugenic, hygienic, no-nonsense Norland-nurse-but-no-Nanny childhood, Micky and Liz instinctively miss a past of old-fashioned rocking and old-fashioned lullabies more than either we or they realise; and when they hear, nowadays, these slow

lulling cradle songs from a kingdom of which they have been robbed, they turn towards it and surrender without resistance. Psychologically, we may have here an old-Nanny fixation.

Micky and Liz had only met once before they came to lunch with me. He was not quite nineteen, in his first term at the University; she was not quite eighteen, and had just been presented. They both had excellent manners towards their elders; this, I think, is where the modern very young generation scores over the weary fractious disdainful manner of the immediately post-War; and certainly scores over the defiant, rebellious: "Oh, you can't under*stand!* I want to be left al*one!*" manners of the Ann Veronica period. It may be that they have no provocation for bad manners. We are not stopping them now from doing most of the things they want to do.

I eliminated myself as much as possible, and listened in some curiosity to hear what complaints they had against my generation. For after all, there was bound to be something, unless we were either wholly perfect or wholly nonexistent in their eyes.

There *was* something. It came out clearly in their chatter: parents were perfectly reasonable; no harm in parents; parents didn't nag much, nor ask many questions, nor stupidly forbid; but they were *maddening* about allowances. No good shielding them or making too many excuses; they meant to be generous; they thought they were generous; but they had not a clear mental grasp of what were *your* expenses, and what were *their* expenses-in-you.

In a lather of indignation, and by now utterly oblivious of my presence, Micky and Liz compared notes on this fascinating topic; they had each just been put on an allowance, and found they were expected to pay for all sorts of things with it. (A point of view expressed in an old anecdote

struck my memory: "The poor chap hadn't a penny to leave to any one; frittered it all away paying tradesmen's bills!") Yes, they actually had to *pay* for things out of their allowances; not *have* the allowance, which was fun, while everything else was still paid for by Authority, but use up the precious stuff bit by bit for fares, tips, petrol, presents, holidays, cinema seats, cocktails, car insurance policies, parking fees, fines, spare parts . . .

I *mean!*

The problem before the house was, how the parents of Micky and the parents of Liz could be brought to appreciate the true proportions of finance, economics and the quarterly budget, without any violation of good manners, tolerance and affection: "Besides, we simply can't have rows in the home!"

It was not, you see, that mummy and daddy were Old Stints. It was simply that they had *no conception*. That makes life very difficult, when parents have no conception. In their day, money values were quite different, and they had practically nothing to keep their allowances for; just a few bouquets for actresses and some white kid gloves with pearl buttons—what else was there, then?

Another (though minor) indictment: They were a tiny bit casual about renewing motor-cars; they seemed to think that the one they last gave you, would do for the next two or three years.

Otherwise, parents were not at all bad. Quite understanding over trifles such as love, health and danger. And they looked nice, too. Parents used to be fearful old frumps, but now one could be quite satisfied to be taken about by them anywhere.

My sagacious pair of guests suddenly remembered me; and lest I should be feeling left out, they asked me eagerly

whether I did not agree over this question of allowances, and mummy and daddy being so unreasonable? " 'As chimney-sweepers. . . .' " I murmured. They looked puzzled; and as it might have spoilt the flavour of their luncheon to be reminded, ancient Egyptian fashion, that they too in their turn must come to dust, I saw no need to expand the quotation. For this golden boy and girl were being very nice to me; and next time an interviewer asked me what I thought of the Modern Girl (they never ask what one thinks of the Modern Boy) I should be able to generalize fluently on their good manners, their mania for speed, their passion for crooners, and their quaint assumption that allowances paid into their own bank account immediately become inviolate and divine and need therefore never be used for base practical purposes.

Usually, when interviewers happen along and sit down opposite me with an expectant air, I have to improvise like mad, and disguise my own astonishment at the unexpected fervours that come streaming out of me. I can always summon them from nowhere by using the phrase: "I can't help feeling very strongly about this . . . " And then, smoking a cigarette and looking steadily into space as though gazing down vistas of hard work, clear thinking and research in some noble cause, wait and see what it is that I can't help feeling strongly about?

Last time, I let loose on a prevailing idea, particularly in the lower middle-classes of England, that thrift was a quality to be ashamed of; that thrift stood for meanness, stinginess and letting your neighbour know you were badly off; whereas a Frenchwoman of the same class regards thrift as a virtue; and not even as a dull virtue, but fierce and glowing and warlike; involving knowledge of commerce, trade, agricul-

ture, the hearts of men, the wickedness of one's neighbour, the breasts of birds and the eyelids of fishes, the fluctuations of markets and the value of rhetoric. Thrift should be a quality that functions incessantly; while economy presupposes unpleasant measures that you are compelled to take in a hurry, for fear of disaster. The process of economising, in my own case, usually resembles the upturning of an egg-timer; the sand all trickles down, and the sand all trickles back again, but there remains just as much sand in the glass.

Thrift as practised among the sturdy French bourgeoisie is bound to strengthen the nation; whereas the fear of the typical English wife and mother that she displays a paltry meanness by inquiring into prices, is all the time having a contrary effect of a slackening and slovenly nature:

"Our British Homes," I improvised, alarmingly carried away by passion, in spirit far from the stunned interviewer who had come to hear my views on the Modern Girl, "our homes are conducted as though the day's marketing were some furtive crime. In Latin countries, the women set out marketing as though they were brandishing a banner. I can't help feeling strongly about this."

When I first began writing, H. G. Wells took me for a walk in a gloomy wood (Virgil and the young Dante, from an engraving by Gustav Doré). He said to me "Do you believe in God?" as he might have said to any companion at the moment, for he was writing "God, the Invisible King." And I might have truthfully answered "Yes," or even more truthfully "I don't know," and thus gained credit for brevity and an unassuming disposition. But I thought that I must make myself interesting to Mr. Wells, so I began to improvise. Ardently I improvised a whole complicated creed and religion unlike any other creed or religion that anybody else can ever have had; gazing steadily into space, my voice shaken by

passion, I must have gone on for quite a long time. When I had done myself full justice, he merely said very gently: "Tynx, you've just this minute made up all that!"

The moral of that is that the only way to find out something of what the Modern Young are thinking, is never to inquire direct; for out of humility, not out of pride, they will invent answers by the hour, feeling that the undecorated truth cannot possibly be interesting enough; that they have to produce something far more complicated to hold your attention.

The first Modern Girl, the first record that the difficult modern daughter was not at all a modern invention, was, of course, Persephone; and Persephone could have given an interviewer a pretty good idea of her views on the old-fashioned mother. Demeter was a darling, of course; a mummy-my-sweet; but terribly unreasonable: "Mummy doesn't realise that one's allowance goes simply nowhere, nowadays; and she fusses over me and talks poppy-cock about sitting at home after dark and it's dangerous to talk to strangers, till I sometimes think I'll go batty. Only this morning we had the most frightful row. She had to go away on business. Oh yes, mummy's good at business, I don't deny that, but the lecture I got first! 'I suppose at least I can go *out* by myself?' I said, but mummy doesn't understand irony. 'What do you want to do, *out*?' 'Pick flowers, mummy darling.' She said she would have some flowers sent in. 'Well,' I said, just to rag her, 'as a matter of fact I've been asked to go for a drive; lovely black Bentley, sixty horse-power, rich man——' 'Who is he?' mummy cried, off the deep end at once. 'Oh, I don't know; name of Pluto.' Then she blew up. 'I'd rather see my daughter in hell——' and all the rest of it. But honestly, you know, I don't want to be narrow-minded, but they *can't* carry on like that. I mean, *can* they?

I wish I could remember where I left my girdle," she added thoughtfully.

Persephone is not dead. She has hardly even vanished. If we fold over the centuries, she swiftly reappears among us as the Modern Girl, still and always a fugitive from her anxious mother, wandering in forbidden flowery fields, questing for fresh illusions: "Here, surely, is the loveliest blossom of all; it must be the loveliest, because to-day is the first time I have seen it." And pulling heedlessly at the loveliest blossom, she opens a way down to the underworld. Her mother cannot follow her, because no mother can ever hope to chart the underworld. Yet sometimes, at the end of her wanderings, Persephone is lucky, marries Pluto quite respectably, settles down, herself becomes the mother of a modern daughter, and the recurring legend begins all over again: "And I said to mummy: 'That's all *poppy-cock* about it's being dangerous to talk to strangers . . .'"

The poppy and the pomegranate are symbols of Persephone; but more beautiful than either is the Iris Susiana of which the legend says that these were the hand-maidens of Persephone who followed her down into hell. I have seen the Iris Susiana unfold with slow lovely gesture from a dark bud to incredible bloom, in a garden in Italy and in a garden in Kent. Most flowers you can take in your stride, without rhapsodising; but the Susiana compels you to stand still and breathless in front of it till you are acclimatised to such perfection. I can give no reason why this tall iris alone of all its tribe should have such a peak-in-Darien effect upon you; smite you with astonishment at what creation can do. It is not black and white, but it is as pale as it can be and as dark as it can be, and pallor and darkness together achieve their enchantment without troubling to explain why, in ordinary terms of prettiness of line and

colour. The Iris Susiana is what I suppose we mean by inspiration.

There are moments when Persephone herself, any very young eager Modern Girl, can give us the same feeling, though one might be criticised by using a comparison of what is tall and motionless and finished, with what is all swift desperate laughing fugitive movement. I have seen Persephone at seventeen, reading a love-letter; and because she could not rid herself in any other way of her tumult of incredulous joy and wonder, stamping like a young pony while she read it.

And Tolstoy's Natasha was Persephone again:

"The tremulous expression of Natasha's face, ready for despair or for ecstasy, brightened at once into a happy, grateful, childlike smile.

" 'I have been a long while waiting for you,' that alarmed and happy young girl seemed to say to him in the smile that peeped out through the starting tears as she raised her hand to Prince Andrey's shoulder. They were the second couple that walked forward into the ring.

"Prince Andrey was one of the best dancers of his day. Natasha danced exquisitely. Her little feet in their satin dancing-shoes performed their task lightly and independently of her, and her face beamed with a rapture of happiness.

"Her bare neck and arms were thin, and not beautiful compared with Ellen's shoulders. Her shoulders were thin, her bosom undefined, her arms were slender. But Ellen was, as it were, covered with the hard varnish of those thousands of eyes that had scanned her person, while Natasha seemed like a young girl stripped for the first time, who would have been greatly ashamed if she had not been assured by every one that it must be so."

Natasha shows us the effect on any very sensitive young girl, of war going on, of war just over or just about to start. They danced; music expressed their changing moods in quick, mad, harsh rhythm; then in slow dragging hopeless rhythm. The ragtime foxtrot. Down to the Blues. Up again with jazz. Down again to more Blues. Quicken to the Charleston, Black Bottom, hot jazz. Then quiet, quieter, tired-out, crooners crooning lullabies. The twentieth-century names for these dances are nearly always chosen from a dictionary of melancholy; though "cake-walk" sounded gay enough for whosoever had not sickened himself with cake. It must have been about 1900 that Williams and Walker brought over their negro musical comedy called "In Dahomey," and made us first aware of mirth stating itself in flashing white grins on black faces, of bodies flung in backward arches from the neck, from the shoulders, from the waist; in extreme cases, from the knees. The cake-walk. I was linked to this new fashion in dancing, by a young man who came to the house wooing my sister; he was a cake-walk expert (though my father did not think this a guarantee of stability) and won the cake in a Covent Garden contest, and demonstrated up and down our drawing-room how he had cake-walked out of the great ballroom, holding the cake high above his head, body flung back and away from it in incredulous delight, in arrogant ecstasy; legs lifted high off the ground at each step; no shuffling through swamps.

But we began to grow sadder, to go mooning about plantations, when the coon-song followed the cake-walk; for the "raccoons," after all, were slaves; coon ladies were heartless; their coon lovers hopeless:

> *You said you'd meet me*
> *Down by the creek,*

I'se gettin' skeery,
I'se 'fraid to speak.
Mopin' alone, gal, waitin' for you—
Come if yo' loves me, mah Moonlight Lou!

Eugene Stratton, the White-Eyed Kaffir; George Elliot (the difference an "l" can make!) the Chocolate-coloured Coon. Coons for a while tipped Pierrot out of my system, while I feverishly arranged coon-plays up in the nursery, and played the coon hero myself in a huge plantation straw hat; wrung my own heart; possibly Nelly's, too; Nelly the sewing-maid was a first-class audience, responding to any suggestion from the author-actor-producer that love had more downs than ups.

Then, with a crash of syncopation: "Alexander's Rag-time Band," "Hello, Miss Ragtime!" Ragtime was meant to be hilarious, but here too, panic crept in presently; panic and menace:

The Rag—time—Goblin—Man
Is mad what was it
Drove him mad?
A Rag—time—tune.
He's beside me—
Hide me—Hide me—
I can see his eyes—

And after ragtime, jazz.

A negro entertainer in a New York night club, the popular "Jasper," one night discovered a new rhythm; the delighted audience called out again and again: "More, Jas'. More, Jas'." They could never get enough, Jazz. *More,* Jazz!

Jazz before seven, blues before eleven.

Sad associations: slavery; raggedness; a fit of the blues; Jas', a tired negro pestered for "more"; the black bottom of the swamp; and at last a crooner's lullaby to bring back childhood on sentimental circle.

"Die Lorelei" was my favourite song; no glass dragon as yet, with trim blue beading round the edge of its mouth; but the traditional siren sitting on a rock, combing her long golden hair:

> *Die schönste Jungfrau sitzet*
> *Dort oben, wunderbar.*
> *Ihr goldenes Geschmeide glitzet,*
> *Sie kammt ihr goldenes Haar——*

Mother used to sing it, playing Liszt's melody at the small piano in the sitting-room, between tea and supper during the winter, for in the summer we were in the garden at this hour. Pianos were draped in those days, or they were not looked on as respectable; so because the sitting-room was in faintly Eastern style, the piece of drapery over the piano was a Chinese tapestry, a fugue of deep wine and gold, which now hangs right across the wall of my own sitting-room.

Mother played by ear. She had no knowledge of how to read music by the notes. Her fingers were long and white and cool, and I believe she played the most disgraceful tricks with them to cover up inaccuracy. But I saw them wander over the keys in a casual and authoritative way that I should never be able to copy, for they told me that I had "no ear." I was sent every Saturday morning to Baker Street by Underground, to have a piano lesson. It was a pity that my teacher should have been a real musician, for she really suffered and became impatient at what she thought was my stubborn resistance:

"Child, your wrists are like wires," she would cry, striding up and down the room, her eyes snapping.

So Saturday morning meant to me, literally and mentally, a sullen fog which had to be got through somehow. It cannot have been my fancy that there was then nearly always a fog on the Underground around Baker Street; and at Baker Street itself, when you came into the upper air. It may have been fun for Sherlock Holmes, there, and even for Watson; it was no fun for me. Yet I played at a Pupils' Concert: "Graziella" out of Mozart's "Zauberflöte"; played it with some spirit, they tell me, and was loudly applauded. I have never, since then, heard "The Magic Flute" performed from beginning to end, and I am longing to know whether I should recognise my "Graziella," that air which I had assiduously, wearily practised with a metronome through the whole of one term. Four or five of my cousins and friends also went to Miss C——, and at the end of one term, before the prize-giving, I remember a short discourse from her, and the boldest of us piping an interruption: "Which of us has got the prize?" and she saying: "You have *all* got prizes," and my scornful disappointment; for what was the use of a prize if not as a crown of pre-eminence?

I received "A Boy Musician"; and to this day can produce curious slices of information about Mozart's early childhood. How, for instance, he had a strong aversion to brass instruments, especially to trumpets:

"But the father was inexorable. He held Wolfgang tightly, and ordered the trumpeter to blow his shrillest blast. But hardly had the piercing tones begun to echo through the room than Wolfgang uttered an agonizing cry, became deathly white, trembled from head to foot, and finally, covered with a cold perspiration, fell down in a swoon."

For years after, it was my ambition to fall in a swoon.

I had a great friend at school who could pull it off about once a week; and I had to suck all the vicarious importance I could, from attending her downstairs to the headmistress's room where she could lie on the sofa; afterwards returning to the classroom with lagging step, laden brow and slow, pregnant shakes of the head when asked by the others how she fared.

Besides "Die Lorelei," Mother used to play over and over again, moving me more powerfully than ever subtle music or good literature could hereafter move me, the song from "Der Trompeter von Säkingen," where the noble trumpeter pauses outside the castle walls to sing his renunciation and farewell:

> *Behüt dich Gott,*
> *Es wär so schön gewesen!*
> *Behüt dich Gott,*
> *Es hat nicht sollen sein.*

which means, roughly translating, that he knew the Princess was a cut above him, and that was that! Also the Waltz from Johann Strauss' "Fledermaus" and the "Nachtigall" song from "Vogelhändler"; "La Donna è mobile," from Rigoletto, and two tunes that were a victory, in her heart, of London over Vienna: "Every Morn I bring thee Violets" and "I have a song to sing-o!"

I, meanwhile, used to kneel on the carpet in front of the sofa, and play a complicated drama that was an outward expression of a vivid reverie. A reverie which went on from year to year. I played it on draught-boards, and mainly with Halma men. The singing and playing meant nothing to me except a falling background of sound like rain. The same reverie went weaving on while I was stringing beads; or sorting the little boxes of coloured sequins Mother used

for embroidery, gold and silver, blue and green and red, winking and glittering through their round glass lids. Weaving on while in carmine and crimson lake, ultramarine and gamboge and rose madder, I painted the illustrations in all but my best fairy books. And weaving on, when I built with bricks on the nursery table, and manœuvred all sorts and sizes of toy soldiers among this brick architecture; I cannot remember that very much war was involved; it happened merely that soldiers were a convenient size for this same continuous reverie, this romantic serial story without sequence. Neither did I, when reading, "curl up with a book" like all "dreamy children," but sat at my small wooden desk in a corner of the nursery by the window; and while I read, I fidgeted splinters of wood out of the desk with a penknife, or drew restless futile patterns all over the margin of the book, while attention wandered again into curves and twists and arabesques of the same queer tiresome reverie.

Tiresome, because it was obviously a hanging of sentimental over-excited stuff that imagination interposed to prevent me for many years from getting a clear sight of reality.

Gordon of Khartoum came into it, dressed in white, as he was in a picture which they had brought into my nursery and pinned on the wall at about the time of a battle called Omdurman, when I was eight. "Chinese" Gordon, they called him, which I connected with his clothes and the tube of Chinese white in my paintbox. They said he was already dead; had fallen bravely and alone at Khartoum, years before; and that now he was "avenged." A word that my reverie grabbed in a moment.

Dreyfus was another figure, less picturesque yet more tenacious, who worked in and out of my reverie. Curious that the Dreyfus case should have made such an impression on any child's mind; although of course it was always being furi-

ously discussed, especially in our pro-Dreyfus family where one of the elderly Rakonitz cousins, a fat man with a white fringe beard, was a Frenchman and a friend of Esterhazy, the villain of the piece.

When the Boer War broke out, we had our revenge on this same cousin, for he resembled Kruger closely enough that he could be linked up with all the obloquy and ridicule connected with Oom Paul.

But it was not the political side of the Dreyfus case which made an impression on me, but pictures seen in an illustrated journal we took in weekly: "Black and White." Some element of passionate unfairness about the story; a few lines read and remembered, that they had knocked off his glasses while dragging him to a place called "Devil's Island," and would not let him stop to pick them up and put them on again. How did he manage without, I wondered, all that time?

Why, when the whole world was babbling and angry and exploding on the subject, I should have kept my burning interest a secret, and flushed scarlet if ever the case were mentioned in my hearing, I cannot tell. Even now, I am self-conscious at any mention of Dreyfus, and went alone to see the film. I can write of it, but with reluctance; I could not talk of it. Only two years ago, I chanced, at a luncheon-party, to meet the lady who had married Maître Labori . . . and at once I saw in front of me again a full-page illustration from a long-ago "Black and White"; a man with a pointed white beard lying wounded on the steps of some official building: Maître Labori had been Dreyfus' counsel, and they had fired at him. I even remembered that it had been necessary to twist the paper round because they had printed the picture horizontally, to get the wider space. The lady must have found me curiously

unresponsive, if she had thought about me at all; she could not have guessed that for me she stood in no ordinary light, but partly englamoured by far-off rays of heroism; partly dimmed by old shadows of fear and desolation.

Dreyfus. So there was an island called Devil's Island. A real place. And any one, at any moment, could be dragged off to it. Even if you had not done anything. Even though everybody, except your horrid old beast of a French cousin, argued that it was a shame.

They said he would never come back alive. They said his hair had turned quite white.

PART TWO

The Cows Come Home

Part Two

THE COWS COME HOME

T HIS bit of the Grand Canyon I occasionally use as a letter-weight.

The statement sounds more impressive than it is. I did not, wandering about the Grand Canyon by myself, carelessly shatter off a bit and bring it home; I bought it for twenty-five cents at the little store up there, while I was buying Indian moccasins for every one in London and a Mexican silver coin for a numismatic godson.

At the present moment, renting a little villa in the South of France, I have in my service a temporary butler-chauffeur-valet-de-chambre-maître-d'hôtel who enjoys a superiority complex. Sitting by my side, in his little mauve Citroën, he admonishes me in long tirades, with the same solid conviction of uttering what was wholly new now but would presently become the Law, as Moses issuing the Commandments. First he pronounces his theme, such as: the Jealousy is the Most Profound of all the Human Emotions. Then he expands it: The badness of the *Nature Humaine,* is, he says, because *les gens* are moved by jealousy and do not sufficiently control it. At the bottom, he says, the *Nature Humaine* is pretty bloody awful. In all such generalisations he succeeds remarkably in disassociating himself from any connection with the *Nature Humaine.*

I do not know who he thinks he is, while he talks in

this strain. I never know who people with a superiority complex (suc) think they are. They interest me enormously. Psychology has dealt so thoroughly with the inferiority complex (ic) that by now even the most unprofessional among us can recognise the more common type on sight and say "heil," or taM htaB; the latter greeting the more appropriate, for an inferiority complex makes bathmats of us all. We realise that it displays itself in obvious agonies of truculence, rudeness, shyness, showing-off, can't-get-on-with-your-rich-uncle, and falling downstairs.

But a suc has been less faithfully investigated. Self-satisfaction remains mysterious. What is the perpetual mental condition of a man or woman with a suc? They do not boast nor throw their weight about; no, no, that is an ic again, functioning as it best knows how, to obtain relief from torture. A person with a suc, like Hippolyte, is never wrong; and even when proved wrong, is still never wrong. They do not have to be reassured, these people. You can distinguish them by their outward state of calm complacence. They do not have to wrap themselves up, shivering, in blankets of self-preservation; they are maintained without conscious effort; they can walk about the world naked, because their skin suffices; and when they utter profound platitudes like *"Les gens sont méchants"* or *"il faut que les gens———"* or *"La nature humaine est mauvaise———"* it does not occur to them that they share in the disabilities or fundamental baseness of *les gens* or *la nature humaine*.

Their souls are a magic onion that can be peeled and peeled, and still you arrive no nearer to the centre. They are completely maddening and perpetually enviable.

I would not interrupt Hippolyte on jealousy, for the world. After he has quite finished, mopped up *la jalousie*, and placed it for all time on the map—or off it—as some-

thing profoundly, unalterably painful to those unfortunates who have not Hippolyte's capacity to deal with these clawing passions, I shall have to lift him and place him on the word "snobbery," and let him browse there for a while, making the large shapeless sounds of cows moving unseen in a field beyond the hedge. When he has chewed enough cud, I will ask him if he does not think *"le snobbisme est la plus basse émotion de la nature humaine,"* just as *"la jalousie est la plus profonde?"* Should he have nothing much to say on the subject of *le snobbisme*, I will deliver all that I have to say, some of it of local interest: "Not one of us, Hippolyte, is wholly free from *le snobbisme*, Hippolyte, but we all condemn in others what we would despise in ourselves had we the honesty to admit it. Reflect, Hippolyte," I would say, "reflect further on the fact that your little motor-car is painted a cheerful light bright violet colour, decorated with black circles and silver horseshoes, and that I, who am making the economy this summer and at the same time do not like to walk, must submit to seeing it thrust its winsome bonnet amongst groups of large sombre Voisins and Lancias and Hispanos belonging to all my well-bred friends round here, whenever you deliver me at a party. An excellent snub to snobbery, Hippolyte, this little car of yours, painted such a pretty colour. I will be the better for it all my life."

There are many other departments of snobbery: the wine-list species, for instance. Can you think that it brushes my self-esteem with no velvety gratification, when at a good restaurant I run my eye down the names of Bordeaux, Burgundy, Rhine wine and Moselles, to be able to pick out a wine, pick out a good Clos or Château, pick out a subtle vintage by name and year, and discuss it with the *sommelier?*

And then there is the snobbery of crime; a perverse bye-path. Crime snobs remark carelessly: "When I was lunching

with Landru yesterday——" or "Have a cigarette? Patrick
Mahon recommended this brand to me——" or "Funny
little gunmetal cigarette-case, isn't it? Crippen's last words
to the chaplain were 'Give my case to Eric Saunders. I
want *him* to have it.' "

The subject of snobbery, Hippolyte, is endless. Clothes
snobbery. Do you go to Schiaparelli? I did, once.
Twice.

And inverted snobbery—but that would take too long to
explain to you. And I suspect that when I had quite fin-
ished, you would respectfully un-invert it again and put
me right on the whole matter, and I should be helpless
and very fatigued at the end of it.

Inverted intellectual snobbery; that, my Hippolyte, is
what we are practising when we assert that we can read
Mr. Fortune and P. G. Wodehouse, but not, my God, "The
Waves," or "Anden's Poems" or "Rasselas" or "Relation of the
Ego to the Unconscious." When that statement happens to
be true, as in my own case, it becomes increasingly difficult
to impress it with simple convincing sincerity. "Snob!"
say my friends, and spit and walk away.

A funny spasm of insidious snobbery once seized me in
an old country house where everything was in perfect taste,
when I caught myself involuntarily admiring peacock's
feathers in a vase; feathers from their own proud terrace
peacocks; yet the same feathers that I should have condemned
had I met them in any landlady's parlour, mixed up with
the dingy white lace curtains, the wedding-groups on the
walls, the Monarch of the Glen and the aspidistra.

But travel snobbery is the most difficult to overcome.

Many millions of people must have visited the Grand
Canyon; it requires neither great brains nor great courage
nor great originality. Yet I like to hold in the palm of my

hand this claret-coloured lump of shiny petrified wood; and concealing the price still scribbled on it (my mentioning the price at all, Hippolyte, is a good example of the inverted snobbery I was trying to tell you about just now) remark nonchalantly: "Yes, I picked this up at the Grand Canyon. You ought to go there, it's a fine sight. I went with a Mexican guide; a great fellow from a log house in the Harvey Company's community, where the Single Boys live."

"Where the Single Boys live" had a dashing sound, as he drawled it out. He was satisfied without being complacent; and his manner and poise were wonderful. But manner and poise can undoubtedly be assisted by excellent old riding-breeches with some very good mends in them, riding boots, a red jacket, a broad-brimmed hat with studded silver buttons on the belt around it, and a shirt with a studded ornamental silver band round the throat. He loved his work and was proud of Arizona. We sat quietly on a rock on Hopi Point, and after a while he volunteered the thoughtful remark that he never grew tired of sitting there and watching the canyon change under the clouds. I did not know he was listening when I said to my companion, presently: "Let's go home. If I see any more now, I shan't have seen anything at all," but he looked up and said: "And that's true, too," in a way that showed he understood.

The Colorado River was no more than a little yellow sash, looking down on it from where we stood. There were three vultures hovering over Bright Angel canyon. Vultures must have been told that they look sinister; by Prometheus, perhaps; for I swear they take pride and pleasure in it.

"Yes, you ought to go, some time. Mention my name at the El Tovar and you'll be well looked after." And if they do mention me at the El Tovar and are well looked after,

that's grand. They would most probably have been well looked after, in any case, but never mind that. If they do mention me and are not well looked after (which is improbable), I may never see them again. And if they never go to the El Tovar at all, they will remain with the impression all their lives, that if they *had* gone there and mentioned my name, they *would* have been well looked after.

I am perfectly well aware that one must not describe the Grand Canyon, not even casually. Nevertheless, the most normal way of all literary flesh would be to continue for several rolling pages, from the first sonorous phrase: "Who can describe the majesty——" (Saki would then have said, politely, as in one of his stories, "Thank you all the same for describing it!")

To wallow in travel snobbery, one needs no competition. It spoils the flavour if somebody present has been there too. Strolling home along the sea-road to my villa the other night, and noticing the green lamp above the two rounded Provençal arches that led up to the porch and front door, there was nothing in the world to prevent me from saying: "Doesn't that remind you of the station at Albuquerque at night, when The Chief waits for half an hour so that you can get down on the platform and buy the carpets from terribly obvious Indians squatting under the arches?" Nothing to prevent me from flinging it out, just like that, except that my companion said it first; she too had been through Albuquerque. And we remembered, simultaneously, the extra bit I had been saving as a postscript: that that had also been where trout were handed up to the train, caught in the Rio Grande, so that we might have them grilled for breakfast the next morning.

If you would nurse your travel snobbery, do not buy a globe; it might suggest humility by the vast spread of land

and water which you have not yet visited. They show up with less tact on the curve than on a flat surface.

I realised this when a certain brisk, wiry little lady whom I had not seen for seven years, and whom I remembered most clearly for her almost disproportionate affection for wearing green silk stockings, sat in the armchair opposite me, and told me where she had been since we last met. Gradually my expression of benevolent interest must have changed, as I grew conscious of an uncomfortable inferiority. She had "done," she told me chattily, Ceylon, Tahiti, Australia, New Zealand, the Fijis. The Fijis, apparently, were quite a nice family when you got to know them. Then she had had to come home, but directly she could manage to save enough, she intended to start where she had left off (I am using her own phrases) and work round by South Africa, across America, Japan, China and then Ceylon once more. I wondered what it felt like to be able to say "once more" about Ceylon, as though it were, for instance, Brighton. And so home, she said, completing the other half of the world. "And then," she said, "I'll have got *that* off my chest."

And I thought of my own chest, and how very, very little I had got off it. I thought of nearly everybody's chest . . . Tahiti and the Fijis were on my chest, and China and Japan, Ceylon and New Zealand and the South Seas. Mexico and Brazil. Most of the world, in fact. It was an ironic coincidence that behind the armchair in which she sat, was the shadowed silver-green sphere of the slanted globe which I had bought with some pride, at a small antique shop in the depths of Suffolk. Yes, I owned the globe, but she had got it off her chest. And here, puckered behind this normal British exterior—normal save for its passion for wearing green silk stockings—was a splinter of that spirit which had sent Hakluyt and Raleigh to Virginia, Scott to

the Antarctic. The English name for it is *Wanderlust*, restless, incurable. It was not to show off as a yarning Ulysses among her friends, that she had set forth; for the only traveller's tale that I heard from her was that she had bought a grass skirt in Fiji, and won second prize wearing it at the fancy-dress ball on the steamer coming home. Nor was it enjoyment of the voyage, for she was often sea-sick, and we know what fun that is. Nor had she the faintest desire to identify herself with the scenes and peoples whom she visited. It is enough for these quiet shrewd little English travellers to loiter, to look on, to be neither seen nor heard.

No, "I'll have got all *that* off my chest," gave me the clue; and her sigh of relief for a chest partially relieved of its tiresome insistent burden. Over, now, the agony of pre-voyage apprehension, while you combat the warnings of friends and relations; the possibility of disillusion; the hoist out of habit and indolence towards effort and toil. It was done, and here was the best part: satisfaction, retrospection. Anticipation is the thief of a good time, for it nibbles away the edges. When I was a child, I remember an advertisement for chocolate in which a small boy went through the five stages from "anticipation" to "retrospection"; and I used to think his pleasure in "retrospection" was overdone; surely there was nothing but misery when the chocolate was finished.

That was a peculiarly infantile view of life.

It is a temptation to those of us who are timid, lazy or sentimental, to return always to the same place, where we have made a dent, and the dent has deepened to a groove; where we greet with enthusiasm the left-hand drawer of the dressing-table which sticks a bit at first but it is where we always have put our handkerchiefs and always will. Nothing much can hurt us, where all is so familiar. But out

there, across the spaces of dim green patina on my old-fashioned globe, anything might happen. Remember mosquitoes, and typhoid germs in the water, and barbaric lawlessness, and not knowing the language nor the time the post goes out in the jungle. Better bring your globe into the sitting-room; better lie back in an armchair and read a book of travel.

It is easy to forget the thousand strange and shining places that we shall never see; too easy, however much we sentimentalise them by repeating, in that peculiarly wistful soul-sick chant which we reserve for the quoting of just that sort of *Sehnsucht* in poetry:

> *Chimborazo, Cotopaxi*
> *Have stolen my heart away. . . .*

"*Je n'ai jamais vu Carcassonne*" is the refrain of a ballad in the same tradition. Over and over again, the refrain occurs. But did the old Frenchman ever *do* anything about going to Carcassonne? Save up? Make inquiries as to routes? No, he was like the rest of us. We yearn a bit, read a poem or two, ask for the latest travel book at the library, buy a globe, go and see Niagara vicariously at the Narcotic Picture Palace, and quiet our restless nerves by the impudent assertion, then, that we have *seen* Niagara. "All right, child, South Carolina won't run away," is the sort of answer with which Nannie used to soothe our impatience. Nannie is to blame for a dangerous delusion; South Carolina is running away all the time, with every year we fail to go there; simply haring along for all it's worth.

A certain old man in the Antipodes collects autographs, and has written to me two or three times; extremely polite letters, but always ending with a phrase which I am sure is designed to appeal to my sense of travel snobbery: "If

you can spare the time," he says, "a few lines would give
great pleasure to an old man as far away as New Zealand."
I was quite touched at the thought of how far away he
was, until my secretary reminded me that I was just as far
away myself, counting from New Zealand.

One of my other paper-weights, looking like a bit of
the mosaic floor of San Marco cathedral, was given by my
father to my mother when they were on their honeymoon
in Venice. She was deliciously gay and pretty, and had not
been told that men-were-like-that. Her husband, eleven
years her senior, was terribly in love. They were lodged in
a Palazzo. The month was January. Early in the proceed-
ings he had to leave her and walk shivering along a labyrinth
of stone passages and corridors to a lavatory at the other
end of the palace. When he returned, the door was bolted
against him. She thought she was bolting it against a mad-
man. It took him nearly an hour to persuade her to re-
admit him. We wore, then, not warm pyjamas, but cotton
nightshirts, loosely flapping, with a strip of red embroidery
round the edge. Our honeymoons were more thrilling then,
than they are now.

In those days, you could throw your weight about, when
you had been to Venice. Now, when aeroplanes are tripping
over each other's records and beating their own records if
they have nobody else's handy, it is going to be difficult to
find any place far enough to "count," reckoned by snob-
bery. The world being round, by the time we have gone
what seems to be far enough to count, we shall already be
half way back.

Yet it is not wholly a matter of distances. The old French
peasant who repeated so often and so plaintively (or was
it with rising exasperation?) "Je n'ai jamais *vu* Carcas-
sonne," "Je n'ai *jamais* vu Carcassonne," probably dwelt no

more than 200 kilometres away at Aigues-Mortes, but had been maddened all his life by various local Hippolytes living in the same village, or at Aix-en-Provence, or at San Rémy; who said to him: "Parbleu, tu n'as pas vu Carcassonne, toi? Et b'en, tu dois y aller. C'est b'en joli. C'est loin, mais enfin, ça vaut la peine!"

Half way across the Piazza San Marco in the shattering splintering brilliance of the noonday summer sun, I suddenly sat down. Not many people can have sat down just there. How it happened I shall never understand. I had had a cocktail, only my second experience of a cocktail, at Florian: "Now let's go home," and then, just where there was nothing substantial to hold on to, nothing near but wheeling fluttering pigeons, that cocktail shot like a divided arrow down into my legs and made them incapable of carrying me. When friends try to improve my mind by sending me picture postcards innocently showing the exact spot where I sank to rest, I wish they would make an *œuf à la coq* of their heads.

My first cocktail was approached, carefully, when I was sixteen, on the lawn of Skindles at Maidenhead; a dashing occasion. While I sipped it and reflected what a dog I was, I did not remember, because vanity dismisses such correction, how I had been brought down to Maidenhead when I was only three weeks old, because father and mother loved it so, and they had taken a houseboat for the season (Yes, they had got over the Venice episode by then). And I cried for three days and three nights without stopping; it must have been lovely to hear me, by the rippling light of the moon stippling the black water. Moonlight was moonlight, in those days; ten years later it began to sag, when the coons got hold of it. It began to lag, to drag, to nag;

conforming to all the rhyming verbs and adjectives that convey a sort of weary giving at the knees of your self-respect. That ragged, partly debaggéd race of coons, represented glamour to my generation. That plantation glamour, that Nigger Heaven, that cake-walk cheerfulness, that Water-boy melancholy, is over Europe still.

In the middle of the third night, father, not able to bear my wails for one moment longer, sent for the doctor, who drove down in his gig as far as the opposite bank; but unwilling to be rowed over, stood on the towing-path, made a trumpet of his hands and bawled across: "Boil the milk twice!" and rapidly drove away again, the sound of his trotting horse growing fainter. They boiled the milk twice, and I never cried again. Naturally, when I go to Maiden-head now, I still make the most meticulous inquiries of my host or hostess as to how often they have boiled the milk which they put in my tea or coffee.

Of river snobbery, there is no end. To be in a skiff when every one else is in a punt; to be in a broad-bottomed punt when every one else is in a racing punt of about the length and width and pace of a single ski; to be in an old steam-launch when every one else is in little electric canoes; to be in a swaying crowd of river traffic, on a fine Ascot Sunday morning just above Boulter's Lock, and in a family party instead of alone or with one other casual elegant person; to be with a man who wears, not exactly black waist-coat and braces, because that would be a horrible exaggeration beyond possibility, but in something subtly approximating to a black waistcoat and braces; to be with some one with too many picnic baskets and too little experience, who gets his skiff broadside on, blocking the way, as the gates open and the whole interlocking jigsaw of brilliant swaying traffic begins to crack up and separate and move, the

lock-keeper calls from the bridge: "Six launches in first, there. Keep your boat *back,* sir, keep your boat BACK, sir, keep your boat . . ." (Yes, yours.)

A "truth" game, recently popular because like all other truth games it was personal and dangerous, presented you with a selection of three men (or, if you were a man yourself, of three women) whom you knew and whom the rest of the company knew. You were then asked: "If you had to marry one of these, go round the world with another, and spend a week-end with a third, which would you do which with?" So that it should not be too easy (I mean, so that you should not immediately allot the shortest period, the week-end, to the most repulsive) this modification in the rules was added: that the week-end would have to be intimate in every sense of the word, whereas round-the-world need be only platonic. An interesting, embarrassing game. For if you played it with passionate sincerity, it told you things about your own first swift secret reactions which amounted to revelation.

But always and always, and whichever man you chose for the week-end, and whichever man you chose as a companion to go round the world, the man-of-the-world among the three offered will be the one you choose for marriage.

You would select him for one special quality; this precious quality of sophistication.

There is a false and a true sophistication; the quality cannot be dismissed as a suave superficial lacquering; as a veneer only; or worse than veneer, as knowingness. A man of the world, if you are paddling in the shallows of the phrase, will certainly be "knowing"; knowing about ships and ports and restaurants and head waiters; able to manipulate a difficult situation. A man of the world will know what to wear, always. And he will not be taken in by the Confidence

Trick. He has, in fact, what the French call "savoir faire": the know-what-to-do. These are all pleasant qualities, but true sophistication penetrates full five fathoms deeper.

A true man of the world will use his imagination, but he will use it as a matter of course and without sentimentality. Sentimentality is presenting a situation to yourself or to others, deliberately doctored to make it seem more endearing, more poignant, more ironic, more touching than life ought to be, even in a skilfully constructed play. Because he is a man of the world, in the literal sense, he will be kind; he will put shy persons at their ease, not from *savoir faire*, but from this very kindness which is the most thrilling of all human qualities. Kindness has too often been confused with mildness; the two have very little in common. And kindness *is* thrilling, however loudly you may exclaim at seeing the words linked; because you cannot be deeply kind unless you do so with authority, and you can do nothing from authority unless you are experienced; in fact, unless you have been pulled through a hedge backwards; and not one hedge, but many hedges; emotionally, almost all hedges. A true man of the world, therefore, cannot possibly be lordly or conceited. After so much pain, disillusion and self-discovery, he will know a damn sight too much ever to be lordly again except on one or two occasions when nothing else but lordliness will save the situation. And then he uses it to some effect. But for everyday use, a matter-of-course imagination will serve him.

If marriage is not to prove a visible disaster, or a mere cantankerous compromise, two people will have to show tireless, vigilant courtesy; and when it is broken, as broken it must be over and over again, they will have to show tireless inspiration in whatever gesture is required to start off once more. You cannot get this sort of collaboration except from a man of the world.

The obvious idea of a sophisticated man is that he will have committed many glamorous sins. False sophistication again. It may or may not be true of the real man of the world that he has committed sins, but it is bound to be true that he has committed mistakes, frequent mistakes, mistakes with terrible consequences, consequences perhaps that he endured badly. There is nothing like bearing a thing badly in full sight of everybody, to enable you to bear it a trifle better next time; and be compassionate when somebody else is bearing it badly, the time after that.

He will be an epicure, but will know, however, when to give way and not insist. As a child, his Nanny will have said to him: "There's a Master Particular," and "Nothing's good enough!" little realising that "Nothing's good enough" promised more for his future than "Everything's good enough." The man who is hard to please is socially and domestically valuable, for he prevents standards of service and efficiency from trailing and slipping and loosening into a state of slack inefficiency; risking unpopularity no less than perpetual accusations of arrogance and conceit. The man who is hard to please will never be as popular as your sham genial man of the world, but by the few he will be idolised. They will recognise that he has a wheat-and-chaff mind, a fastidious mind. And a man who is kind, balanced, austere and fastidious, is the very salt of the earth.

There must be delicate virtue in being fastidious; fastidious, not cantankerous; it reaches right down to integrity, which is the final virtue. Jane Austen called it "nice":

" ' . . . But now, really, do you not think "Udolpho" the nicest book in the world?'

" 'The nicest; by which I suppose you mean the neatest. That must depend upon the binding.'

" 'Henry,' said Miss Tilney, 'you are very impertinent. Miss Morland, he is treating you exactly as he does his sis-

ter. He is for ever finding fault with me for some incorrectness of language, and now he is taking the same liberty with you. The word "nicest," as you used it, did not suit him; and you had better change it as soon as you can, or we shall be overpowered with Johnson and Blair all the rest of the way.'

" 'I am sure,' cried Catherine, 'I did not mean to say anything wrong; but it *is* a very nice book and why should I not call it so?'

" 'Very true,' said Henry, 'and this is a very nice day; and we are taking a very nice walk; and you are two very nice young ladies. Oh! it is a very nice word, indeed! It does for everything. Originally, perhaps, it was applied only to express neatness, propriety, delicacy, or refinement; people were nice in their dress, in their sentiments, or their choice. But now every condemnation on every subject is comprised in that one word.' "

JANE AUSTEN was one subject casually handed out to me when I was once asked to contribute two sections to an encyclopædia. Because I have the same terrific respect for research and erudition as I have for men of science or for pro-consuls, I was certain that I was a thoroughly incompetent choice for such a job; but that if I could somehow or other manage the authorship of those reticent unamusing-looking columns, I should be prouder of the achievement than of any witty fiction or coloured descriptions. Jane Austen was, of course, pure jam. The other was: "The Fabulists." In my innocence I thought The Fabulists were Æsop and La Fontaine. Æsop and La Fontaine could be polished off, I thought, in an essay of four or five clever pages.

Slowly I went searching and researching. I discovered that the section called "The Fabulists" would be expected

PART THREE
A Pound of Feathers

to contain no less than all mythology and legend, folk-lore and fairy-tale. I went researching a little further, arrogant in my metaphorical seven-league boots; in the look of my desk with weighty volumes spread out upon it to support me while I enriched the cause of learning with solid substance (magnificently ignorant that "The Golden Bough" had already been written).

Suddenly I became aware of one of those weaving interlocking linking-up patterns-in-invisible-ink that give one a queer incredulous thrill and then an obscure mental satisfaction comparable to no other: I became aware that the reason why certain fables recur insistently through mythology and history, at all periods and for all races, is that a certain King Charles's Head is common to all mankind. And the perfect function of fable is to assure and reassure the underdog, by safe and easy symbol, not only that he is as good a dog as his oppressor, but that a Time Will Come.

In Europe, in the Middle Ages, the jongleur, the troubadour, the minstrel, all fabulists, were created by the desperate need of the people to solace their misery by faith in the ultimate triumph of the quick, clever, common little fellow over Princes, Barons and Bishops. Hence the legend, Greek, Arab, Scandinavian, Russian, Redskin and Chinese, of Jack the Giant-killer. Hence the fable of Renard the Fox; the little fellow, by using his wits, not always scrupulously, gets the better of his big blundering oppressor. The Roncesvalles legend, that Roland is not really dead for his horn can still be heard echoing up the valley whenever his nation is in distress, belongs to another "reassurance" group of fable. He-is-not-really-dead is a protest that raises itself so often and so persistently against the final extinction of a hero that it would seem acceptance of death for a hero is another of mankind's obsessions; a King Charles's Head as

persistent as fear; that, and the desperate need to be told
that a Time Will Come.

Theseus; King Arthur; Friedrich Barbarossa; Roland;
Charlemagne; Napoleon; Kitchener. He-is-not-really-dead.
The common people will accept death for themselves, for
their brother, their wife, their child; not for their leader;
not for the superman. Something is fundamentally wrong,
they think, if a leader can die as easily as any one else. So
the fabulist, the jongleur, the troubadour, the grandmother
in the inglenook, fulfilling their function, soothe this alarm;
give it pictorial shape and a hope to look forward to. They
take the responsibility of saying that Theseus has been seen,
a gigantic shadowy figure, fighting, stalking with his club
at the head of the armies at Marathon; Barbarossa, though
still heavily asleep in a cavern under his castle, will wake at
the hour of need; Roland's horn will be wound again;
Napoleon?—

> Longtemps aucun ne l'a cru.
> On a dit: Il va paraître,
> Par mer il est accouru,
> L'étranger va voir son maître.

As for Kitchener, he is not really dead, he was not drowned,
he has been seen—in China. When England's distress is at
its sorest, he will return.

So fable and folk-lore and fairy-tale equip endurance for
yet another day, another decade. Then brave little Jack will
slay the Giant, and quick little Renard elude the Big Wolf.
Then Theseus, Friedrich, King Arthur, Roland, Napoleon,
Kitchener will rise up and show they are still alive.

I think that I advanced several more theories in my article
on Fabulists, none of them very profound, but sounding so
educated that I could hardly believe that any one as near

home, so to speak, as myself, could possibly have elucidated
them. The article commissioned was to be about fourteen
thousand words. I suppose I wrote fifty thousand. Three
thousand were printed. And even these three thousand are
lost, for I cannot remember the name of this particular en-
cyclopædia; nor do I possess a copy of the MS., for I went
to live in Italy shortly after I had handed it in, and destroyed
all unnecessary papers. The editor, Sidney Dark, when ap-
proached in a friendly way at luncheon the other day, roared
with laughter and could not recollect what I was talking
about, though he certainly said: "I hope you were paid?"
"Oh yes, thank you, I was paid." And somewhere or no-
where can be found this anonymous contribution of mine
to the sum of all knowledge and theory, for which I shall
get no personal credit whatever, which is right and as it
should be.

My contribution to the Jane Austen bibliography is the
conclusion, reached link by link, that the one great love
of her life was not, as generally believed, an unknown gentle-
man who died in 1801. This is how my chain is linked; and
she must forgive me if I am impertinent:
All biographies, chronicles, comments and letters surround-
ing Jane, mention her deep attachment to her elder sister,
her only sister. In every one of her six books we can read
Jane's own tribute to this happy companionship; she limns
a Cassandra quieter, more controlled, more deeply sensible
than herself, tenderly deprecating the giddier heedless im-
pulses of a mischievous impenitent younger sister. Elinor
with Marianne, Isabel with Emma, Fanny with Susan, Elinor
Tilney (if not sister, sister-in-law-to-be) with Catherine
Morland; beyond all the rest, Jane Bennett in relation with
Elizabeth. Whereas Elinor, Anne, Fanny, Jane and so forth

seem Jane Austen's ideal and wish-fulfilment, her Cassandra; and Elizabeth and Emma and Catherine depict (unaware of how enchanting they are) various phases of herself, Marianne is her burlesque of her very young self; her fear of what she might have been; perhaps her hope that by so exaggerating chumpery and holding it up for herself to see, she was for ever minimising the danger. It is significant that she saw no danger in priggery, which must therefore have been so far from her that she never ceased presenting it as a quality for our pure admiration.

Here, in these many intimate portraits of Cassandra and herself, is a strong suggestion that where Jane Austen's emotions were personally involved, she would not (or could not) keep them out of her writing, even should they prove of even more emotional importance than her feelings towards her own sister. So that if her one passionate attachment to a man had been, as generally believed, the same that ended, after a brief acquaintance, with his death, it is unlikely that when her nine years' strange silence, nine years of mourning, perhaps, came to an end, and she had to write again, it is unlikely that in none of her subsequent stories should she have dwelt on the experience of suffering bitter loss by death.

Yet though none of the Jane Austen lovers die to leave the other of the pair broken and desolate, there is, as with the two sisters' theme, an ever-recurring motif of what we conjecture was now most persistent in her mind: her King Charles's Head which thrusts itself up over and over again. As there could be as yet no such word as "camouflage" in her dictionary, so there was no camouflage in her soul: Emma loved Knightley and feared he might be in love with Harriett Smith; Fanny loved Edmund, who was infatuated with Mary Crawford; Wentworth had once loved Anne, but she had to watch him absorbed in Louisa Musgrove. The three couples endure a long separation; misun-

derstanding; alienation; hope almost gone. He cared for some one else; he believed she did not care for him, so he went away and kept away. Always written from the agonised point of view of Emma, Fanny and Anne. But in the last chapters of each of these books, she flings the couples into the ecstasy of a radiant reunion, all longing fulfilled, all suspense suddenly at an end. Flings them? flings *herself*. It is easy to bend aside the decorum and good taste of her sentences, to look beyond those brittle palings, at her single-minded passionate desire that thus her own story might end; thus perhaps, and still, perhaps, might it happen to herself at any moment; thus (for reverie cannot be checked at will) he might come back to her, in this manner or in that manner, a radiant reunion, longing and suspense at an end.

For relief is indeed, at its zenith, the strongest, the most glorious of all happy emotions; stronger even than love, though love is contained within it; for it lies more sharply against the contrast of the despair and suspense which has gone before. Relief is a long cold drink when you have been racked with thirst and have believed that there will be no end to your thirst. Relief is after the nightmare of thinking that a friend has betrayed you, when comes the discovery that the report was a lie. Relief is hearing the expected letter flop heavily on to the hall mat, when your nerves are frayed to pieces with waiting and you have given yourself a hundred reasons why that letter will never come. Relief is the gleam of light through the shutters of your window, when you lie there suffocating, sweating in the dark, thinking you have gone blind. Relief is when Knightley returns to Emma, Edmund to Fanny, Wentworth to Anne.

Relief is Jane Austen's man returning to Jane after long estrangement.

Only he never did.

In "Persuasion," Jane Austen finally betrays how her heart craves for such relief; those last chapters seem to me the most heart-rending, the most gorgeous burst of wish-fulfilment ever materialised on to paper. So I can only believe that the unknown gentleman who died was a minor attachment wistfully rounded off; he was not the great love in her life. Did Edmund simply catch cold and die? or Knightley? or Wentworth?

No, Wentworth came back, having loved Anne all along.

After *nine* years, he came back. And *nine* years Jane Austen spent without writing. Is this wholly coincidence? Nine years—("Conjecture! aye, sometimes one conjectures right, and sometimes one conjectures wrong. I wish I could conjecture how soon I shall make this rivet quite firm")— of separation, misunderstanding, alienation, hope almost gone. These things are worse than death; they are not wistfully rounded off; they have torn and jagged edges.

After these nine years, she wrote her own story of waiting. Wrote it three times over, because he was still alive and yet hope was quite gone that he would ever return to her. And the third time, the most poignant, her own reverie dictated exactly how Wentworth came back to Anne. The happy scenes of his return to her were laid in Bath. In 1801, Jane went with her family to live at Bath. Say that in the real story, both the encounter and the parting happened there. Would it not be the natural way of reverie to imagine and stage and finally materialise a reunion in the actual place where it might happen at any moment, though the present was all blankness and loss?

Jane, poor Jane. How can we believe, after reading "Persuasion," even though fiction is such a confused adulterated version of pure truth, that Jane lost the man she loved, only by death?

Proofs? I have none. Let us say that Cassandra burnt them, after Jane's death. For granted that the elder sister felt it unseemly that personal letters should be read by the prying world, in that case, why leave so many unburnt? All were intimate, for intimacy was Jane's subtle magic. Why not burn them all? Yet though it is established that she burnt some, two large volumes of them remain. I think, then, that Cassandra only destroyed those or the portions of those that would have told us what we shall never know. The stable door was securely locked before the horse was stolen. No one has seen the colour of that horse. In Chapman's edition of the Jane Austen letters to Cassandra, there are none extant between 1801 and 1809, but Cassandra was probably with her during most of this time.

Her three novels of the earlier period, "Northanger Abbey," "Sense and Sensibility" and "Pride and Prejudice," have the same happy ending, relief after suspense, as the later three; only less intensely marking the agony of having actually believed him in love with another woman. Whereby those of us who are writers will be reminded of how strangely one invents situations that persist in rising from nowhere as though they foreshadowed some special significance for us. A significance that only later on crystallises into personal destiny. So her books stand like sentinels, three before and three after the event, and all Jane's life between them.

We call her Jane. Miss Austen is one of the few authors I can think of who has no self-consciousness about her Christian name. Rarely does an author choose her own name for any of her characters. A light taboo lies on it. We hear our own names used all day long; they were often the first sound to reach us on waking in the morning, though linked to the sinister words: "Get up!" So if we pick up a work of fiction, and opening it, see this name of ours familiarly

strewn about the page combined with unfamiliar appearances and situations, embarrassment assails us. It has the shock of a slight physical encounter.

How much less, then, are we likely ourselves to select this item of personal property for a heroine, when there are so many thousands of other names. But Jane, so over-whelmingly "Jane" to us, "Jane" uncontested (though there has been a Lady Jane Grey and a Jane Seymour, a Jane Shore and a Jane Carlyle in the chronicles of England), Jane herself can hardly have cared what she was called; so free was she from foolish consciousness that she bestowed her name on two of her characters, Jane Bennett and Jane Fairfax, where she allied it over and over again with the adjective "beautiful." "Oh! my dear, dear Jane . . . I was sure you could not be so beautiful for nothing!"

Her range among names was tethered: Jane, Mary, Anne, Elizabeth, Fanny, over and over again; Emma, Elinor and Eleanor; Catherine, now and then Charlotte, Isabel, Susan or Harriett. Once, only once, Marianne.

How peculiar, then, that having a sister Cassandra and a mother Cassandra, that she should have been, perhaps, sensitive in the region of names for them and not for her-self. Not a Cassandra to be found in all Jane Austen. An-other oddity, though trifling, betrayed that Jane Austen did not, like most of us, feel that a name once attached to a character, bit itself in and could not carelessly be detached and flung later on to quite a different personality. She took off these labels and flung them round another neck as easily as though they were the "Whisky" or "Brandy" on the detachable tabs that hang round decanters. Elizabeth Ben-nett, the most adorable of her creations, had presently to lend her name to Elizabeth Elliot, proud, dense, unfeeling, humourless. Fanny Price is her favourite among her heroines;

yet she had already used the name Fanny for a mean greedy shrew, in "Sense and Sensibility."

" 'The Miss Musgrove that all this has been happening to. Her Christian name: I always forget her Christian name.'

"Anne had been ashamed to appear to comprehend so soon as she really did; but now she could safely suggest the name of 'Louisa.'

" 'Ay, ay, Miss Louisa Musgrove, that is the name. I wish young ladies had not such a number of fine Christian names. I should never be out if they were all Sophys, or something of that sort.' "

So said Admiral Croft, in "Persuasion." Louisa does not seem to us an especially "grand" name, now. "Ouida" which was Louisa de la Ramée's way of pronouncing her name when she was a baby, sounds, perhaps by association, curiously grander and more romantic.

Delusions of grandeur may, apparently, be untethered when you come to name your dog, and you will not be mocked for it. Recently I came across the pedigree of an Alsatian bitch I had had. Her sire was called Hadley Erich; that was simple enough, and her dam, Lotus. But her grandparents had nobler names; Champion Erichsohn von Starkenmark, and her great-grandmother, Cilly von Tummelplatz; they sound arrogant and melancholy as though they had stepped out of one of those novels of German castles and the Rhine, of barons, demons and bleak winds howling through the Black Forest; a tradition of diabolism so much to the taste of maidens like Emily Brontë. A little flippantly, I called my thin little Alsatian "Tessa," because she was too young to marry; because she had breeding without beauty; because we thought to discover in her a wistful immature quality which would probably

cause her to die early. Names, however, should not be in-
spired by sentimental conjecture; she grew up an Incon-
stant Nymph, and poor old Boris, her husband, had a lot
of trouble with her. A lot of trouble, poor old chap. Till
we took him to England and presented him to a Mounted
Policeman, which he found much more restful. Moreover,
Tessa grew up beautiful, slender, graceful, nervous and con-
ceited, her ears constantly pricked for trouble; highly sen-
sitive except over the feelings of others, which, I have heard
her remark in all but words, were not of the slightest con-
sequence. Yet she was a devoted, scrupulous mother to her
litters of wolf-pups with their soft, shining, grizzled silver
fur, great owlish spectacle-marks round their wise puppy
eyes, and small, floppy ears like silk purses. It would have
been more picturesque of Tessa to have shared the fate of
her prototype and of all those whom the gods love. For
when, on returning to live in England, we left her with
our friends in Italy, she attached herself soul and body to
the Italian gardener, and enthusiastically lost her figure, her
youth and her fleetness. And she will, no doubt, continue
to populate Liguria with wolf-pups of degenerate name and
breeding, fallen from Champion Erichsohn von Starken-
mark standards, till the cows come home.

Till the cows come home.

The cows gradually take shape in a darkening landscape;
gathered in from distant corners of the clover field, a field
husky with scent, but the colour drenched out of it in the
half light. Some of these kine have been standing knee-
deep in water (kine never go in further than the knee) but
they, too, with no perceptible call to summon them, have
joined in the slow procession coming home, filing through
the gate, and swinging slowly, slowly up the lane, chewing
the cud twice.

No, this is not one of this year's Academy pictures; nor does it hang on my dining-room wall; nor, even, did we give it to Granny for her fiftieth birthday. It is an attempt to justify "The Cows Come Home," as a title for an auto-biography; a title which struck me just now, on accidentally writing the phrase, to give pictorial body to the whole theme: after all, if your thoughts have been compared to homing birds, and, by Alice Meynell, to sheep, there is no reason why they should not take a slightly larger outline. "The Cows Come Home" . . . trooping in like platitudes; like those profound thoughts which one had hoped were so vital and original; like memories in the half-light, big, slow, unwieldy and cumbersome; like memories standing knee-deep in water; all now, at summons of the autobiographer, filing through the gate, swinging in procession down the lane; more and more cows, coming home. For an auto-biography is, in a sense, home. We can go on like this till the cows come home.

> Oh, Mary, go and call the cattle home.
> The lowing herd wind slowly o'er the lea.
> The years like great black oxen tread the world.
> And the harbour bar be moaning.

Mary, never doubt it, was the family half-wit. They sent her out on this peculiarly dangerous job, quicksands and sudden tides and so forth, hoping that one day she might be "never-salmon-yet-that-shone-so-fair." Or else there never were any cows, and the girl imagined them all.

The horse, the dog, the cat, the monkey, the parrot, perhaps even the agile goat, the elusive lizard or the infer-nally industrious spider, have all been in turn acclaimed as the intelligent friend of man; the most sentimental writer must hesitate before he flaps eulogies concerning the intel-

ligence of Dilemma the Cow (you cannot deny that Dilemma
is a good name for a cow). Perhaps this effect of heavy
stupidity is due to the weight cows carry, like over-cargoed
ships, below the Plimsoll line.

The intelligence of animals has been over-rated to satisfy
some obscure desire to add to the rumour of our own intel-
ligence, by boasting that we dominate not a subject race,
but species hardly less intelligent than ourselves.

That cat up at the swimming-pool.

I could think of no possible way to reassure it; quite
simply make it understand that my intentions were benev-
olent, and so it could pass me at leisure and without strategy.
And yet the cat's instinct is supposed to be so much more
acute and sensitive than our own. Their instincts do indeed
quiver and give warning where there is danger; but rarely
function at the opposite extreme, saying: "Here is no
danger."

Up at the pool on the summit of a Mediterranean garden,
it was so quiet that when three white doves suddenly flew
together out of a tall, thin young eucalyptus tree, I started
up from the marble steps, my heart beating strongly.

Then I sat down again. The pine trees grew darker at
sunset; the spray of olive trees, more silvery. A pale flame
lay striped over the light shimmer of the sea. Gradually the
mountains darkened and sharpened to indigo. The sea be-
came steel; the sunset stripes, ruby. The Great Dane's steps
sounded strangely human as he mounted from terrace to
terrace. He stood on the edge of the pool, his reflection
darker than himself; then, with a leap of the back haunches
that gave him a primitive shape, he disappeared into the
undergrowth, seeking his master.

And now that small, lovely, long-furred cat, walking

daintily round on the marble seat, suddenly caught sight of me. She stopped dead, waited, controlling even her shudders. Waited. Would this dangerous human never go away?

At last, with one terrified leap, she went flying past me towards the pigeon-cote among the trees.

A flare of fiercer ruby over the sea heralded darkness. A restless bird fluttered and swooped over the pool, touching it with the tip of a wing. Where his wing had touched, the ripples went on spreading. In the distance, two birds were flying steadily. Now, if ever, without being a Man of Assisi, communion with beasts might have made itself clearly felt.

Yes, but that cat. I would not have hurt her for the world; yet she had endured some eight minutes of agony, unable to go on, unable to get past me. And I had no language of sign or word to soothe her fear.

No language of sign or word to inform the elephant, Bébé, that he had made a very simple mistake; that to sit on his trainer's daughter and remain literally planted (*planté là*) for two hours, courteously declining all offers of refreshment (*il restait insensible au pain et au sucre*), was not the perfect way to assure her of your respect and affection. The French journalist reported the occurrence with a touch of naïveté that matched the event:

"*Pour une raison inconnue, 'Baby' changea brusquement de méthode.*"

Yet the elephant's methods can be reasonably enough interpreted as a kindly desire to let her know that she had sex appeal: "It's time I showed that girl some delicate attention. She's such a nice girl, and she's been depressed lately. What can I do to lift that depression?" *Et il se laissa litteralement tomber sur l'artiste.* "No, I'm not the sort

of animal who does things by halves. The little lady is feeling happier already (*Je t'ai fais mal, ma petite?*). I've put my hand to the plough, so to speak. After all, she's my tamer's daughter, and as such maybe I've been neglecting her." *Après de vaines tentatives, que se prolongèrent plus d'une heure:* "Though mind you, she's not my style; not my style at all. What are you making such a fuss about? I believe I hear groaning in the distance. I think you'll find it comes from the far tent over there."

From tortoises, not from elephants, do I get my special response. I do not speak to tortoises, I recite to them. A Suffolk tortoise in a friend's garden had given no sign of life under his shell; for several days he had been no more than a hair-brush without bristles. Heaven knows what impelled me to use recitation as a sort of divining-twig, in the hope that what was inanimate would leap up in joyous reaction. Holding this potential hair-brush in my hands, I glided through the various selections from my repertoire. Presently four scaly little legs began to ripple and stretch themselves. Presently a coy head, bald, flat, with an engaging expression, poked out from under the shell. (I have never been able to decide whether or not I prefer the *beauté du diable* of a tortoise to the mere chocolate-box prettiness of a toad.)

> *Lars Porsena of Clusium,*
> *By the nine gods he swore——*

The head waved rhythmically to my words, from the folds of dried skin folded like a Regency neckcloth. Held up in a certain light, a tortoise's eyes are dark blue.

It opened and shut its mouth and said "Wuff!" several times.

When I had finished several stanzas of "Lars Porsena," and began to recite something else, Little Lightning, for so my friend had named him, put his head back, disappointed, and became a hair-brush again. I re-started "Lars Porsena of Clusium," with a result similar to before. Out of deference to my peculiar gifts, my friend changed his name to Lars Porsena.

As I have just remarked, I have long been unable to decide whether I prefer the chocolate-box prettiness of a toad, to the mere *beauté du diable* of a tortoise. Shakespeare calls the toad "ugly and venomous." Shakespeare might perhaps have had a prejudice, dating from his boyhood at Stratford, on having been chased by a keeper with toadish sort of looks.

My own associations with toads, originally set up by Norman's Friday afternoon visits, have all been charming. Two books that I could not lightly spare are "Toads and Toad Life" by Jean Rostand, and Kenneth Grahame's "Wind in the Willows," an animal epic which wears a precious jewel in its head; that jewel is "Mr. Toad" himself, Toad of Toad Hall, who sang the praises of Toad in so *dégagé* and so melodious a strain; as free from inhibitions, from all affectation of modesty, as the buttercups in the meadow blow free from wire in their stalks.

> *The clever men at Oxford*
> *Know all there is to be knowed,*
> *But they none of them know one half as much*
> *As intelligent Mr. Toad!*

> *The queen and all her ladies*
> *They sat at the window and sewed,*
> *She asked: "Who is that handsome man?"*
> *They answered: "Mr. Toad."*

"Toads and Toad Life" by the son of the author of "Chantecler" is neither a play nor a novel, though it has the character and passion of both. The writer's style and angle of approach assumes without question the Toad's candidature for the place of hero to be as valid as that of Sidney Carton or Don Quixote. "Toad," he seems to say, "Toad has too long been wronged, misunderstood, neglected." His championship of Toad swells into defiance:

"Linne states that he saw it eating navel-wort, bane-berries and decayed wound-wort. Bory de Saine-Vincente and Valmont de Bomare accused it of raiding strawberry beds. All these accusations are entirely false."

"Travelers and naturalists of authority say that Indian toads stuff themselves with charcoal." (What was the author about, not to have had his book engagingly illustrated?) "Our toad shows no taste for it."

"Some exotic toads suffer from nervous spasms in their toes while they are contemplating their prey. Our toad does nothing of the kind."

"Our-toad," spoken of thus, develops a sort of pained dignity which reminds one of George Robey whenever he thinks that some one has accused him of trying to be a funny man. But toads are funny—and tragic—before they even begin to try. That wistful, conceited mouth, which deprecates the whole way round its head; those bulging, throbbing, passionate eyes. One could never say: "a little smile played round the corners of his mouth," because our-toad's mouth has no corners; or: "he was grey round the temples," because he has no temples.

Apparently our-toad has: "six months' lethargy, one month's love, five months' normal life."

"Toads," we are told, in a fashion to disarm prudery, "toads frequently sing during copulation."

"While it is shedding its skin, the toad humps its back and thrusts its head forward; it crooks its forelegs more than ever; sometimes it uses them to pull the skin off the top of its head." (How this reminds us of that occasional glimpse of our fathers, husbands or brothers struggling to remove their shirts!)

"While it avoids a strong light, a dim light attracts it." (Surely this again is an echo? Yes, of course: "Cleopatra" in "Dombey and Son": "Rose-coloured curtains for the doctor!")

"On 1st April I found a female toad in a fairly deep hole." (Origin of a dish called toad-in-the-hole.) "She had certainly spent the winter there, and had consequently met no male." ("How can you expect to get married, Galswinthia, if you spend months stuck away down here where you never meet so much as a tadpole?")

"For several years spring will leave the toadlets untroubled," says Monsieur Rostand, in poetical mood. "Seven Aprils must elapse before they hear the call of the water."

For those who are condescending in their attitude towards Toad, or who are inclined to find him "disgusting," it is at least chastening to be informed that this hand of ours, which writes sonnets, which guides racing cars, which paints masterpieces, originally derives from the toad: "Batrachians occupy an extremely important place in evolution as the first terrestrial vertebrates, the first walkers. They inaugurated the limb with five digits, a significant innovation, for from it, was to develop the hand."

Such items of information about the smaller animals I find soothing and pleasant. One need not remember them unless one wants to, but they run in and out of the mind like little lizards. In the Philippines, little lizards are so fair and transparent that you can see their hearts beat. They

are thus most decorative when they run over a white lamp-shade when the lamps are lit at night, and most discon-certing when they fall from the ceiling into the soup.

Similarly, though not in the Philippines but in a restaurant in the West End of London, I found a whitebait in the *paté de foie gras*. The restaurateur hesitated whether he should describe it as a *specialité de la maison;* or advance it as a voucher, like a fly in amber, that the *paté de foie gras* was real, not imitation; or yet again, assuming a humbler attitude, explain with effusive apologies that Young White-bait had become too active in the larder, and eluding all vigilance, made a dash for the jar of *paté,* hurled itself in and there died a noble death.

Or it may be that burying yourself in *paté de foie gras,* is the whitebait equivalent of turning your face to the wall.

The most evil animal face I have ever seen and one that should always be turned to the rock is on the underside of a Mediterranean sea-urchin. At first, on the blue-black pulp, you can see no face at all; then you become uneasily aware of a circle of sharp white points, rather smaller than a Maundy penny, in the very middle of the blue-black pulp, the moist glutinous pulp. If you lightly jab at this circle of sharp white with a straw or with a knitting-needle, it appears and disappears, recedes and protrudes. It is teeth; I should say: "These are teeth." And presently, round the circle of teeth, a face dimly sketches itself; a face infinitely evil, a face seen in a nightmare of hell. You would not know that it was its face, right in the middle of its under-side, except that when you offer it something to eat, the tips of the five white teeth appear, ready to seize the bait. But it is not until the urchin is dissected, that you get the full horror of these teeth, which are long tusks; they are almost as long as the urchin is thick, curved over to the

centre, and have nerves like the nerves of human teeth. They are like the monstrous things you dream about under gas at the moment when the dentist is extracting a normal tooth from your own jaw.

I would never dream of saying to any but a bitter enemy: "*Tiens*, you have a face like a sea-urchin!" It is safer, indeed, not to compare the human physiognomy at any time with the fish physiognomy.

A French coiffeuse and manicurist, not very young any more but with an air of breeding and ironic appreciation which makes me delight in her company, told me, à propos of this same matter of faces: "I once told an English young man who loved me, that he had a face like a gurnet. It slipped out so suddenly that always afterwards I have been sorry. 'Do not stand there and look at me with your face like a gurnet!' I cried."

I will not say that this led to a discussion on fish, because with gurnet we were, so to speak, with a leap and a splash and a shiny curve through the air, in the subject of fish already. And suddenly she began talking of the 2.25 to Oxslip: "Years ago, when I was a young girl living in England, working at a coiffeur's in Notting Hill Gate, on Saturdays we shut up the shop early. And I would have to hurry and run and only just catch the 2.25 to Oxslip; quite a small station and then a long walk across fields to the little farm where I had rooms for the week-end. My valise, the carrier he brought it later. And then to change from my town things and put on my big waterproof boots and the overall with huge pockets; I kept them down there, always. And into one pocket the bait, the worms, and into another the tackle. And walk again. It did not matter what one had to climb nor how wet one got in scrambling through the hedges, splashing into ditches; getting wet—well, you

dry again; it did not matter. A long afternoon of fishing; gudgeon and roach. Gold lights and green shade, or perhaps grey sky and the fresh rain bubbling the fresh water. Remembering how I had called that poor boy a gurnet, it has brought it all back into my mind again. How tired I was in the evening, and what a good supper of the fish I had caught for myself. No, no, you are mistaken: gudgeon it is *not* tasteless. And up very early, and the whole of the next day fishing, too, till Monday morning also very early I had to put on my town clothes and my silk stockings and high-heeled shoes, and start back to my work again. I shall never forget those week-ends; they were my happiest."

I wonder why it is always touching, this love of England when we encounter it in a foreigner. Somehow more touching than plain patriotism. There were Germans who felt like that about the stretch of river between Bray and Cookham, when war broke out in 1914 and they had to go.

She was dressed beautifully, always, and her manner was a little sedate, as though her week-end as a matter of natural choice, would be spent at *les Courses,* Chantilly, or taking an occasional promenade in the Bois; as though one would meet her in the boudoir of an old château; or at an exclusive but chic little restaurant with people whose style was revealed by the timbre in their voices; who reminded you of old lace, fine but not robust. For although she speaks English so perfectly, it is difficult to imagine her out of France. If she followed *le sport* at all, I might have placed her, wearing a tricorne, with the Forêt d'Halatte pack in the Ardennes; the pack originally called, how romantically, "Par Monts et Vallons."

Why it should have given me such queer satisfaction, I cannot tell, to have my obvious conclusions destroyed by this unsuspected revelation of a breathless laughing girl

tearing to catch a train that she might the sooner be standing in the bedroom of an English farm, thrusting smelly, slippery bait, worms and tackle down into the huge pockets of an old overall. So often we have the world spread out flat for us, because everybody on it conforms as they are intended to conform, without variety or rebellion from their type: "I knew you were a billiard-marker, the moment I saw you!"—or a golfer, or an artist, or a Dame of the British Empire. And yet we try to make our voices ring triumphant, to console us for the flatness of a world in which we always guess right. So we score over the flat world, when we are told in the *salon de manicure* of a big Riviera hotel, while having a fashionable shade painted on our nails, that gudgeon are really not so bad; are, in fact, very good indeed if you know exactly how to cook them fresh from catching in the rain, in a stream near Oxslip. So the world is not as flat as all that, flat as my hat. It is round; the horizon is tilted, so that a ship is heralded by the tip of its tallest mast, leaving the satisfaction of speculating as to what manner of ship it may prove to be.

And a queer satisfaction, though in a different category, the Hong Kong harbour category, was when I saw, actually saw Chantecler himself in proud, cruel action. When I saw him, in fact, cock-fighting; not as an arranged sport, but by accident. I was passing through an orange-grove in the South of France at Christmas-time. First I heard a dull thud as the two cocks clashed together; and I wondered what sport was going forward. Then I saw them: one, Chantecler himself, big, black, with a full-grown scarlet comb, scarlet flannel wattles and an arrogant greenish-black bunch of cock-feathers behind. The other was small and of many colours, wherefore I called him "Joseph";

deep pinks and mauves predominated in his feathers. They approached—and paused. Then flew at each other with again that sickening thud of contact. Joseph always managed deftly to slip forward under Chantecler, and so escape mauling. At last, however, he had enough, and turned and ran squawking away under the orange trees to the solitary hen-house. Then big black Chantecler began proudly treading the ground, stamping and kicking up clods of earth. After that, he drew himself up till he was half as tall again, and crowed loudly. Several hens ran and gathered round him: "Qu'il est beau!" they remarked audibly several times. "Qu'il est beau! Qu'il a du courage. Quelle triomphe!" Chantecler struck up more earth; strutted a few yards and crowed again. Meanwhile, the poor little conquered cock ran out from the hen-house, still squawking piteously from his hurts, and ran apart from the rest, up the alley. The hens took no notice of him.

I was the more impressed by the spectacle of cock-fighting, because in my mind it had been, up till now, one of these literary affairs: one had read about cock-fighting, but never seen it. Like Hong Kong harbour and Berlin and Datchet. Now, when some one uses the stale cliché: "It beats cock-fighting," I automatically on the word get my old literary image of cock-fighting, which has to be thrust aside to allow the genuine experience to slide into its place. One day I shall see real pig-sticking, and then that, too, will cease to be my mind's picturesque invention of men, pukka Sahibs, enjoying after-tiffin sport. One day I shall see the temples of Angkor; the road to Samarkand; Kinchinjunga and Popacatapetl, the Amazon and the Guadalquiver. One day I shall see the Kremlin. I thought I had seen something very like it, a short while ago, from the little bridge over the lake in St. James's Park.

They had drained out all the water for cleaning operations, and the grey concrete bottom looked weirdly like ice in the pale wintry light; pipes and channels and drains writhing across it, and very small, very black figures of men at work on it. Hundreds of sea-gulls were flapping their grey and white wings in desolation. Over towards Buckingham Palace lay a wan silver sunset, and beyond the Horse Guards to the East, a cluster of dim grey pinnacles and domes: "Like the Kremlin," I remarked without any justification. "This," I remarked again, travel proud, "is *exactly* like the Kremlin." And then as a corrective to impudence, for I have never been nearer to Russia than by Chekhov and by ballet, I also murmured to myself: "This is exactly what I expected Hong Kong would be like!"—as The Brushwood Boy said, when floating about in his dream on a small clockwork steamer, he hits a large stone lily labelled "Hong Kong."

From the same bridge I once saw, in Autumn, an amazing ballet of starlings in flight: sometimes winding like a scarf over the trees and the lake; spreading and paling into a wide thin fan over the sky; then the colour thickening into a denser black as they drew together again. But always they flew as though commanded by unseen rules of symmetry.

When I was at Santa Monica, the Pacific Air Fleet passed over our heads, first two triangles of large planes flying in perfect team formation, then streams and streams of tiny silver-grey ones flying high and looking very soft and feathery as they flowed across the blue sky; just behind them appeared a flight of birds, dark flashing to white, camp-followers behind the squadron; strangely like bird comment on men in flight.

It was in California, too, lying on the Santa Monica beach, that I noticed a mad flight of sea-gulls; at first singly,

then in battalions. From all sides they came flapping; flapping—and then suddenly whizzing with rigid wings down an invisible line; purposeful, noble as though on some immortal quest; urgent as though commanded by the need to carry news; news from Ghent to Aix; news of the battle of Marathon; news that Constantinople had fallen, that the Armada had been destroyed. Purposeful, noble——

Towards a small scatter of bread from a tripper sitting on the Pacific shore.

A terraced road ran high above the Canyon and then sloped down to the ocean, just outside the garden of our Spanish bungalow in California. The hills across the canyon hung in loose baggy folds of dim purple and indigo. And as I strolled down towards the Summer Ermine house, I smelt that sweet pungent evening smell of damp striking on short grass, as our Japanese gardener imperturbably watered the gardens and terraces. All along the edge of the road, flowering bushes and aromatic trees built a Californian equivalent of an English hedge; pepper trees and broom; camphor trees, light and graceful, dappled with bright red leaves; mimosa and mesembrianthemum in flower; masses of crouching brilliant scarlet berry clusters, and yellow jasmine, and judas trees that the Fall decorated with long-fingered leaves, not red nor brown, sinister as Judas's blood. The wild lilac, blue and silver-grey, bloomed there in early March. And bright cherry-blossom. And tall green eucalyptus trees with moonlight-coloured bark.

A eucalyptus tree once grew in our garden in Cornwall. We had signed a lease in the autumn for seven, fourteen, or twenty-one years, of that little house and garden; and returned to take possession in the spring.

During the winter, in London, we talked of that solitary eucalyptus tree; a rare prize to find in an English garden. And while we talked, it grew taller, more strange and silvery and beautiful. Not many people in England, we told each other, have eucalyptus trees in their front garden.

When we returned we found it lying prone across the lawn. Our Cornish landlord had cut it down to make "a gentleman's avenue." "Ee must have a gentleman's avenue," he said repeatedly. I wonder why he thought so. He had busied himself, too, in his lighter moments, at a mysterious process known as "graining" the front door. "Costs good money, graining does." He never spoke of money by itself; always of "good money." The graining of the front door, when finished, was not in any way related to the actual grain in the wood, which it so bumptiously overlaid.

We burnt the eucalyptus tree on our hearth during the cold spring evenings. And we tried to wash the front door of its shame.

But somehow we never got on with that landlord; and less than a year later, gave up the house above the cove. He had not the right feeling for wood; and we evidently had not the right feeling for good money. He would shake his head over our caprices and objections, in sad amiable bewilderment. When something was wrong with the well, a boy was lowered by his orders into that gloomy dark-green shaft, between dripping walls and down to the ominous gurglings at the bottom of the long drop. The boy mended what was broken, and came up alive. "Ah," said our landlord, congratulating himself: "Good thing I had my own boy, Ted, to send down. A dangerous well, that; it'd have cost me good money to have sent down a man." For, after his fashion, he was one of the sincerest people I have ever met.

When we gave up the house and wanted to sell the furniture, our landlord suddenly remembered that in his youth he had been apprenticed to an auctioneer for a week or two; and that there was no reason why he should not revive this accomplishment, auction our furniture himself, and earn the commission. It was a pity, he remarked, to let (good) money go elsewhere.

But in California, eucalyptus trees were no solitary specimens; they were as pines in the Black Forest, or poplars on the roads of France.

I had been preparing a treatment of one of my books, "Long-Lost Father," for the film studio at Hollywood where I was working. The girl in the book has to sing a Torch Song at the cabaret of a restaurant in London. I had not written the words of the song myself; but I had called it "Summer Ermine" because the heroine afterwards gets sent a coat of summer ermine when she is feeling most down on her luck, by her debonair young father who had run away from her when she was a baby, and was now—(and by "now" I mean now at that stage of the novel; not "now" in Hollywood, or "now" where I am sitting and writing; or "now" while you are reading about "now"; a muster of nows in conflict, and all with equal rights; more nows than there are harbours in Hong Kong)—who was now (firmly) the proprietor of the very restaurant in which she sings her torch-song.

"Torch-songs" should be the vocal expression of a woman in extremis; her belief that her desire to retain a specific man, however single-mindedly she may pursue it, will never materialise. For torch-songs are anti-proverbs; not good literature, and often not good music; ranting, pseudo-romantic. They tell you to bite that bitter almond and then

take another. They should be written and sung in the first person singular, and should dispense with reticence or generalities. As the label declares on a 1906 liqueur brandy: "Obscuration nil." She loves her man (he is rarely her husband) more than her man loves her. She has a desperate obsession about him. He is in her bones. "Can't help loving dat man," from "Show-Boat," was a torch-song. Not always need the man have jilted her; enough that he may at any minute; that he endures rather than seeks her love; that his heart is a pound of feathers whereas hers is a pound of lead (and we know that a pound of lead *is* heavier than a pound of feathers!). On a moonlit terrace one evening in the South of France, I sat with my arms round the neck of a Great Dane. The noble melancholy animal endured the embrace, his head slightly turned away. Goaded by his beauty and indifference and the fragrance of the tobacco-plant, I lavished on him every appropriate and inappropriate endearment. He sighed, and turned his head a little more away. A gentle onlooker suggested that the episode perfectly illustrated a torch-song; unwisely, I had been asking for the definition earlier that evening.

"A Telephone Call" by Dorothy Parker, though not in song form, is probably the most agonised, most agonising torch-song ever written. I would give you the Hundred Most Massive Highbrow Living Writers, the kind who creak and heave as they thrust their shoulders at the wheel, like figures in a frieze of Modern Labour, for what Dorothy Parker can do by not quite using half the strength in her little finger.

The hero-villain who inspires the theme of a torch-song, I visualise as looking like the man in the picture called "The Last Day in the Old Home." You remember him? An impudent rake, but handsome, with debonair moustaches;

the perfect example of a man-of-the-pseudo-world. The centre of a woebegone group engaged in various ways of spending a Last Day in the Old Home, he sits astride of a table, his glass raised, his eldest son imitating him; the young rascal admires his wicked father intensely. It almost breaks his wife's heart, but what does he care, the libertine, the hero-villain of a torch-song who cannot even be faithful and loving to his mistresses, let alone his wife? And he does let her alone, make no mistake about it. You may catch another glimpse of him (for I am sure it is the same man) careless posture, impudent legs, debonair moustaches, in a ballad of which the main contention is that he went to the funeral just for the ride. The ballad, Rebecca West has always contended, is an outburst from the female re-lations of his wife, spinsters in black with pointed red noses, who had "always known" what Alfred was like!

> We *went to the funeral*
> *And oh how we cried!*
> *Oh,* how *we cried——*

Herrick's "The Mad Maid's Song" is a good torch-song; her love had surely abandoned her; I will never believe he was in his tomb. But it is significant how seventeenth- and eighteenth-century "torch-songs" nearly always betrayed a state of affairs in exact reversal of the present state of affairs. For always seventeenth-century poets reveal the lady obdurate, indifferent, light, changeable, hard-hearted; the man tormented, desperate, pursuant, imploring, faithful, and ready to pour out his love-sorrows to any one handy. Anthea is cruel, and so is Julia, Pancharilla, Ceila, Clarona, Florella, Cloe, Belinda. How their tendril names curl them-selves round the sweet cheats.

One night, while I was working on my treatment of "Long-Lost Father," a fellow-author strolled up to dinner from her own house in Santa Monica, about eight minutes down the road. With her was her collaborator, an extremely brilliant young composer. They were both dead beat after a day of complicated work at the studio.

I happened to mention, at dinner, this torch-song in my book, saying that music would have to be put to the words if the studio were ever to use them; and that the words were anyhow not my own; for at the time I had been at work upon the novel, unable to write poetry, I had begged a friend of mine, a well-known dramatist, to write the torch-song for me.

The composer read the words, shook his head, and said that effective as they were, they could never be set to music for some technical reason.

"And you'll want more repetition," his collaborator added; " 'Summer Ermine' must come into the refrain again and again."

He objected: "Impossible. It would come out 'Summer-rermine.' "

"It needn't, if the beat separated the two words. Like this. . . ."

She demonstrated. He sprang up from the table, dashed to the piano——

I had heard of the way that genius worked, but that was the first time I had actually seen it in action. It was a double event; for his collaborator, closely following up the tune that was bursting from his fingers, began supplying him with words; first the chorus; then the verse. They were dead tired, as I said, and temperamentally ablaze. Between them, they completed in less than an hour one of

the most effective sensually exciting torch-songs, words and music, that I have ever heard.

I had supplied nothing but the title: "Summer Ermine," but they thanked me warmly before they departed that night. I said: "You're welcome," as I had learned to say in stores in America. The thing got into the air among our group of friends out there. It was played to them once, and they could never stop singing it; wherever we went it was summer ermine all the way. As I used to go up and down that aromatic road that ran along the rim of the canyon and down the hill to their house and to the ocean, I could not prevent myself from humming "Summer Ermine" as it lilted through my head . . . and then it would join with the sound of it being played on the piano in the other house, so that I could never tell at what point I began to be accompanied. It was one of these tunes that get into your brain and into your feet, so that you walk to the rhythm of them; that get into your coffee so that you drink them, and into the air, and into the whistle of the errand-boy on his bicycle going down Burlington Gardens, and on to the pier and into the pantomime! "The tune of the moment" we call it. But I found it a new and exclusive form of snobbery, being in at the making of a tune which is potentially a world property.

I believe we are humming some such tune obscurely inside our heads, far more often than we catch ourselves at it. Now and then, when I have been able, so to speak, to lay a finger on it and bring it out into the open, it has been, quite by itself without any help, not "Summer Ermine" or "Stormy Weather" or "Night and Day," but actually a stray motif from a Beethoven Symphony. We are extremely gratified when Our Subconscious plays up to our snobberies like this.

I have an especially strong reaction from summer-ermine ladies with long cool throats; ladies exquisitely groomed, waved and manicured; ladies with rows of pearls; ladies who wear summer-ermine coats at (English) summer luncheon-parties, and winter-ermine coats at winter luncheon-parties, always allied to the right and perfect curve and tilt of a luncheon-party hat.

I had never been to a luncheon-party at the Embassy. Certainly I had already published four or five books; but the hands which wrote the books still fumbled youthfully over the matter of drawing a cigarette-case out of my handbag, opening it, offering it, lighting a cigarette and putting it in a holder and talking to the Man-of-the-World beside me, all in the nonchalant style of being aware that the handbag, cigarette-case, matchbox, holder and Man-of-the-World are perfectly in order and that I could afford to be careless and confident about the whole set. It is an ignoble business, this desire to be reckoned only as a perfect accessory to one's own perfectly lacquered equipment.

The man who invited me to the Embassy to lunch was debonair, as we use the word now. (The French Bible translation spoke of Christ as "de bon air" where ours said "meek.") He was younger than myself, and he and I had broken the tape together at the start; for we were in the same line of business. I had run somewhat ahead of him for a while, though he had noticed this and I had not. Then suddenly he had been swung up on the flying trapeze of one of those exultant fantastic successes, out of the blue and into the gold, bridegroom of Danaë, idol of the press-photographer; he had struck oil, hit the bull's-eye, any other metaphor you may care to supply. It happens to have happened to three or four young men of this century, these fever-chart ascents up and up almost at right angles from

the horizontal line where most of us dwell. Michael was airily determined to show that he was not staggered at the style with which that little bud, the universe, was opening for him into opulent flower. He had been hard up enough, before, to be first dazed and then spiritually tipsy at the sensational change. You cannot one day walk about in a five-guinea suit of clothes that is already three years old and still beyond your means; and the next day possess the sandals of swiftness, the purse of Fortunatus, the touch of Midas, diamonds and pearls running out of your mouth with every epigram, without becoming for a brief while (let's face it) fairly unfit for human intercourse.

Meeting me at a party and kindly patting my head, my Man of the World suggested lunch two or three days hence, at the Embassy. Gwendolen thought she was going to lunch with him alone (it may be less embarrassing for this personal allegory of the three watches if, temporarily, I become Gwendolen). Gwendolen dressed with great care, and because it was summer she pulled on a large shady hat; a shady hat several sizes *too* large; it lurched a little. The luncheon-party numbered eight, and the three other ladies were such as we have already described; summer-ermine ladies with long cool necks. Their conversation was so socially allusive as to be incomprehensible; even had Gwendolen been in a mood to contribute, she could not have done so, for she was, in Shakespeare's phrase, "gravelled for lack of matter"; lying, as it were, under sacks of gravel; gravel and sand and stones. Lunch was an interminable tragedy. She sat on the left of her host. Once he turned to her and said in his quick engaging voice with its spatter of foreign accent: "You are in a very bad temper to-day. What is it?" For he and Gwendolen were intimate enough to justify this banter. "Nothing," she answered, about as con-

vincingly as St. Elizabeth of Hungary or St. Rosaline of Provence must have replied "Roses" when their brutal husbands caught them carrying bread to the poor in closed baskets, and asked them what they had there concealed?

Half an hour later, Gwendolen made her next remark. She said: "I must go," and glanced at her wrist-watch. The Man of the World glanced down as well: "Why do you wear Big Ben on your wrist?" he asked lightly.

He did not mean to be cruel. He is essentially a man of ample kindness. He thought her silver wrist-watch was large, that's all; large and round. It *was* large and it *was* round; a schoolgirl sort of watch, it told the time in a clear business-like fashion; it had been a birthday present when she was fifteen. Had she reflected, she might not have put it on for this lunch with London's Pride at the Embassy; but she had strapped it on automatically.

So Gwendolen's third remark, not counting "Hello" and "Good-bye" and "Thank you" and "Salmon-trout, please," was made silently, on her solitary way out of the restaurant. She said: "I'm biding my time——" and really believed she was. She had to believe it.

Big Ben, Benvenuto and Little Ben: those were the three phases dividing my ignoble desire to become the equivalent of a Man of the World, into three sections of time and geography and watches.

The second was the Italian phase.

I lived in Italy for five years. A certain success had come to me, but gradually; not in the fever-chart style. I was passing through Verona; it was summer again, and I sat with my companion in the hot shade at a table out-of-doors near the amphitheatre. We were contented and lazy. We watched lizards run up the baked amber walls, and we drank a wine called "Soave Veronese": a wine with

that name could not be otherwise than smooth and pleasant; it is a heavenly way of describing those whose behaviour has a natural aristocracy: "his manner is *soave Veronese.*"

Presently we went for a stroll which led us to an arcade of shops where only watches were sold; watches, entrancing little watches; watches in shops on either side of me; a twinkling saraband of watches. Obviously, though I did not know it, watches were the special manufacture and export of Verona. In Toledo there was a Street of Swords; in Barnstaple, a Street of Butchers; nothing but steel, nothing but meat; here, in this arcade of Verona, nothing but watches. But our ramble through Italy and the Dolomites had cost us too much and I could not afford to buy one, then.

A year later, I made some money unexpectedly, as authors do and as authors don't; it all depends. Big Ben had been dipped accidentally too often into the Mediterranean to be really satisfactory any more. A friend of mine was going to Verona. I gave her about a fiver in *lire,* and asked her to buy me a watch, describing the arcade. Any one in Verona would direct her; it must be famous: a covered arcade with watch-shops on either side. "They sell nothing else there. Get me a nice watch, *not big.*"

She returned from Verona, with a puzzled air of apology; for she had not found the arcade of watches, and no one there could tell her about it. Watches, apparently, were not a special manufacture of Verona. And never had been. There were two or three ordinary little jewellers' shops in that town, as in every town; so, following my instructions, she had bought me quite a nice watch, pretty, not big, with an oblong face, and "Zurich" engraved on its back.

I was puzzled, too, and said, not very graciously, that it

was a pity I had not bought it myself at the time. However, Benvenuto was welcome as an improvement on Big Ben, and I wore it for many years without pleasure or pain.

Big Ben. Benvenuto. Little Ben.

One's situation improved; one's taste developed; one's income and opportunities slowly widened; slowly, never sensationally. Meanwhile, living in Italy, I had not seen my Man of the World, and he was passing through what was not exactly an eclipse, but not a very good period. A temporary failure, not in his prospects but in his health, had sent him away from the World he was a Man of.

Then I saw him again.

I was staying in a furnished "appartement avec service" in Paris, near the Etoile: a friend had asked me to take an apartment for her in the same house. I was able to get one next door; all the rooms communicated in a long line. Her apartment was much bigger than mine, for she was bringing her family along. She was expected in an hour or two; the doors all stood open; viewed as one apartment for one woman, it looked a pretty sumptuous affair.

Suddenly, the concierge telephoned me that Michael was below. I was surprised, and wondered if it were a bad joke? When he came in, I said as much, but affectionately. The Pagliacci which dwells in all of us, made him throw back his head with a rueful ironic laugh, saying that he was indeed a bad joke . . . he had thought so for a long time. Then he looked round, and remarked, astonished: "Nice little suite you have here."

"Would you like to see the rest of it?"

I led him down the long vista of rooms: it was something like Versailles. It did not seem necessary to tell the man who had once asked me why I was wearing Big Ben on my wrist, that only less than half Versailles was actually mine.

He went away in a respectful state: "Ah, little Gwendolen," etc.

Luck, I thought! though realising that this was a foolish game of values we were playing. I cannot believe that by now, either of us played it very seriously.

He married, and took a house in London.

Meanwhile, I had acquired another watch.

I had acquired it (I swear, unconsciously) by the means that I am sure were used by the identical summer-ermine ladies whom I had envied all my life. Quite simply, this is the story:

I was in a car; I was late; I looked down at Benvenuto and it had stopped. It had stopped often, lately. I murmured, half to myself: "I *must* get another watch." There was a man beside me and he said: "Let me give you one" —as easily as that.

So it worked! Right down the ages, it worked. They call it gold-digging, now. What did they call it at the time of Phryne?

Summer-ermine ladies. Lordly generous men. And all you have to do to set the clockwork tradition in motion, is to say, half to yourself, "I *must* get another watch." Example is better than precept. Here was my example. Now and for ever I would believe in the oldest formula; I would believe in the sum and its answer.

He sent me three watches to choose from. He had said: "What kind of a watch?" and by now I did not reply modestly: "Oh, not big," but, emphatically: *"Small."* Of the three he sent me, I chose one with a mignonne wistful little face set in stripes of platinum and pale gold.

That was, and is, a watch. When I glance down at my wrist, large genial gentlemen make teasing remarks, such as: "Now don't tell me you can see to tell the time on

that!" Mannish remarks made to this foolish-little-lady with her absurd pretty little toy, of no practical use whatever, given to her by a Generous Gentleman. Yes, it all worked. How satisfactory if one could all one's life be a summer-ermine lady by temperament; not, as now, only for a minute, and by accident. They score, the summer-ermine ladies. *Next* time I am born, I should like to be——

Would I? I'm not sure. But it showed how meritorious had been my life hitherto, how innocent of the verb to exploit, that I should have been so disconcerted. "I must get a watch." And since I have convinced myself of the proper functioning of these platitudes, I have felt like the man who could work miracles, in possession of a power I am afraid to use in case it works; or equally, in case it doesn't.

My new watch kept beautiful time. A watch, a clock, they are the only things that can keep time. The rest of us squander it, lose it, forget it, clutch at it, are burdened with it, let it escape, cannot catch up with it, chase it, plead with it, sigh for it, die for it——

My new watch, as I said, kept beautiful time.

I went to lunch with Eliza. My Man of the World was there. He was married, happy and prosperous; though not again spiritually tipsy, as he had been at the Embassy lunch.

I had come to live in London now, and I was feeling what Americans call "swell." By the trivial standards of the game we were playing, my dress was effective and my career in an excellent humour. I sat on his right. It was a gay lunch, and I was sorrowful when I had to glance down and remark (again, I swear it, accidentally): "I shall be late. I must go."

"Adorable little watch you're wearing," said my Man of the World.

Yes, he said: "Adorable little watch you're wearing."

Certainly he had forgotten "Why do you wear Big Ben on your wrist?" It had not been significant to him, giddy and glossy with his sensational success. Only to me.

I replied in pure delight and without any rancour whatsoever:

"*Now* I'll tell you."

And I told him.

He is one of these charming people who can appreciate a joke against themselves, provided it has flavour and point. A rotten joke against him makes him cross and revengeful; but he shouted with laughter at the description of that Embassy lunch, viewed, from my angle, down the archways of the years. "Little Ben," he said, still impudent, still free from remorse, "is charming."

Big Ben. Benvenuto. Little Ben.

I could have wished for the merest touch more of wistfulness; a flicker of: "My dear, forgive me; I was cruel, tactless, heavy-footed." After all, had I been through agony, just to give a Man of the World something to laugh about one day at the end of Eliza's lunch? So, to put a sunset chill on his warmth, I promised to send him Big Ben as a souvenir. I knew that with its loud factory tick silent, the silver tarnished, it was lying, a discarded lump with other broken out-of-date trinkets, thrust away somewhere in an old jewellery-box.

"You may put it under a glass case with my visting-card, and show it in years to come to your little son and little daughter, and tell them the story of what you did to me long ago because——" pause and thrust "——because you weren't *quite* a Man of the World."

I found Big Ben, laid it on cotton-wool in a Cartier box, and sent it round to him. It looked very discarded indeed.

Months later—this is the epilogue and the allegory—I met him again, down on the Riviera. We were old friends and constantly together. Little Ben was temporarily in eclipse; as usual, I had forgotten two or three times that one did not wear a wrist-watch into the sea. So I called across to him at lunch on the terrace, after bathing: "What's the time? I shall be late."

Involuntarily he glanced down at his own wrist; it was naked. "My dear, I'm sorry, I don't know."

"Poor little rich boy, have you had to pawn your watch?"

Suddenly, at this, he turned to me in a rage:

"You're a good one to ask that! The damn thing has already broken down twice. It's being repaired. This is the third time."

The luncheon party were surprised at the rancour in his voice.

Surprise was beyond what I felt: "My sweet" (for that is the way we address each other, we Riviera dogs) "my sweet, don't tell me you've been *using* Big Ben?"

"Of course I've been using it. What did you expect I'd do with it?"

Big Ben, Benvenuto, Little Ben. Little did I think how Big Ben was to appear on a second reincarnation; that a Man of the World would be wearing it as a matter of course. For Michael took for granted its practical uses; there was not the faintest suggestion that he wore it with an ironic sense of the past, or to add flavour to the present, or to score off me, or to amuse me by scoring off himself, or to bring the circle round with a swing to its starting point. But if you say "I will bide my time," and bide it, the biding, less passive and more dramatic than just waiting, will help carry you over the period of weeks or years

that must be endured between, symbolically speaking, Big Ben and Little Ben. It is part of our daily weaving of a tissue called compensation. Compensation weaving is not, I think, quite the same, psychologically, as reverie: I should define the difference, if the shouts of professional analysts could let me be heard, by saying that the first was necessary and the second harmful.

It may be that we establish compensation within us as a sick dog eats grass. The gospel promises "As thy days, so shall thy strength be," but when we are suddenly invaded by battalions of disappointment, pain and black injustice, our strength, unhappily, is not quite adequate to our days. We are sick; we must eat grass; we must bide our time and weave compensation fables so that we may "get by" on them.

But all the while a part of us should know, though only semi-consciously, that we *are* eating grass, and that when we cease to be sick we must also cease this form of diet.

But reverie is a much more dangerous and insidious matter. Reverie, like compensation, is an escape; but whereas compensation is merely a temporary rearrangement for emergencies, reverie implies a fundamental discontent with the whole of our lives as they really are; gradually compelling us to set up a lazy, voluptuous, glamorous dream-establishment aside from the reality, and spend as much as possible of our time in residence there. Napoleon, and Kaiser Wilhelm, too, were examples of grandiose reverie uncontrollably obsessing their victims. Dictator's Reverie, indeed, is a form of disease that, combined with energy, can have unpleasant results for the civilised world. But it very rarely combines with energy, as in itself it is a sapping process.

Mrs. Thompson in the Thompson-Bywaters case, was a

suburban girl in rather a dull home; who built herself a fire-escape from tiresome duties and monotonous happenings, into a state of mind where she could not clearly distinguish any more between truth as it was and what her imaginative wish would have it be. She was a clear example, in humbler circumstances than Kaiser Wilhelm, of reverie with ghastly consequences. Her husband and her lover were its victims.

The censorship is a colander eccentrically shaped; it allows gay lumps of "Restoration" to pass through ("Restoration" is apparently a word with abracadabric powers); it allows a Snigger Heaven in which all the characters are amusingly employed in pimping, bawdry and cuckoldry; yet the holes of the same colander once shrank and would not pass a play called "People Like Us," founded on the Thompson-Bywaters case. A play that was an honest exploration into the causes of things that begin to happen in that region of the mind that might be called under-the-bed.

Our fathers and grandfathers were so preoccupied with throwing streams of shuddering white light on to the top of the bed, that they too rarely bothered to look under it. Under-the-bed has always been a horrid place, dim and frowsy; things are shoved there and forgotten. We, the children, rather avoided under-the-bed, even in games of hide-and-seek.

The title "People Like Us" should have saved any play from banning, for the characters are not only characters in a drama; they are people like us caught helplessly into a tangle of events that spring from common Monday reverie. Such a chastening is good for us to behold; it acts as—a restoration, shall we say? A restoration to reason; an astringent on too lush, too complacent, too flaming fantasies.

A maiden's reverie is not the pretty-pretty thing of Mr.

Sant's picture; and youth is less a period of milk-white in-
nocence, than of fierce egoism and unwillingness to adjust
romance to facts. Noel Coward, with the honest tub-
thumping streak in him which is so reassuringly typical of
modern dramatists, once concentrated the same lesson into
the song of a popular revue:

Imagination is a source of flagellation, if a sensitive child
Lets it run wild;
It dims the firmament till all the world is permanently
blue . . .

Yet censorship regards Musical Comedy, where the action
is one wild resplendent orgy of glamour and impossibility,
as a Botticelli meadow from which not one white daisy need
be plucked. Influenced perhaps by these uncensored little
shows, reverie is started; reverie swells; Edith Thompson's
reverie. There are many million Edith Thompsons in Eng-
land and in every country in the world. By a comical
paradox, I believe the censorship would have permitted
"People Like Us" if it had been obviously about people
not like us: symbolical people; the girl meaning All Girls,
the husband meaning All Husbands and the crime All
Crimes. But the living heart and soul of an audience does
not readily respond to symbolic figures; they are too arti-
ficial, a highbrow attempt to intimidate us with an enormous
abstraction. If "Journey's End" had been written in the
same style as Moeller's war play "Douaumont," in which
the soldier was All Soldiers, it would be less representative
because more consciously representative. We respond to
Sherriff's Trotters and Osbornes, for they dwell within our
ordinary range instead of beyond it. You can only achieve
universality by accidental means. Write the story of a

few individual human beings, a few officers and men in a dug-out and their personal reactions to the circumstances of war, and because they are individual they will be true, and because they are true they become universal, and because they are universal they will become symbolical. A longer way round than by drawing them symbolical to begin with; but they prove better lasting material than those figures, vague and cloudy and cosmic, that are drawn larger than life-size to begin with; and so, having shed humanity, immediately cease to matter.

Certain fiction is of the very stuff of which reverie is born: "A Tale of Two Cities," "Under Two Flags," "If Winter Comes"; the taste does not die, nor the desire to read and hear about sacrifice that we may gloriously identify ourselves with the man who said on the steps of the guillotine: "It is a far far better thing that I do than I have ever done."

This universal illusion, that we are capable of great sacrifice, and our satisfaction in planning it, imagining it, seeing it on the stage or films, reading of it in books, may link up with a fear faintly lurking down there in the cellar, in the lumber-room: fear that we would only be capable of sacrifice if it were picturesquely staged and duly acknowledged.

If I had a little daughter, a wide-eyed child squatting at my knee, lips apart, eyes rapt, fair hair tumbled back from the forehead; if she confided in me how deeply, how faithfully she was in love; if she were to go on and say her love was of that unique kind that desired to make sacrifice, to bear his pain as her own, to take it over so that he might be free of it, to die for him, if necessary, I might be capable of the steely question: "Would you be willing to bear his pain for him if he were never to know it?" (The most horrid sort of sacrifice.)

However tempted, my mythical little daughter, forbear

from giving up the Greatest Thing in your Life; we shall
all be more comfortable if you give up a few small things.
Sacrifices remind one of Stonehenge; they look very well
against a sunset, but would be heavy lumber in the home.

Sacrifice. The Sidney Carton complex of the world.
Whenever a book or a play suddenly achieves enormous pop-
ularity, it is rarely without the sacrifice theme. Bracketed
with "A Tale of Two Cities," "Under Two Flags," was my
favourite book when I was ten. I am not sure, indeed, that
I did not prefer "Under Two Flags," which had two sacrifices
to Sidney Carton's one. For not only did Bertie Cecil,
"Beauty of the Brigade," as lightly they called him when he
was in the Guards, and respectfully "Bel-à-faire-peur" when
he was in the Foreign Legion, not only did he sacrifice his
honour, his love, his rank, to save a younger brother (no-
body knew until the end of the book, but they did know,
then; not half they didn't), but Cigarette, the little vivan-
dière, "enfant de l'armée, soldat de la France," also sacrificed
herself to save the life of the man she loved so that he
might live happily with another woman of his own high
station: "And you will be happy with her; it is better
so."

A successful play, recently produced, presented us with
a heroine who deliberately walks into a burning barn, to
ensure that her beloved husband shall live happily ever after
with a more beloved than herself. Another play by the same
dramatist showed us a man, an invalid, who loses all control
and decency, who viciously strikes his wife and howls in
hysterics because she is going to forsake him (didn't he know
that invalids are noble and patient, gentle and sacrificing?).
That second play was not a success.

Ruritanian sacrifice was born by Escape out of Reverie.

The stud-book shows, moreover, a strain of Discontent in the blood. There will be a renaissance of Ruritania whenever the world of reality is being rather more unheroic than usual. People "change places" a good deal, in Ruritania; a process which is obviously part of the universal escape complex; I have never yet had the pleasure of meeting any pair in real life who had "changed places" and only occasionally those who swop hats.

Ruritania gets modernised, of course; and Rudolph Rassendyll, instead of taking that branch line from a junction in Central Europe and alighting at a little frontier station in that rather mountainy country that we know so well, will nowadays, as likely as not, be an airman; and where in an earlier period the chivalrous young Englishman was "glad that some instinct had bade him keep up his fencing," nowadays it is more useful for him to slip his pilot's certificate in with his passport. But the gallant unrealities will remain for ever the same; that sublimation of what history has already inflicted upon us, and our dread of what it may inflict in the future; that reduction to scale, to a toy game of kings and queens; to a movie seen in the mirror of the Lady of Shallot.

Robert Louis Stevenson knew how to play the Zenda game: "You shall seek in vain upon the map of Europe for the bygone state of Grünewald. . . ." George Meredith used the happy formula in "Harry Richmond." In musical comedy, Grünewald melts into Cadonia, but it smells as sweet. Gilbert and Sullivan in "The Gondoliers," name it Barrataria (satire will not do in Ruritania; you must never name it "Erewhon"). We find Ruritania in "Phroso," "Sophy of Kravonia," "Graustark," "Young April," "The Garden of Lies," "The Stolen March." And even if we turn to our disillusioned young moderns, it is still freckled by the early-

Balkan suns: "The Queen Was in the Parlour" by Noel
Coward: "Act II. The Queen's private apartments in the
royal palace at Rodelle, Krayia."

It may even be that the modern apotheosis of the whole
Ruritanian complex lies glowing on every page of Soglow's
"Little King." The little king, though often he blandly
follows his inclination to enjoy himself unkingishly, may
yet not impossibly turn Rudolph Rassendyll and say: "If
for the good of my country I must (*a*) die, (*b*) abdicate,
(*c*) give up marrying the girl who plays the fiddle in the
orchestra, I will, s'welp me."

Ruritanian romance is wish-fulfilment: a presentation of
our unreal selves nobly functioning; of quiet renunciation
following on gallantry and never hoping for reward or rec-
ognition; all this placed in an atmosphere constructed to
look as real, as practical and as business-like as the author
can make it, so as to give an illusion that this is how men
and women do it in England. Enoch Arden is the typical
English sacrificer; Cyrano, complete with swagger and
panache, the typically Gallic version.

But the English temperament seems now to be swerving
more towards the Russian ideal. Once we were solemn and
noble and Poona-Poona. We played the game, and played
cricket, and were reticent about our feelings; said that the
best man won because he was a pukka Sahib; and that we
were not clever, not like these writing Johnnies. We said
that the fox likes it. Since the War, you will be much more
likely to encounter an Englishman who is kindly and casual
in his surface manner, but quick with nerves underneath;
as afraid of the tricks his own imagination might play him,
as though it were a jack-in-the-box.

Russians do not need to administer soporific spoonfuls of
man's nobility and sacrifice, like clear honey in a silver spoon.

Their characters can without embarrassment behave like the
Marx Brothers, in the same sort of withdrawing-room in
which the reticent hero of a polite English drama used to
make his reticent renunciations. Russians can wear uniforms
that flap about them loosely, and goloshes and funny old
hats; but wearing these, they are permitted to make speeches
(quite long ones, too) about their own souls, and the soul
of the woman in the next room, and the soul of the man
upstairs. But then Russians, it must be recognised, have no
small talk; Russian small talk is big talk always. And it is
not so much to their credit as it might appear, that they pre-
fer cosmic themes like War and Peace, Universal Love and
Misery, Madness and Prostitution, during all the years that
England persisted in ignoring the cracks that appeared in the
surface of the world, and still wrote dialogue round a tea-
table; for those themes I have just mentioned *are* the Rus-
sian tea-table themes: the congenial subjects that most nat-
urally crop up round the samovar; and sacrifice, with them,
cannot be sober, well-bred and quietly effective, because they
visualise it, truthfully, as a mixed affair of egoism, exhibition-
ism, and despair; of wearing a cocked hat crookedly, and at
the critical moment sliding on a banana skin and falling on to
your backside.

English audiences appreciate sitting in rows to watch a
well-mannered rendering of what would undoubtedly be
their own perfect behaviour, given a Ruritanian setting.
They are lulled into softly believing that because Rudolph
Rassendyll, a tall strong type of Englishman on his travels,
looks more like themselves than does Harpo Marx with
his mop of scarlet hair, enormous golden harp and inspired
idiot grin, that they are closer in reality to one than to the
other; thus making it easy to identify themselves where
identification is most desirable. They do not care for the

grotesque element brought into sacrifice; indeed, they do
not care for the grotesque element at all, in their fiction
and drama; nor the fantastic; nor the satirical; nor all
three. In a Marx Brothers film, in a René Clair film, in
any of those perplexing, quizzical, semi-tragical dream-
plays like "Beggar on Horseback," "Hannele," "Peggy-
Ann," Reinhardt's "Venetian Night," "The Moon in the
Yellow River," "Heartbreak House," "She Loves Me Not,"
"Of Thee I Sing," in all these cannot-quite-happen stories,
the properties, the sets and the events are fantastic, but
behaviour is real and human beings unheroic, often ridicu-
lous. They wander in on their wedding-day only half-
dressed; they dream of grandeur and waken to loss; occa-
sionally the best man wins, but his reward is irrelevant, his
gallant deeds often accidental, and his virtue exposed to
freakish humiliations.

Strangely enough, American audiences will stand ironic
fantasy better than English; more than stand it, they re-
joice keenly in this sort of exposure of their own tendency
to romantic uplift (witness their passion for Thurber and
Arno cartoons). Ironic fantasy is too fierce and too true for
English taste. However incredible the setting may be, the
psychology, if examined, will be found to be dead right;
dead right and most unpalatable. Here is the way life
tumbles us about, taking no heed of our dignity; not be-
lieving in our capacity to bow the head and walk out into
the night, leaving her-or-him-we-love to be happy with
another. This characteristic form of modern ironic fantasy
accepts defeat, accepts that we are not Rudolph Rassendyll,
Sidney Carton, Bertie Cecil, Mark Sabre; that we are merely
the fools in a Marx Brothers highcockalorum, where our
complexes caper nakedly, hilariously, in full view of every-
one, giving way to the most astonishing impulses; and this or

that King Charles's Head crops up to disconcert us like a
bad investment of which we cannot be rid.

A film by the Marx Brothers exactly expresses the crazi-
ness of modern life, if "exactly" is a term that can be used
of their inconsecutive antics:

"It's my belief," says Groucho to Chico, "it's my belief
that the missing picture is hidden in the house next door."

Chico objects to the theory: "There isn't a house next
door."

"Then we'll build one!"

Thus devilishly Groucho sums up our special pride in
being children of the Twentieth Century; he gives us an
effect of swift logic, decisive action, ruthless efficiency, hun-
dred-per-cent. organisation, and the result nonsense. This
bit of dialogue epitomises contemporary life; including as
it does the reeling silliness of dancing Marathons (or of any
other Marathons except the original Marathon, and of even
that); of being given a whole large roast bird on one's plate,
at a dinner, and knowing no swift and practical way of trans-
ferring at least two-thirds of it to a creature in the darkness
outside, who may be in some need of roast bird; of tyrants
thundering for freedom; of the shortest cut to peace, it
would seem, through war; of the elaborate complicated
dangerous farce of frontiers, passports and customs; and the
solemn fact that human beings can be banished from coun-
try to country, refused admittance, chivvied to and fro
and round and about and backwards and forwards, belong-
ing nowhere, rejected everywhere with official frowns and
portentous menaces, for no better reason than that to
enter one of these lunatic asylums or to leave it, you must
have something mysterious called "your papers"; if "your
papers" are not in order, God help you, for you become a
Flying Dutchman that may not even harbour in Holland,

a Wandering Jew with no rights to Zion. Of building a
house next door and using the very best materials, so as to
find the missing picture which might have been concealed
in it had there really been a missing picture anywhere.

Granted that the earth exists in a rough sort of way for
the purpose of people planting their feet upon it, all these
moron proceedings are obviously no more and no less than
a Marx Brothers film. Or a René Clair film. It is difficult
to define the difference, though it may be no more subtle
than between French outlook and Jewish-American out-
look. Sense is not shaken quite so loose, coherence has not
been violently shattered into quite as many pieces, by René
Clair as by the Marxes. A René Clair film has more patina
on it. If it be horse-play, it is race-horse play, not cart-
horse play. Once, walking round Berkeley Square, I met two
perfectly ordinary solid British policemen striding towards
me in their perfectly ordinary solid uniforms and helmets.
As they approached, I discovered with a shock that they
were talking French. That is precisely the type of delicate
incongruous shock that a René Clair film might present;
in a Marx Brothers film, it would be natural, not a shock,
for policemen to be doing anything incongruous. Yet the
satire which animates them both is the same: that contempt
for what we do in the sacred name of progress, that savage
determination to show us what it all amounts to.

I should like to see the Dreyfus Case as a film inspired
and directed by Groucho Marx:

"It's my opinion that the *bordereau* was written by the
traitor next door."

"But there isn't . . ."

"Then we'll . . ."

Part Three

A POUND OF FEATHERS

A L M O S T every child will of its own accord enliven a dull walk on pavements by making rules; such as not to walk on the cracks or to skip every third crack. The child does not even arrange penalties for a transgression of this arbitrary discipline; but simply says: "It's not allowed"; thereby itself suspending a mysterious authority over itself.

I have said that three times I will start from a casually selected object; draw three lines from three points and see then whether the space they enclose remains a vacuum, or whether anything of interest, any personal King Charles's Head, has got itself involuntarily shut into the triangle. Nobody has forced me to this formula and to these rules; and no one presumably will pass sentence upon me if I break them. At the moment, indeed, it would be very much easier to break them, for I wish to start this time from an old wooden picture found on a rubbish heap; but also I have three pictures hanging on three walls of my sitting-room, and I wish to start from all of them. This is against the rules. A rule made by yourself at some stage or other cuts its umbilical cord, gets severed from its kindly maternal conceiver, and exists merely as a rule swinging in space above, coldly threatening you, as though someone else had swung it there. In the same way, a letter when you have written it is

still yours; directly you have posted it, it becomes the property of the person to whom it is addressed; not the copyright, but that particular sheet of paper with your writing upon it. If, calling on them next day, you see it lying on the hall table and you are tempted after all to pick it up and put it back in your pocket, you are committing a theft. Nevertheless, a feeling must persist that this is unfair; that the letter is yours.

And if you have written a book, and if it is published, and if you give a copy to a friend and that friend is reading it and you want to interrupt and talk to him, you would not have the same scruple in pulling the book from his hands and throwing it without reverence on a side-table, as you would were the book by Tolstoi, Hemingway, or P. G. Wodehouse. You might argue that it is for you to say, not for them, whether they will hear the living words from your lips, or read your printed words on the page. Rapidly becoming conceited in the heat of a congenial discussion, you will remind them that the living words are being spoken only this once and for them alone, whereas the book can be read at any time and is a privilege shared by anybody with a library subscription or for the disbursement of a few shillings. They, if their mind readily supplies a quick answer, will then argue that your talk may be trivial and egoistic, and they have no guarantee of quality. Whereas the words you have written for publication may be, at all events should be, a fastidiously selected portion of your mind and experience which has slowly grown to fruition and importance. And I suppose the answer to all this, to bring it into relevance, is that one has no claim on the book, the letter, the rule invented by oneself.

Therefore I may only start with one picture. Perhaps the others can be linked on later as accessories, but not at the

starting-point. It was lying face downwards in disgrace on the rubbish heap under the wall, up by the olives; its origin unknown, for I had rented the villa from an agent. Turned round, it revealed a white dog, chiefly spaniel, painted on the lid of an old wooden box, split right across, blistered and faded from the weariness of too much Mediterranean sun. His ears were loppy and brown, and one enormous eye did not match the other even more enormous eye; but both eyes were equally beseeching, and so was the angle of the crooked paws; and so was the fact that only the head had been carefully and beautifully "shaded," and then the artist had grown tired of his job and left the rest "in the flat." That small white dog, chiefly spaniel, was born to be let down; a victim of promises betrayed. For when I rescued it from the rubbish heap, I vowed sentimentally that I would take it back to London with me and give it honourable place in my walls with my sea-picture, my "Winter in the Garden" and my "Red Horses."

And did I?

Well, it was like this (and here follows a long explanation delivered in equal parts to conscience and to the unknown artist of the little white dog, ending much too plausibly with the suggestion that the Customs would be sure to hold it up as an Old Master).

I possess my sea-picture because John van Druten wanted to buy a picture of brown hills for a friend, and asked if he could take me along to see it first. Instantly my heart grew troubled with premonitions that I should want it for myself. Then peace closed around me as I looked at it in the window of the galleries and realised that these were not hills, which I love, but mountains, which I find formidable and unfriendly. I have never been one for mountains; they come too close; they come to sit on your breakfast-

table. Barrie wrote of an Island that Likes to be Visited;
to me, all mountains are a Mountain that Likes to be
Climbed. Except, maybe, when you catch sight of it un-
awares in the very early morning, misty across a lake. Then
it seems to float, ethereal as the colour drained from a pearl;
and you are glad at the sight of it, as you are for a few
moments again in the evening light: "Über alle Gipfeln
ist Ruh," one of the few poems that has in the very sound
of the words, apart from the meaning, a tangible quality
of hush, of settling down; coolness after fever; silence smooth-
ing out clamour.

I once climbed a real mountain, Sorapis in the Dolomites;
by "real," I mean that it was marked as a peak in the maps;
and it had thick dazzling blankets of snow spread about
the summit, although it was July. Can I really have climbed
it by putting one foot in front of the other on a steep
slant for hours at a time? It cannot be true that I have
climbed it; memory accurately tells me that I have, but I
shall remain for ever incredulous. "If pottery's your thing,"
said an enthusiastic young man once trying to explain to me
some William Morris ideal of a Utopian world drained of
individual possession, "why, then you begin to shape a
pot, a beautiful pot, perhaps in London, and then you get
removed, let's say to Pekin; there you go on with what
you are doing, starting just where you left off, but on some-
body else's pot, and then——"

If pottery's your thing. Mountains are not my thing.
The sea is my thing.

We went into the Galleries to ask the price of the moun-
tain-picture. It was rather high. They offered a smaller
picture by the same artist. One glance at it, and I knew
that this time I was done for: it was a picture of a cold
grey sea blowing in on to the sand dunes, in the sort of

weather when you cannot tell what are waves and what is
spume and cloud; the wind is driving it all backwards.
Standing there on the sand you would have been wet through
in a moment, though not from actual water or from actual
rain; your eyelids, especially, would be wet and that would
be very strange, because they are a part of you that rather
get out of the wet when you are simply washing your face.
And your cheeks will be stung and feel like a child's cheeks,
fresh and scarlet and icy cold. Yes, it was a cold picture,
without line or horizon; cold and grey and green and wet.
Your sight blurred as you gazed at it; and I knew without
any doubt that John van Druten would want it for his
friend, and that covetousness is one of the Seven Deadly
Sins to which I am especially prone. There is something about
one's neighbour's ox, a *je ne sais quoi,* which endears it to me
far above my own; and that ass, too; and oh that man-
servant!

John did not care for the picture. He bought the moun-
tain and I bought the sea.

For the first thirty-eight years of my life I could eat no
oysters, which was a great grief to me because I was sure
that, spiritually, oysters were "my thing"; and that if an
oyster could only find its way into my mouth without my
knowing it, I should become one of those fanatics who would
wish to call the month of May the month of Mary, and
would make contracts out of contacts. But somehow I
could not stomach the way an oyster looked up at me from
its shell. Besides, two very jolly men had, years ago, given
me what they called "A Prairie Oyster," without warning
me that the ingredients bit. A prairie oyster is no matter for
slow voluptuous dalliance in the mouth; but I discovered
this too late. As a child of six, I was given my first ice-
cream, pink it was and pretty, without being warned by

the grown-ups that it was more than normally cold; the palate naturally expected this heaped-up spoonful to be delicately *chambrée,* like the rest of food. My system survived that shock, and I still enjoy pink ices. But I was thirty-eight before, at a small dinner-party, a plate of oysters was set in front of every guest but myself, and my considerate hostess provided caviare for me instead. Yet I had never seen oysters so plump, so pearly, so virginally alluring, so like those mountains seen across a lake, misty and shimmering at dawn. My partner offered me one; my partner persuaded me. Suddenly all Brighton pier, all Southend pier, all the piers of the world were sliding down my throat, with a whiff of ozone and the salty tang of those crusty, barnacled, sea-weedy bits of structure right at the end, half under water, below the boarding and the bandstand. The sea, grey and green, Swinburne and sharp keen kisses, spume of the waves blown back, and my picture on the wall, all slid down my throat. . . . Presently I was roving round that dinner-table cadging oysters from every plate; trying to make up for the past thirty-eight years of stolid ignorance and prejudice.

There is a little estuary village on the East Coast, which had once been a borough town of much pomp and panoply. Queen Elizabeth had herself granted it a charter. The regalia of this town, consisted of two great silver punch-bowls and ladles, the heavy seal that stamped a castle standing on a boat, a big mace with the crown and cross on it, two small silver maces, slim as dancers, and the two silver badges that were worn on the blue cloth coats of the Sergeants-at-Arms. It included also two silver oysters that measured the standard sizes when the town still had its oyster-bed traffic and grew rich on it. This little town treasured some curious personal histories which were told to me by the custodian of the regalia. I scribbled down a couple of notes,

thinking, no doubt, that here was good material for stories. All memory of the details has now been washed away from the notes and left them bare. I will quote them as they stand, that you may wonder with me what they meant and what I meant, and whether, indeed, a good story lies here forgotten:

"Sir Richard Wallace of Suffolk who married a Boulogne fishwife who never learnt English. Dying, he left his money to his secretary on condition the latter never left his wife until she died."

There is no date to this fragment, but I believe that the period was post-Elizabethan and pre-Anne. I still cannot help thinking that the material, though undeveloped, is potential and exciting. Here, clearly marked, we have the three usual characters of a triangle, but behaving unusually. Sir Richard Wallace; the Boulogne fishwife; Sir Richard's English secretary. Obviously the Boulogne fishwife would have been beautiful; Sir Richard would have been twenty years older than herself; and the young secretary would have been in love with her and she with him.

She "never learnt English." What a queer life, then, to have led for years and years and years in this little English town, surrounded by English water: sea, river and estuary; surrounded by a race stubborn with tradition, suspicious of foreigners, puzzled by strange ways. Boulogne must have been two thousand miles away from Saffham in Suffolk.

Was she lonely? No, is the simple answer to that, for her husband had a secretary. Paolo and Francesca; Pelleas and Melisande; I would wager sixpence or more that Sir Richard's secretary learnt French, if he did not know it already. Yet all this is an old story though in a tolerably original setting and circumstances. Suddenly we get the twist, and the twist is founded not on surmise but on fact.

Sir Richard "dying, left his money to his secretary on condition the latter never left his wife until she died." Does this look like jealousy? Or was Sir Richard perhaps one of these noble characters (like Sidney Carton; like the husband in "The Fountain") who could unselfishly wish his beloved wife after his death to be happy with her chosen love; and so by practical means promoted their happiness? This is too like saintliness; try another version:

Sir Richard, then, was not a full twenty years older than his Boulogne beauty. He was, on the contrary, an impulsive young man who met and married her while he was on the Grand Tour, before returning to his castle. He grew tired of her very quickly, as you might grow tired of a wife who obstinately would learn nothing to say in your own language except "please yes," and "thank you no," and "Goodnight sleep well Good-morning." So he was unfaithful, and went with that tall fair shy girl, daughter of another Suffolk squire, whom he should have married in the first place. But his Boulogne fishwife was not going to stand for that. She knew enough English to make the girl a byword. The tall fair shy girl went into a decline and died in the snow. Sir Richard lost his love and never forgave his wife. He determined that as he had not known wedded happiness, why, nor should she. Therefore he made a will by which his money went, not to Lady Wallace, but to his crabbed elderly Puritan secretary who jealously hated the foreigner for her dark beauty and animation, her freedom of speech and manner. The condition was that the secretary *should never leave his wife until she died*. No guardian angel, then; no young lovers made happy by sacrifice, but a tale of hate, revenge and loneliness. Let us hope that she shook off the crabbed secretary, the money, and the shadow of Sir Richard, who really should have had the sense

not to have married so unsuitably and dangerously; and made
her way back to Boulogne, where her memory of the Saffham
castle and estuary grew dim and shadowy. Every morning
she would sit watching the French fishing-fleet go out;
every evening she would sit and watch the fishing-fleet draw
in. When her piping grandchildren asked her (d'après
Béranger) if it were true that she had once been là-bas to
England, her wrinkles would grow deeper, her sunken eyes
glitter for a moment: *"L'Angleterre, ah, c'est bien loin, bien
loin d'ici. Je vous conseille, mes petits, de ne jamais y aller.
Choisisez vous pour mari un bon pêcheur de Boulogne.*
Please-yes, thank-you-no, goodnight-sleepwell-goodmorning.

The other more obscure entry in my notebook from which
I am not even going to attempt any development in fiction,
is just this:

"The valet who went down in the *Lusitania* and left be-
quest to the town, partly for upkeep of stained glass window
that didn't exist."

The return of a fishing fleet, whether it be to Boulogne,
Cornwall, Brittany or down by the Church of Les Saintes
Maries, in Provence, must always be a temptation that any
painter with old-fashioned hankerings will find hard to
resist. I believe, many pages back, I have told how a writer
also may find it difficult to resist contributing a "cameo"
or "prose poem" or "vignette." Yet I have succeeded in
keeping this Breton fishing fleet at bay until now, when
the story of the Boulogne fishwife seems to have been too
much for control, and it has burst through my exemplary
reticence. It may as well appear, then, disguised as an ex-
ample of what should be enshrined in no autobiography
whatsoever; or, untethered from autobiography, as an exam-
ple of what no editor should or could or will ever be per-

suaded to publish and pay for in any daily, weekly, monthly
or quarterly; or finally, as that passage which positively
must be cut out during final revision of your novel. We
will call it boldly "Vignette at Roubesac."

I sat on the terrace at about seven p.m. and watched what
seemed like a measured fantasy of a fishing fleet returning
to harbour; gravely sucked in as though by some invisible
magnet. The sails were triangles of dark hollyhock and
faded wine; damson and pansy-brown. One light-blue boat
with pigeon-coloured sails broadly spread, had a legendary
look against the deep plum of the sea at that hour. A pause,
and then more boats drifted past my look-out place and
into the kindly curve of the bay: sails yellow as wallflowers
or as leaves in autumn; one of them vivid with two rose-
hued sails; another seeming to be curvetting sideways on
the lacquered water, with sharp-cut swallow wings, white
and dazzling. Two or three of the boats were run by motor;
you could not hear them at this distance, and they still
kept their sails spread. Look at that one, with green-
turquoise sails blown back in ovals and lovely rounded
curves from the mast; blown back, and yet the boat steadily
advanced, so that it gave the illusion of a phantom moving
in swift and contrary direction from the urgent persuasion
of wind and sail. One boat, more venturesome than the
others, had already gone out the day before, and now came
back at eve with its fine blue fishing-nets draped round
the mast to dry. These flying blue nets that bellied back-
wards from the mast like the Madonna's veil in some primi-
tive but reverent picture, recalled that boat of holy legend
which had once carried the Three Maries, as it flew over
the bright dark curling waves that shattered whiter on the
rocks than Saint Veronica's handkerchief——

You see what I mean? And now, perhaps, a bit about that moving primitive of Saint Veronica in the Alte Pinathokek at Munich; holding up her handkerchief spread over her breast, her face rising still pure and still utterly without expression.

As far as I remember, my contemplation of the Breton fishing fleet returning to harbour, was broken at this juncture by loud voices disputing behind me whether any one from the little hotel on the point had as yet removed the carcass of the dead sheep that had drifted over the rocks into the swimming pool? and if not, whose duty was it? Madame's English partner declaring loudly:

"Cette carcass de moutong est rieng à faire avec mwah."

It was in Munich that I first saw a picture by Franz Marc: "Red Deer." A reproduction of his "Red Horses" is one of the three pictures hanging on the walls of my room, but the original is at Essen and I have never seen it. In a gallery in Berlin suddenly when not expecting it, I found myself looking at his "Tower of Blue Horses," which, though formally built, yet piles up to a queer romantic thrill. His gazelle, too, and his "Deer in the Forest," how intensely alive they are, lying in that angular bony way of very young animals caught unawares.

The red horses are active little red horses. I associate them with New Forest ponies, but that may be because I cannot now separate the actual picture from my use of it in a novel called "Little Red Horses" in England; "The Rueful Mating" in America. Artists usually object strongly when a writer translates paint into words. They say angrily that the one has nothing to do with the other. Musicians object even more strongly. I would hardly dare mention to a musician that I first went to hear Beethoven's Fifth Sym-

phony because I had read of its effect on the heroine of
E. M. Forster's "Howard's End": "a goblin walked across
the world from end to end." I should be even more fright-
ened to mention that it was Aldous Huxley's "Point Counter
Point" that awakened my desire to hear the A minor Quar-
tette.

When ponies gallop clumsily across a rough field to where
you are standing by the rail, warmly wrapped-up, for this
is late autumn with a bright harshness in the air; and they
whuffle into your pockets for apples, nosing each other out
of the way, with their soft warm lips turned back and
their breath rising steamily out of your pockets as they nuz-
zle and crowd; it is then that I can most feel myself like
one of the Rectory Children. Ponies must be part of the
fantasy. A pony went down regularly at the head of my
Christmas list till I was about fourteen, when Vaal River
diamonds crashed and the Rakonitz fortunes with them,
and I knew there was no more hope. A pony; bricks (stone
ones); a large paint-box (tubes, two rows; optimism on
one occasion crossed out "two" and wrote "four"). I was
never given the pony. For a London child it might have
been an awkward pet. But the Rectory Children of my
fantasy, however many to a family, however poor their
parents, always had a pony, and were always running out
to feed it, leaping on to its back, stroking its nose. A pony
was part of the fearless, shouting, laughing good time they
had, which I so passionately envied. Sometimes the youngest
little boy fell off the pony's back; it was usually an amiable
old slow family pony, so it did not matter. I cannot recall
the title of the book where the children were given a new
pony called "Diamond," but it must have been in the
same book as Gracie, the grey-eyed heroic sensitive little
cousin of the Rectory Children (only they were the Manor

Children, which is the same thing but on a slightly higher social scale, with better and wider sashes to wear, and more pocket-money). Gracie's hero was General Gordon, and her most tragical moment was when she heard Khartoum had fallen. The Manor Children were hardly sorry at all, so for once I cold-shouldered them and identified myself with Gracie who grieved bravely alone; she was a soldier's daughter and so was I (not true) and a picture of Chinese Gordon, Gordon in white, Chinese White Gordon, hung on my nursery wall.

Horses can be seen over and over again, stepping delicately through my pattern, like the famous Libyan horses in the Spanish Riding School in Vienna. Originally there had been three hundred of them; they had long flowing tails and they were only mounted by the royal family, the archdukes who rode with the Empress Elizabeth on a May morning through the Prater.

Two white horses suddenly seen from a train window, in a wild gallop up a bright brown triangle of field sloping steeply against a winter sky.

"Little Red Horses," "Tower of Blue Horses"—why is a centaur so rarely described as an ideal of fascinating manhood? Looking up "Centaur" in the Classical Dictionary, I learn that: "The centaurs were the fruit of Ixion's adventure with the cloud in the shape of Juno" (and what do you know about that?). It is fatal to pick up a Classical Dictionary: idly you turn the pages and learn that "Chrysippus, a stoic philosopher of Tarsus . . . died from laughing too much on seeing an ass eat figs on a silver plate." Pliny says that he saw a Centaur embalmed in honey which had been brought to Rome from Egypt in the reign of Claudius. We should like to have seen that ourselves. We would also like to have seen Bellerophon mounted on the winged Pegasus.

Flight, the longing to fly, to leave earth, the failure to
fly, and the inevitable return to earth, how it recurs in
mythology. We seem to have out-distanced, now, the demi-
gods and heroes: Dædalus who invented the wedge, the
axe, the wimble, the level, the sails of ships, and statues
which moved of themselves, must have been an ingenious
fellow, but flying literally got him down at last. His son,
Icarus, who accompanied him, did not survive that experi-
ment, but remains a useful symbol for moralisers: "Don't
fly too high or the heat of the sun will surely melt your
wings of wax." Dædalus, they say, was apt to be sensitive,
afterwards, if you so much as asked him to light a candle
for you. Tact must have been complicated and difficult in
mythological days; one would certainly never have asked
Prometheus for the loan of a box of matches; though
it is possible that a schoolboy humorist might have shown
young Jason a nose-bag, rudely calling out: "Foster-
fathers!"

The treasure of the Glypthokek in Munich, is the Bar-
berini Faun. He may not be of the greatest period of classic
art, but he is the perfect study of unselfconsciousness in
statuary. You see him at the end of a long narrow vista of
galleries, a round glass window behind him sharply out-
lining his head. He is sitting on a rock, his head flung
back, asleep after bacchanalia. The droop of his massive
limbs shows utter exhaustion, especially when you walk
round and see from the back his right arm and hand flung
behind his head; his sulky sensual beautiful face, aban-
doned to sleep, looks almost innocent again.

I like him nearly as much as that other faun, the faun of
Praxiteles, the one in the same room as the Dying Gladiator
in the Capitoline Museum in Rome. The faun awake is
also unselfconscious; he is too indolent to be anything else;

insolent and indolent. I have been told that he, too, is not
of "the best period"; the second-best in statuary seems to
have an unlucky attraction for me.

It is difficult to be unselfconscious: even if you can man-
age to forget most of yourself, a fragment, a shoe, will
still obstinately protrude. Once upon a time I had an ap-
pointment with Mr. Basil Dean; and a mysterious message
reached me from him that I was to come round to the stage
door of the theatre, because he had a shareholders' meet-
ing that afternoon. To the word "shareholders," the adjec-
tive "angry" immediately attaches itself. All shareholders'
meetings are, surely, "angry shareholders'" meetings, or
have I merely built up this image of broad red faces and
furiously waving arms, an apprehensive voice crying "Or-
der! Order!", from Galsworthy's famous description of
such a meeting in "The Forsyte Saga"? That meeting where
Soames, the scapegoat, ends his speech with the words:
"Gentlemen, I do not tender my resignation. I resign."
Or from the angry shareholders' meeting in J. B. Priestly's
fine play "Cornelius"? At all events, I looked on Mr. Dean
as already doomed. Probably he would be torn limb from
limb. I met him among the scenery; and to my surprise
he blushed like a small girl going to her first party as he
explained that he and the others were presently going up
on the stage ("the others" consisted of Sir Gerald du
Maurier, Mr. R. D. Blumenfeld, Mr. Arnold Bennett and
Sir Neville Pearson) and he thought, in fact they all thought,
it would be nice if they could have a lady to sit up there
with them. That I was a totally irrelevant lady did not
seem to occur to him. Being called a lady, gallantly, always
makes me feel like "one of the fair sex." Naturally it
crossed my mind that he hoped the mob of angry share-

holders might not charge on to the stage if one of the fair sex were in evidence.

Ehret die Frauen, sie pflechten und weben
Himmlische something-or-other in's irdische Leben

A murmuring, a sort of hum, could be heard from the stalls, as though armies of discontented bees were assembled. "I think we'd better go up now," Mr. Dean suggested to the others. There was a certain amount of diffidence; of pushing each other forward; of "You go first!" "No, you!" "No, *you!*" Finally Mr. Dean went first; then two gentlemen; then the lady; then two more gentlemen. We sat on the stage, in a semicircle round a table. There was a glass of water for Mr. Dean who made an eloquent speech about films and an affiliation with Hollywood. The stalls and dress-circle were crowded, but the shareholders seemed perfectly amiable. Gradually I realised that I had been brought on to the stage more as an ornament than as a protection; a sort of softening of the atmosphere: "The ladies, God bless 'em," and so forth. It might have been a happier, more flattering thought if I could have forgotten my shoes. If I had known beforehand that I was to sit on the stage of His Majesty's Theatre with five notable gentlemen, I should have put on my best shoes. These I had on were somewhat down at heel; they were all right just to run round to the stage door for a brief chat in the semi-darkness with Mr. Dean, but in that fierce light which beats upon a throne, they were frankly unworthy. And of course the shareholders were staring at them *hard* all the time. . . . For about an hour and a half I sat up there, thinking about my shoes. I could imagine exactly, without looking down, their shape, their pose, the way the light fell upon them.

You are not liable to go far wrong in a mental vision of your own feet; if imagination fails, you can, after all, stick them straight out in front of you and have a quick look. But I should very much like an anthology in which about two or three dozen famous people described honestly and conscientiously what they imagined to be their own faces. If the anthology were a private collection, then the contributors, naturally, would not be famous, but, better still, consist of one's own personal friends and relations. I doubt if any of these "cameos" would be a portrait either of the face seen by its owner in the glass, or of the face seen by the owner's friends; nor would it be recognisable as the face encountered by its owner with surprise and pleasure in a skilful studio photograph; nor, again, that more affable and striking but perhaps less agreeable encounter between the owner of a face and a snapshot. A mental vision of ourselves is an impulsive uncontrollable affair wholly unrelated to fact; occasionally touched up by flattery or corrected by dispraise; and even after such correction, liable to slide back again to its former state of spontaneous creation by some process that cannot be identified as reasonable.

For it is true that most of us, looking in the mirror from motives of curiosity or in preparation for battle, are liable to say always with some surprise: "Is this *really* myself?" Myself is not a miracle that presently we take for granted. We take changes wrought by age or illness far more placidly; we expect these, they are natural; the mystery is that original conception of shape and bone and colour, that sudden likeness to a parent or ancestor.

Yes, such an anthology, if it could be collected with a preface by any good professional cynic, might be a perfectly handsome gift book to present at Christmas time.

Gift books amount to a passionate problem of what you

are to do with them. Nowadays they are so precious and exquisite that they even have to be contained in outer boxes as precious and exquisite as their own bindings; so you cannot look a Gift Book in the mouth, because it is wedged too tightly into its outside case. They must not be allowed to lie about on the round tea-table any longer than six or seven weeks, because they get in the way of the tea. You cannot throw them out of the window, because somebody might be badly hurt. I think perhaps they should be suspended from a beam in the ceiling, like home-cured hams in an old-fashioned kitchen.

Quite the nicest sort of book, however, either as a present or to keep, is made of blank pages, about three hundred and eighty-six of them, within real book-covers. There can be no disappointment about such a book, for you can write it yourself on these white, receptive pages; or use it as an intimate diary. ("I feel strangely miserable this evening. I wonder why. My friends don't seem to understand me. Probably I'm far too complex.") I once came across a dummy book with the title "Chapters on Symbolism." It was very seriously and decorously bound, with a cross, a circle and a triangle stamped outside in dim gold; and the empty pages had been used by a child of seven for drawings of fat people with funny legs, and of crooked houses with door-knockers but no chimneys. . . .

I once painted a picture of Noel Coward painting a picture. Both at the same time, we had been seized with a passion for doing what was not our own job. Browning tells us in his dedication of "Men and Women," that Raphael would much rather make "a century of sonnets" than draw Madonnas; and that Dante had no end of a good time painting an angel to please Beatrice. Browning says, furthermore, that it is for the sake of the one and only beloved,

that artists like to break away from their professional jobs, for dalliance in amateur experiment. There I disagree; we would always wish to do our best for the beloved; and our best, for better or for worse, lies within our own profession and not at a tangent. Raphael could not have thought his sonnets very good (those seventh and eighth lines!) and Dante must have had some doubts of his angel's symmetry. They would have done these for fun.

For fun. In short, for themselves. The beloved would never have been given so much as a sight of them.

Noel sold me the painting that he did that morning for £1 18s. 6d. The sum shows clearly enough that bargaining took place, and that his original valuation was £2. He demanded, further, that it should be insured for not one penny less than £4,000. It really might be a good deal worse: a rather solid yet Whistlerish effect of dark blue archways across the Seine at night. He called it "Where the Bee Sucks." The portrait that meanwhile I was making of him was less artistically successful, yet it must have contained some rude elements of truth or my model would not immediately have destroyed it. I recall that I gave him three legs instead of two; three legs seemed essential for the balance and rhythm of my composition. I still do not think that by so doing, I tampered with the likeness. If I had been left long enough to play around with it, if indignation had not intervened, I have little doubt but that it would have been gradually incorporated into one of my wonted patterns; the third leg was merely the beginning of the usual eccentricities of loop and curve and spiral. Presently my own monogram would have been woven in, and the letter "M" and other arabesques.

The third picture on my walls is "Winter in the Garden" by Henry Lamb. I prefer cold scenes in a warm room.

"Winter in the Garden" shows no actual traces of winter as yet; I should have placed it in late November. The earth is purple, and the distant woods are shown in that melancholy only-just-leafless stage when people comfortably indoors are saying: "How the days are drawing in." A colder picture than actual snow. The same sort of lighting that I remember when I was about fifteen, lugeing slowly home, down to Montreux after a tingling day spent high up where the snow was thick and the sun hot and the air sharp and clear and fresh as though early morning lasted all day. I had plenty of company lugeing up there; but I always liked to make the homeward journey in the crépuscule (almost anybody can be forgiven for preferring the word "crépuscule" to "gloaming"). The snow would get thinner and more threadbare till there were long patches of hill and village street where the luge could not be forced to scrape and bump along another inch, and I had to get off and carry it; then again for about a quarter of a mile I could shoot swiftly downwards. This was solitude without loneliness; it had a quality which is exciting to remember, though I cannot tell why, for there was no danger in the journey. Most of my companions used to prefer going down together, chattering, by the funicular. So perhaps this sense of stolen delight was because these solitary two or three hours were voluntary. Mother, waiting for me down in the brilliantly lighted hotel beside the lake, would have preferred me to go down by funicular. I had so often heard her say: "Because, after all, you never know." She said this as a deterrent, but to any one youthful it might easily have been a recommendation.

London silence and solitude is a wholly different matter, especially when you are over forty. Whenever I am unexpectedly left alone for a long quiet evening or late afternoon, I begin telling myself with firmness how deeply I appre-

ciate solitude flowing round me like water in a moat. Stead-
fastly I think of the lapping sound of thought; and I
remember with determination all I have ever read about
thought and silence, by people of distinction who have sin-
cerely needed and loved them. And I try to link myself
with them in spirit.

But I cannot do it. I am deceiving myself. I love solitude,
but only on condition that it is not compulsory. Had I been
told, when I was fifteen, that I *must* luge and walk home
towards evening down the mountainside because there was
no funicular and because I had no friends, I would not have
been exhilarated; I would have been slightly sorry for my-
self instead, desolate and alone in the half dark; and fear
would have had to be tripped up and laid sprawling by
drama, the drama of being alone; and that would be the
end of that mysterious elation which has nothing to do with
dramatised self-pity.

I will always assume that the best people prefer to be
alone; and that great and unpremeditated things happen in
their minds through these hours and days and weeks of
retreat. And could I be sure that at any moment I *could*
summon the Rectory Children, my preference would cer-
tainly be for their room rather than for their company. For
those Rectory Children laugh and chatter so loudly! they
sing so many choruses; they scuffle and wrestle and fling
each other down with such robust energy! What would the
hermit of Milton's "Il Penseroso" have thought of them?

Hermits are mostly exhibitionists. When I was shown a
troglodytic cell at St. Emilion, and told with profound re-
spect how the saint had sat or lain for years on that cold
stone slab hewn out of the rock, while pilgrims visited him
all day long admiring his solitude and begging for his bless-
ing—it did just occur to me that there was a flaw in this

hermitage; and that the good Saint Emilion (I recommend the wines that bear his name, and particularly Château Ausone) might have been heard loudly complaining if his visitors' book showed only one hundred and eighty-seven signatures that Wednesday, when on the Saturday before, no less than four hundred and six pilgrims had dropped in for a chat.

That Christmas at Montreux was the second after we had sold our home in Ladbroke Road. The previous one had been spent at a Hydro in Brighton. I had dreaded it, having a formula of Christmas as a matter of presents in the morning, holly in the dining-room, family dinner, and a tree in the billiard-room after tea, with games to follow and the prospect of a pantomime on Boxing Night with the Rakonitz uncles. Surely it was impossible that it could be enjoyed in any other way? But the Hydro at Brighton was a revelation of what a cheap good time could be. It was, in fact, a new and glittering version of the Rectory Children. We had gymkhanas and we had fancy dress balls; the "Merry Widow" waltz, then new to England, haunted the air, and I told myself that this was life and no mistake. Sometimes one is shy and not popular, and sometimes one is popular and not shy. This was one of my periods for being popular. Especially with Rollo. Rollo was eighteen, and after these holidays was going out to Ceylon on a rubber plantation. We settled that I should join him there. We were not romantic, only heady with excitement; Christmas-excited; Hydro-excited; hydro-headed.

Two years later, when I was at a day school in Wiesbaden, living with mother and father in a hotel there, I had a letter from him. The evening before, I had had a proposal at the Kurhaus ball from an engineer of thirty; a good-

looking Bavarian who was going out a few weeks later to
Valparaiso and wanted to marry me and take me along with
him. Flattered, at sixteen, by the solemn integrity of his
intentions, I had accepted him, Valparaiso and all.

Now came Rollo's letter.

How could I ever think that I would marry a German?
I went to school heavy with the problem of how best to
free myself from the engagement. My fiancé had already
spoken to father, and I had not grasped that father's rich
chuckles were in any way connected with this almost holy
interview, this impressive turning-point in his daughter's
life. My German schoolgirl companions were mostly in love
with the English mistress; they called her "Goldfischen,"
meaning "Little goldfish," and inscribed her name across
lozenges which they wore round their necks; they were
exceedingly sentimental, and sighed that her eyes were the
heavenly blue of forget-me-nots. Naturally, an English mis-
tress, like legs to a bus-conductor, was no treat to me, and
I reflected proudly on my superior state of being engaged
to one man whom I loathed, while another in a far land
sent me messages of inconsolable passion ("I say, I do wish
you were here. Do you remember what larks we had at the
old Hydro? I say, I often think of it, that last waltz and
what you promised me when it was finished, only you didn't
give it to me, did you? Yesterday there was a native dance
which the chaps arranged . . ." and so forth).

During the night I lay awake, and suddenly I could bear
no longer the burden of being really engaged; I jumped out
of bed and rushed into my parents' room crying: "I can't
marry him, I can't!" or something equally in heroine tradi-
tion. "It can wait till the morning," said father; and with
another of those perplexing chuckles, turned over and went
to sleep again.

A month later we went to Montreux, where my education was being finished and given a lick and a high polish. During the holidays, when not lugeing, I was taken on the lake by a jeweller from Bukarest who wanted to marry me. (This is not such a pageant of triumph as it may seem: Jewish girls develop very early and often get less proposals after they are twenty than while they are still in their teens.) Father, for reasons I still cannot quite understand, while he had not considered Ceylon or Valparaiso seriously, was rather taken by the suggestion that I should become the bride of a jeweller in Bukarest: "Mother and I could visit you there," he said; "we should like that." Had I married this estimable gentleman, my situation during the Great War, in the very heart of the Balkans, might have been a little uncomfortable; or I might have become wholly orientalised by then, and have written no books, and munched quantities of Turkish delight; a very different décor from sitting here in Regency London with my three pictures on the walls.

The first time you ever buy a picture, you are amazed that such a thing can actually be done. Connoisseurs buy pictures, and dealers, and very rich men, and Soames Forsyte; dukes used to buy them; you had never imagined acquiring a picture yourself in that bold and hazardous fashion. At the age of about seven, I suddenly asked for a picture as a "chief" Christmas present, instead of the usual pony, paintbox or stone bricks. But Louis Rakonitz, my uncle, was a patron of the arts, a bit of a Mæcenas. So to him mother passed on the request, feeling no doubt a little proud of her so unusual small daughter. Uncle Louis, puzzled as to what would be suitable, lowered his standards and compromised with my age and innocence. A mistake; he should have brought me a picture which would have put some strain on

my appreciation and purified my taste. The picture he selected was called "Two's Company." It was not even cheerfully juvenile: a fair lady in blue was sitting on a garden bench under a tree, flirting with a gentleman in a claret-coloured coat. A dark lady in yellow was walking away from them and looking back jealously over one shoulder. I was elated with my grown-up picture, and learned from it two or three valuable lessons, mainly the one which Anita Loos, years later, was to teach the world in three words.

But after I had bought my Algernon Newton seascape, and my Henry Lamb "Winter in the Garden," a drunken longing beset me which had to be fiercely fought and beaten off: a longing to buy more and more and more pictures. There was a Vlaminck that I wanted and a Bisière and a Chirico (a delicate little white mare, all fire and flying grace and excitement, prancing on the sands beside the sea; tempting a black haughty stallion, who eyed her with the same reluctant admiration, and the same determined control of it, as Darcy had for Elizabeth). Those small private shows are the very devil. Once inside the galleries, I became reincarnated as one of my uncles. The proprietor had known Uncle Louis very well indeed, and always received me and showed me round with an air flatteringly equal, one critic in fine shades conversing with another. I caught myself replying with the inflection and delivery I had heard from my uncle; the identical moderate pessimism and occasional cool appreciation which he had used towards modern painting. When I paused in front of some special bit of work I fancied, and stepped back and fidgeted about the way the light fell, I could have sworn that my left hand was fumbling with the monocle that he wore. A touch of impatience, or let us call it irascibility; then a quick fear lest I should have offended my companion, so a little extra courtesy and deference to

his opinion. . . . It was terribly hard, after I had been my uncle and a connoisseur for the past twenty-five minutes, to leave the galleries without definitely buying. I *wanted* that Vlaminck; his bold country roads and sunsets and harvests and vases of flowers and snow-scenes and other peaceful hackneyed gentle subjects are somehow brilliant and catastrophic and lurid. He wrenches his paint on to the canvas. It lies in thick swirls and ruts, with stiff edges standing out in ridges. I wanted the Vlaminck, or I wanted one of Utrillo's many versions of a road in a small French town, with the shutters down because it was Sunday, and an empty café at the corner.

It was to be a day of three separate incarnations. When I reached home, I found myself alone in the sitting-room; the broad high window that looked straight down the Eastern vista of Savile Row, turning dark Mediterranean blue as the daylight ebbed and a richer colour filled up the luminous rectangle between the straight line of burgundy taffeta curtains that fell heavily on either side of it. I could lie back in my armchair, in that faintly enchanted silence, that droning peace, lulled and oblivious as though I were under the sea "full fathom five" and had learned how to breathe down there. The slightest sound would have shattered tranquillity, except from the traffic far below, and that drifted up to me steady and rhythmic as a waterfall; not, as it so often was, spasmodic, shrill and jerky. I had not been able to buy a picture; nevertheless contentment lay in my lap like a purring drowsy cat, so nearly tangible that I put out my hand to stroke it.

Then, like a prelude to bad modern music, came three shattering crashes, one after the other, on the ceiling above me.

And that was the end of contentment and rich dark Mediterranean blue, droning silence and the distant lull of

a waterfall. For the ceiling above me was, naturally, the floor below somebody else.

These attics had a fitful tenancy; the tenants, before they could be ejected as noisy and undesirable, had to give proof of being both; then they were heard of no more, and for months the attics would be silent. At the moment, I knew that a couple of very quiet girls, students I believe, were inhabiting them.

Yet this did not sound like a couple of very quiet girls; it sounded like lunatics and elephants dancing and throwing trunks at each other. Every few minutes came a wild scurry of feet right across the ceiling from end to end, running races; then thud, thud, throwing down wardrobes; crash, crash, that was a rehearsal for the next Marx Brothers film; then some more lunatics dancing with more elephants. No voices and no music; just heavy furniture having bad dreams and stamping about in its sleep.

I will not say I listened, for there was no option in the matter except going out for the rest of the evening; and I had no wish to go out. A certain grim relish blended itself with rage, for the artillery above my head was so overwhelming that I could deal with it without wondering if I were being perhaps unnecessarily irascible. After about twenty minutes, I got up, and went to my desk, and picked up my fountain pen. As I did so, the noises stopped as though they knew. Then, after a pause, three more defiant crashes announced that the overture (by special request) would be repeated.

Now I had thought I was going to write to these overhead fiends either like an angry author or a nervous invalid. So that I was more than surprised when the letter came out in courteous old-world phrases of one who would not see seventy again, no, nor seventy-five; who politely regretted her inability to be indulgent towards the natural barbarities

of the young generation, alas, so far removed from her, but who threw herself, lavender and old lace, mittens, white curls, quavering voice and ebony cane, on the mercy of a gentleman's tolerance and understanding. The very handwriting of the letter was spikier and sloped more than usual; it was definitely not my handwriting; neither was this my phrasing; it was too suave, too detached, too delicately deprecating; the irony was not of iron at all, it was filigree. I concluded by inviting the unknown miscreant, the host of that assembly of lunatics, elephants and trunk-throwers, to honour me, with any of his friends who would care for such mild entertainment, by coming downstairs for a glass of sherry. The last line of my letter before the signature, ran: "You must forgive me; I am a very old lady," and at this the handwriting sloped more than ever and was more finely pointed, with a slight quaver in the down-strokes.

I had no intention to deceive anybody, or deliberately to put on fancy-dress and assume another character. This very old lady had taken possession of me, as my Rakonitz uncle, the fine connoisseur of pictures, had taken possession of me a couple of hours ago. It must have been from first to last, a day in which my own personality was weak and could easiest be conquered by a mood, a memory, a sense of what befitted the occasion.

I sent the letter up with my maid. Followed an awful pause in thumping misrule. I could imagine the guests tiptoeing away, one by one, for they could not all have suddenly been lying slain upon the floor which was on the further side of my ceiling. No, they had tiptoed away whispering "sorry" to their appalled host, who now sat up there alone, wondering what the hell he could do about this old old lady whose declining days he had helped to murder.

He must have sat remorsefully brooding (I could almost see the shape of his remorse through my ceiling and his floor) for a full twenty minutes. Then the telephone bell rang. But by that time it was too late; the frail old lady had assumed another incarnation. She had only occupied my soul for a short time.

If I am spared, shall I inevitably become this frail old lady? One cannot tell; but I fancy she was a little too courteous; placed too much reliance on the chivalry of her opponent, having been brought up to believe this the only way to victory. I suspect that the old lady who lies ahead of me in time, waiting for me to join up with her, will be of rougher texture; more prone to advance towards a situation like the present one and scour it as you scour sauce-pans, with a handful of harsh glinting copper shavings, than politely massage it with delicate, mittened fingers. Not that it is a bad thing at moments to try on your future age, its exigencies and limitations; see if it fits ill or well with what you are now; see how supple you will be to adjust yourself. It is difficult for youth to try on middle-age before they reach it, though middle-age can occasionally stroll forward and meet old age half-way. Youth is too rigid, too unim-aginative; alternately too conceited or too diffident for deal-ing with any perilous state (since all ages seem perilous to youth except the one actually on them and surrounding them). But when you are middle-aged, you have a wider, more prophetic and more flexible range. "In middle years, a fearful thing," thus dramatically the ballad opens:

> In middle years, a fearful thing
> Befell Archduchess Ann.
> She looked outside her wedding-ring,
> Upon a comely man.

The balladmonger seemed of the opinion that the middle-aged Archduchess ought to be jolly well ashamed of herself. The balladmonger was George Meredith.

I have little belief in that woman so well-known to fiction, who suddenly one morning looks into her glass and with a shock sees that she is old. What, I ask you, has she been doing on other mornings in front of the dressing-table, for the last seven years or so? I have in my collection of walking-sticks a very good practice stick in preparation for a formidable old woman; not, mind you, the gentle lady who wrote that letter to the enemy upstairs; she would lean on ivory always; or perhaps in her statelier moments, on white malacca. My formidable stick is of stout oak worn smooth since it was first cut in 1813, two years before Waterloo. The curve at the top leans back and thickens before it bends over into a small hook. It has no ornament, though originally it was pierced for cord and tassel; no ornament except a tiny worn silver oval let into the top, which says: "H. Melville, 1813."

For a little while the novelist in me fought hard against the conscientious biographer, to make it the property of that Herman Melville who wrote "Moby Dick"; but investigation proved that it could not be managed by a full two years. The "Jalna" grandmother would have used this stick; and the Duchess of Wrexe. I have, however, several ivory alternatives, in case, contrary to what is indicated now, I should fulfil my years differently. For this heavy oak with its smooth thick crook bending proudly backwards is not by any means matched to a scrupulous or considerate personality.

But when the telephone bell rang, I was neither an ancestor nor a prophecy. I was writing a dedication. My own personality must have been especially fluid and tenuous, that day, to have thrice permitted itself to be so

easily dislodged from its rightful habitation. I hope truly
that I shall never become as the man who wrote that dedi-
cation; nor that I have ever been as heartily bogus. Yet I
swear it was no conscious parody, but a corporate soul of
many many dedications of recent times:

MY DEAR MICKY,

You may remember perhaps, or you may not, one sullen day
in October when we were walking slowly home across the stubble
in the Sussex swale, when you suddenly said, prompted by I know
not what impulse: "By Jove, wouldn't it be a grand thing to
translate Marcus Aurelius into English sonnet form?"

Your words made no deep impression on me at the time; the
otters had not risen well that day, and I was tired from a night's
beagling. But later on they returned to me, not wholly unprofit-
ably, with the result that you now see before you in this little
volume, whose sole claim to notice is your acceptance of responsi-
bility.

<div align="right">G. B. S.</div>

So I was out of harmony with young Mr. Kronen when
he telephoned down from the attics apologising with such
strong sincerity for having violated my peace, and begged
that I would show him my forgiveness by mounting a flight
of stairs (oh, *very* slowly and carefully; in fact "I'll come
down and fetch you, if I may") to drink, perhaps, a very
small cocktail (mixed, oh so slowly and carefully). He
intended a subtle flattery by offering the old lady a cock-
tail as though she were a contemporary, instead of the
obvious Madeira or sherry that her palate was accustomed
to. And he was naturally a little perplexed by the bluff
manner in which his apologies were accepted, dealt with
and shoved out of the way; the vigorous tone with which
the sweet old thing explained that she was busy working,
and some other time perhaps young Mr. Kronen and she

would hobnob together over a couple of quick ones. He had said that he had been lent the attics for a couple of days, and no one had warned him of the obvious necessity for the most perfect tiptoe behaviour, so he had given a *little* party, just two or three of them; "and perhaps, you know, we *were* making a bit too much noise. I'm so frightfully sorry. You'll forgive me, won't you? If I'd known . . ."

I liked young Mr. Kronen, but why, I asked him, did he and his little party of just two or three, unpack and then pack again and then throw the trunks about?

"Throw the *trunks* about?"

"Yes, and the wardrobe, too; wearing Wellington boots."

He was terribly puzzled. One of them *might* have dropped a sandwich, certainly, but—trunks and wardrobes and Wellington boots?

I had meant to inquire, as well, about the rush of rogue-elephants across the floor in a potato-race; but he was too bewildered, and I let him ring off.

In dedications, it is more blessed to give than to receive. Therefore those dedicating should always, if possible, use the language of the gratified person for whom the inscription is meant. Thus that strong, austere "To J," no more than that, will be a great disappointment to "J," if he hoped to find printed on the front page of a book for every one to read, a flowering description of all his best qualities:

To J.
Who could never be tried by his peers,
For he has none
That debonair gentleman whom to see
Seven days in the week, thirty days in the month, three
hundred and sixty-five days in the year, would be all too little.
That irreproachable dandy

Who beneath his waistcoats of impeccable taste and restraint
conceals
But not from his friends
That quality rarer than the phœnix
of Not
Knowing how rare he is, how distinguished, how amiable
I dedicate
This trifling inconspicuous unworthy all too mediocre totally
valueless
Little volume
Only fearing
That from those motives of great-heartedness
In which he excels
He will find virtues in it
That are not
There-at-all.

I am fond of dogs; deeply and unreasonably fond of them;
though I have never subscribed to the platitude that the dog
is the "intelligent friend of man." For consider a spaniel,
for instance; how with ears flapping, forepaws scuttering
in all directions, he will chase a rabbit year after year, some-
times the same and sometimes a different rabbit, but with no
hope of ever catching up with it; how he will lie down
heavily on a bed of your recently planted bulbs just begin-
ning to show tender and fragile above the earth, and when
you furiously holloa to him to come off, will wag his tail,
gaze up at you with love and devotion unalterable in his
sherry-coloured eyes, and then roll over heavily on to his
back the better to destroy the little green shoots. And a
million other examples I could give, proving that the word
"intelligent" should be deleted from that sentence.

So I would never dedicate a book:

To my Three Dogs
Waffles, Hereward and Spot
Who are my Severest Critics

because it can bestow no real benefit on Waffles, Hereward and Spot; so there is a gesture wasted. And anyhow, they are not your severest critics, and well you know it. For the same reason, I would not dedicate any book except what is uncontestably a book for the bairns, to:

Darling Teddy, Bettykins and Baby Dot
Who are my Youngest and Severest Critics

for exactly the same reasons. For even if they grow up and are able to read the dedication, they would appreciate a less silly compliment.

Another irritating form that dedication sometimes takes is purely esoteric:

To You
For what you once said to me
On a certain evening
And for what I did not reply because I dared not
Only now perhaps you will guess!
And anyhow the shape of the water-wheel always remains
But how I wish we had taken that horseshoe home.

You cannot help feeling that all that might have been argued out between you in privacy, over a cup of tea.

Dedications and prefaces of to-day are mostly as flippant and not more important than the button-hole on a distinguished toilette. Except in some cases of over-dedication, where the book that follows is the button-hole.

The great period of dedication was during the Elizabethan era; which might almost be named, in a term of contemporary slang, the Yes-man Era. A perpetual portrait is painted for us in these dedications, of Gloriana enthroned on the seashore, surrounded by a group of poets, dramatists, song-writers, masque-makers, essayists, adventurers and

soldiers of fortune, all assiduously assuring her that the in-
coming tide will not advance save by her permission.

But though it was recognised that the Elizabethan writers
had to make their dedications a matter of expedience:

I being now led by powerfull custome to seeke a Patron for
this my Worke, and knowing that the weakest frames need
strongest supporters, have taken the boldness most humbly to
commend it to your Honour's protection: which vouchsafed, it
shall triumph under the safeguard of that massy shield . . .

it would be unfair to think them only flatterers, only yes-
men, in their dedications. Dedication was then an art in
itself, and they would have been ashamed not to take pains
to lend it grace and spirit and savour.

I possess an Anthology of Elizabethan Dedications and
Prefaces which charms and amazes me whenever I turn its
pages, by the lovely rise and fall of its cadences, and by
the thrill of finding spilt recklessly into print such signifi-
cant names and events as "The Holy Bible, authorised ver-
sion, 1611. To the Most High and Mightie Prince, James
by the grace of God." And Edmund Spenser's "Faerie
Queene," 1596: "To the Most High, Mightie and Magnificent
Empress Renowned for Pietie, Vertue, and all gratious
Government, Elizabeth." Poor Greene's valedictory pref-
ace: "To those Gentlemen his Quondam acquaintance, that
spend their wits in making plaies, R. G. wishes a better
exercise, and wisdome to prevent his extremities." Later
occurs the poignant phrase: "deeplyer serched with sickness."
And he ends: "Desirous that you should live, though him-
selfe be dying."

Sir Philip Sidney says: "To My Deare Ladie and sister,"
speaking of the Countess of Pembroke in terms of praise

and affection that are not in the least those of Any Brother
to Any Sister. "To Mistris Anne Fitton, Mayde of honour
to the most sacred Mayde Royalle Queene Elizabeth," sets
us all wishing we might write a story of Gloriana, in order
to title it "Mayde Royalle." Strangest thrill of all, and last
of this gallant collection, is the first dedication of William
Shakespeare's "Comedies, Histories and Tragedies": "onely
to keepe the memory of so worthy a Friend and Fellow
alive, as was our Shakespeare, by humble offer of his plays
to your most noble patronage."

We may smile at the hyperbole of love, the witty abase-
ments, the extravagant supple protestations; but lightly
running our fingers, as it were, through this carved and
glittering profusion, we are given gems of the period which,
anticipating the absurdities of our own twentieth century,
might easily be set into a Cochran Revue of the Elizabethan
Age:

"You may perhaps judge the writing of my daily ex-
pences in my journies to be needles and unprofitable, in
respect of the continuall change of prices and rates in all
Kingdoms" (sharp rise in the dollar; francs drop to 71.55).
"In 1599 Kemp undertook the morris-dance from London
to Norwich. His journey required twenty-three days, but
he spent only nineteen days in actual dancing." (And where
are your Marathons now?) And again: "This early report
of the state of Russia begot a note of protest from the East-
land merchants, who remonstrated with Burghley lest it
give offense to the Russian Court." (Our intricate foreign
policy.)

And "We commonly see the booke that at Christmas
lyeth bound on the Stacioners stall, at Easter to be broken
in the Haberdasshers shop." (From Hatchards to Wool-
worths.) "It is not straunge when as the greatest wonder

lasteth but nyne days, that a newe worke should not endure but three monthes." "We have a strange secte of upstart Phisiognomers growne up amongst us of late, that will assume out of the depth of their knowings, to calculate a mans intent by the colour of his complexion; nay, which is miraculous, by the character of his reporte." (Flourish and alarum, and enter professors Freud and Jung.) And "For Diet, none but the French Kickshoes that are delicate" (such as Cod à l'Anglais).

But neither casual mention of the immortals, nor the always amusing discovery of the fellowship of then with now, can compare with the delight in coming upon such wine, such magic, as is splashed upon five or six pages of Richard Hakluyt's preface to "Virginia Richly Valued," published in 1609.

"To the Right Honourable, the Right Worshipfull Counsellors, and others, the cheereful adventurers for the advancement of that Christian and noble plantation in Virginia"; and then much excellent talk, interwoven with Spanish phrases and streaked with Indian names, of "mines of gold" and "copper hatchets found in Cutisachiqui, standing upon the River of Santa Helena," and "a great melting of red mettall," and "the huge quantitie of excellent perles, and little babies and birds made of them," and "neither are the Turkie stones and cotton wooll found at Guasco to be forgotten," and "the great number of Mulberrie trees, apt to feede Silke-wormes to make silke. . . ." And so on, through more enchantments than I have room to quote. This is the very grain and texture of Elizabethan adventure.

Thomas Lodge, another explorer who wrote of "discomfortable mountaines," while suffering more than discomfortable stomacke on a ship in the "straits christened

Magellan," comments shrewdly (for indeed shrewdness is a significant thread twisted through the blossomy tapestries of euphuism): "To be short, who lives in this world, let him wincke in the world; for either men proove too blinde in seeing too little, or too presumptuous in condemning that they shoulde not."

To be short? But this book forces a lingering spell on whosoever reads it. Who can be "short" when another turn of the page brings up the first dedication of one William Shakespeare's "Troilus and Cressida": "And beleeve this, that when hee is gone, and his Commedies out of sale, you will scramble for them . . . His mind and hand went together; and what he thought, he uttered with that easiness, that we have scarce received from him a blot in his papers."

An amusing difference appears between the style of dedications to Princes and Earls and other noble patrons, and those that are simply dedicated to the reader, or to Any who will Read It. The latter betrays the natural man. Michael Drayton, indeed, shows such honest anger with his critics for not liking his book enough, as can cause us to-day to envy him for not being held back by considerations of bad form:

"Such a cloud hath the Devill drawne over the World's Judgment, whose opinion is in few yeares fallen so farre bellow all Ballatry, that the Lethargy is incurable; nay some of the Stationers, that had the Selling of the first part of this Poeme, because it went not so fast away in the Sale, as some of their beastly and abominable Trash (a shame both to our Language and Nation) have either despightfully left out, or at least carelessly neglected the Epistles to the Readers . . ."

In 1623, John Heminge and Henry Condell dedicated

The Comedies, Histories and Tragedies of William Shakespeare, twice over. First:

> To the Most Noble
> And
> Incomparable Paire
> of Brethren
> William
> Earle of Pembroke &c. Lord Chamberlaine to the
> *Kings most Excellent Majesty*
> And
> Philip
> Earle of Montgomery, &c. Gentlemen of his Majesties
> Bed-Chamber. Both Knights of the most Noble Order
> of the Garter, and our singular good
> Lords.

. . . "For, when we valew the places your H.H. sustaine, we cannot but know their dignity greater, than to descend to the reading of these trifles."

This of Shakespeare, mind you. And having got it off their chest, they then dedicate the same volume to the great Variety of Readers:

"From the most able, to him that can but spell: There you are number'd. We had rather you were weighed. Especially, when the fate of all Bookes depends upon your capacities: and not of your heads alone, but of your purses. Well! It is now publique, & you will stand for your priviledges wee know: to read, and censure. Do so, but buy it first. That doth best commend a Booke, the Stationer saies. Then, how odde soever your braines be, or your wisedomes, make your licence the same, and spare not. Judge your sixepen'orth, your shillings worth, your five shillings worth at a time; or higher, so you rise to the just rates, and welcome. But what ever you do, Buy. Censure will not drive a trade, or make the Jacke go."

It is not only Elizabethan writers who used embarrassing euphuisms: "The Spectator" thus inscribes his first volume to the Right Honourable John, Lord Somers, Baron of Evesham: "I should not act the part of an impartial Spectator, if I Dedicated the following papers to one who is not of the most consummate and most acknowledged merit. None but a Person of a finished Character, can be the proper Patron of a Work, which endeavours to Cultivate and Polish Humane Life. . . ." And after more, much more, in this strain, he adds: "Your Elegant Taste in all the Polite Parts of Learning, of Your great Humanity and Complacency of Manners, and of the surprising Influence which is peculiar to You in making every one who converses with your Lordship prefer You to himself, without thinking the less meanly of his own Talents."

One must wonder whether the subject of these compliments and others in a similar position, on reading them for the first time, did so truly recognise the tradition as obligatory but meaningless, that the words themselves conveyed no personal gratification? or whether they said to themselves with a delight that was only half incredulous: "Can these things be true of me? Is this indeed a faithful portrait of myself?" Or if they merely murmured: "He's laid it on a bit *too* thick this time."

Yes-men in history books are alluded to as "flatterers"; under that name they play quite a prominent part in history, as though they were a special sect. "The king then rid himself of his flatterers," or: "But the duke gave ear to his flatterers." So solidly established were they as flatterers, that you wonder if they did anything else in their spare time, or just lay down and rested. Our juvenile history books, indeed, used certain words over and over again that

we accepted without much question as part of the mysteries
of other times: flatterers and favourites. Piers Gaveston was
"the king's favourite," a euphemism used as a noun and
never as an adjective. In the Upper Second or the Lower
Third we were accustomed to this injustice of favourites.
The French mistress had her favourites, and the drawing
mistress; not, however, the science mistress; she was fair;
she did not have favourites. So that it did not actually sur-
prise us that either the nobles or the people should rise up
and protest against this Piers Gaveston or his prototypes;
even demand by riot and battle that the king should give
them up. "Quite right," we remarked, "he shouldn't have
favourites; it isn't fair."

"Banishment" was another recurring word, which has
dropped out of our modern system of punishment. Now-
adays, whole hordes of people deemed undesirable by dic-
tators, are deprived of their nationality; but in juvenile
history books, banishment was more usually bestowed
singly. "The earl went into banishment"; and when we
wondered what he did there, the answer seemed to be usually
that he "picked quarrels."

Impostors there were too, in this juvenile history of which
one remembers arbitrary words so faithfully, while use-
ful facts have darted away to the right and left of one's
brain, hiding at last like lizards in the chinks of a wall.
Flatterers, favourites, impostors, usurpers and pretenders.
Perkin Warbeck and Lambert Simnel were impostors, though
I doubt if they quite reached the dignity of pretenders.
It would be interesting if one could discover the mental
process of an impostor or pretender; find out to what de-
gree he believed in his own imposturing. It cannot have
been much fun if he believed nothing of it himself. He
may have had some divine inflation which was genuine;

some call to follow the leadership of that other self of his that thought it should be king; but realising this would not be enough for others, had invented or allowed to be invented on his behalf enough facts to uphold the structure of such wild and glorious claims. Perhaps by the fervour of his trusting adherents he may have grown to believe in his own added inventions, as well as in the original inspiration that prompted the necessity of lies to uphold it. Yet there must have been moments, too, when he disbelieved the whole thing, lies and claims and inspirations; when he must have grown weary of his followers' tiresome fidelity and longed to say to them bluntly: "I'm an impostor and a usurper and a pretender. Do you think it's all jam being an impostor-usurper-pretender all the time? Let's give it up and go home."

But if he yielded to this temptation, gave it up and went home, how maddening to wake up the next morning with a mood that had twisted round again while he was asleep, as moods do, so that he believed once more in his arrogant reverie.

Among my rough notes for books, of ideas that I intend should be written some day, is a biography of Perkin Warbeck, written in the first person. Lambert Simnel would come into it; they were not simultaneous impostors in their attempts to topple King Henry from his throne. But there is no reason why they should not have met and talked. The novelist, eternally struggling to be free of the biographer, would not only take for granted such conversation, but would make one of the two impudently aware of his impostership and enjoying the game; the other, a more serious character, solemnly, fanatically even, a disciple of his own cause. It might even be amusing to let the impudent, quick-witted youngster with no belief in his own claim

to the throne save a strong desire to sit upon it, be curi-
ously and against his will enmeshed in a belief that the
other impostor is a true claimant. At this stage, naturally,
the biography would become a novel, and everybody's
name would have to be altered.

It would seem then that Philip Guedalla was right
during a discussion in which he laid the task upon me to
write a biography before I died, to discipline fancy and
steady the mind. All novelists, he contended, should make
at least one essay in biography, just to learn 'em. ("Just to
learn 'em" was not his elegant phrase, but inserted later
by me.)

Novelists plunge about so, he said. If they want to send
their hero to Paris on a given date, all they need do is to
send their hero to Paris on a given date, and if later on this
should be inconvenient to the story, they can alter the
date. It was all too simple; novelists were gay, heedless
people who should be sent to school. A biographer, absorb-
ing himself in a new theory of character, is helpless if he
finds his whole conception upset by a fact laid across it
like a log across a road. He may not move the log or take
a different road. If fresh discoveries in his material prove
that the man was not in Paris on such and such a date
when the lady was there, or the General, or whomever
it was essential for the theory *should* have been there; if
he was only in Paris three and a half hours later, it upsets
the whole damn theory, however ingenious, and that is the
end of it; no changes and no arguments permitted. You
have to learn to work rigidly within yours over facts.

My answer to all this was spirited but not altogether
convincing even to myself. I contended that a novelist was
held within the strong supports of less tangible discipline,
as the old port (you know the anecdote?), when the cask

had rotted away, was found to be contained within its own crust. That biographers suffer the cask was undisputed; but novelists do throw a crust in imagining characters that must behave in a certain way according to the truth by which we create them. If it be arbitrary for these characters who by now have a life of their own, to give in and conform to an author's mere convenience, the author knows well that he must not force it or his whole creation will be untrue and valueless. In fact, I argued eloquently, hoping all this was as good as it sounded, "novelists are governed by invisible limits, rules and boundaries none the less severe for having at the original conception emanated from themselves and not from without."

Mr. Guedalla dealt with this briefly. I dare not say how briefly. Down in the wistful weeds and puddles of my soul, I agreed with him. We tried to invert the proposition that every novelist should at least once cross the road and write a biography: should every biographer write at least one novel? No, the experience would disintegrate the biographer fatally; he might never be the same again. He would be running wild, ceasing to put on evening dress up at the lonely hill-station, going native on one of these South Sea Islands and permitting Tondeleo to dwell in his bungalow; yes, for a biographer to dally with the idea of writing fiction was "mammy-palaver," neither more nor less.

The right test of a mind with the true biographical turn is revealed, I am inclined to think, by its method of selection. They select their subject because of the period itself and the tendencies of that period. Geography may share in their reasons for the choice. If you are attracted, not idly attracted, mind you, but solidly attracted, by Russia as well as by the seventeenth century, then you

write a biography of Peter the Great. Nor is it too frivolous to let a profession influence you: you may write of a great lawyer because you are interested in law, or a great diplomatist or a general or banker because your mind can concentrate without too much wrenching out of its usual groove, on diplomacy or war or banking. But because I belong to the trade of jongleur, fabulist, story-teller, my natural inclination is to pick the subject of my one biography (unwritten, but it is going to be splendid) by some provocative point in psychology that intrigues me. This motive is flippant and unworthy. I am not peculiarly adapted to write of Scotland in the sixteenth century; yet in my rough notes, as an alternative to the idea of writing the biography of Perkin Warbeck, I find scrawled the words "Bothwell's Wife. In the first person." The amount of research and special knowledge which would be necessary to produce a true record, especially in the first person, of Bothwell's wife, is colossal. I cannot believe that I ever meant to start on such researches, or that they would be rewarding to posterity if I did. What quite foolishly attracted me was hearing that Bothwell and his wife Jane so loved each other that she was willing to divorce him so that he could marry Queen Mary and rule Scotland; and that even after this marriage, his former wife became his tender mistress, the only object of his secret enduring passion.

The story of a husband who desires to get rid of an importunate wife so that he may be free to marry a beautiful queen, is psychological A B C. The abandoned wife, no doubt, pines away and dies of sorrow and unrequited love, but who cares? Unless, taking the quicker way, he kills her. Leicester, Amy Robsart and Elizabeth were just such another triangle, and Elizabeth was not even beautiful as Mary Stuart was beautiful.

But what an entrancing change, entrancing, that is, to the palate of a novelist, when you find the wife is both the beloved and the mistress; and that the beautiful queen presently symbolises satiety. And was it by love transcending the love that possesses or repines, that she was willing to give him up, make his way easy to glory and power? or was it in serenest confidence, knowing that the queen's husband would always remain a faithful lover, chafing to return to her whenever he could? Did she bear the separation proudly, or suffer fierce regret for what she had done? Did she persuade him, or did he persuade her?

These two biographies, Perkin Warbeck and Bothwell's wife, will never be written by me. They are of the kind that remain permanently among one's rough notes. One will tell oneself that one had not the leisure nor the opportunity to write either. One will not tell oneself that one was prevented from writing them because one was a coward. A coward and idle, you will suggest kindly. But I do not agree with the accusation of idleness; I could do the hard work of research if I were not so deadly afraid of that mysterious word "scholarship"; a fear shaded by awe and veneration.

Especially for scholastic ladies, who seem to have ears, hands, organs, dimensions, senses, affections, passions, but possess in addition this miraculous power of erudition. They make no statement without solid authority and reference; their wisdom is not haphazard and instinctive as mine; an occasional waif strayed in from over the border; their wisdom goes up floor after floor, solid as a skyscraper. Yet when I am in the company of scholastic ladies, I am curiously conscious that the difference between them and myself, a difference certainly all to their advantage and on which I could write them several Elizabethan dedications,

is not a matter of post-school careers, but goes back earlier
than that. It has a pre-natal shape to it. Scholastic ladies,
I am convinced, have a vocation which they neither can nor
desire to elude. The time has long gone by when men
sniggered at bluestockings for their lack of beauty and
sexual attraction. Even the coarsest, stupidest man will
hardly say in this year of grace 1936: "She became a pro-
fessor because she couldn't get a husband." A scholastic
mission has nothing to do with books; scholastic ladies move
within unseen cloisters. Not in any erotic sense (this must be
clearly understood, if analysis is to have any basic value at
all) they usually prefer the company of their own sex. They
are nuns, unworldly and simple. When I am with them, I
feel that they are mysteriously excluded from vulgarity and
coarseness; they do not understand innuendo. One could
recognise them already at school among the mistresses and
among one's companions. Not that they were prigs; on the
contrary, they were usually of a cheerful type, pleased by
small innocent bits of fun. They were also reliable, and
did good work on committees. The teachers and lecturers,
of course, were already fulfilling their mission; it was not
difficult to discern that they were scholars. But even school-
girls are divisible into worldly and unworldly types, and
we knew that the unworldly ones would remain for ever
so.

Now, when I meet scholastic ladies I like them, respect
them, yet feel as though I were skating precariously on
thin ice all the time; or rather, that my brittle ice is their
solid terra firma. Will they find me out, I wonder? find
out those frightful gaps in my education?

Very rarely do I meet one scholastic lady alone; usually
two or three in a group of friendship. They wear friendship
like a warm durable cloak that does not fray or need

patching. They do not insult one another; they tell gay teasing stories to show up each others' good and generous qualities, and while they are doing so, the subject of their story always tries to stop them; whereas we, the rest of us, naturally feel the bitterest disappointment if anything happens to interrupt or distract the conversation while lovely things are being related to our advantage. Shamelessly we would like to say: "Yes, but let's go back to what we were talking about. What *were* we saying?" after one of these maddening interruptions. And even then, the glamorous theme never seems to go on quite long enough. Scholastic ladies are obviously more generous and unselfish, but nevertheless a little embarrassing in their hearty appreciation of each other. You are ashamed again when it transpires that what is a daily occurrence to you in the material kingdom, they look upon as a treat, a festivity, an extravagance. Even if they have a great deal more money than you, treats, festivities and extravagances remain little shining peaks.

They have ceased to look on men as monsters or enemies; yet they treat men as though they were not likely in the natural course of things to play an important part in their lives. With men who are fellow-scholars, they will be good friends; with all other types they are alternately a little playful or a little maternal; but they can dismiss men from their minds the moment the actual substance of man has left the room; whereas they will go on praising other women; loving them or worrying about them. They would never be rude enough to say so, but they do think that men are inclined to be a little bit childish and silly.

They are domestic; they like pretty things; they do not neglect their homes. They appreciate nice clothes for themselves, but their clothes are never provocative.

I met a woman the other day who is one of the greatest
living authorities on fourth- and fifth-century Latin. She
had a delightful sense of humour. It was terrible to realise
what a very small portion of myself could safely be shown
to this lady and her friends, and mingle with them in merry
conversation; the rest of me had to be put away in packing-
cases and sent down to the box-room.

The fine simplicity of scholastic ladies finds its parallel
in the equally astounding naïveté and ingenuous quality of
a certain school of scholastic men. You are respectfully
aware that in their mine of knowledge, you could sink a
shaft anywhere; whereas your own learning, even where you
are most vain of it, would not stand more than a six-inch
investigation. My awe of professors, especially of science
and mathematics, is even more colossal than my veneration
for scholastic ladies.

Professors don't dress. One day I must ask a professor of
this school if I dare, *why* they "don't dress"? Frequently I
have been invited to dine with this or that eminent man
and felt myself honoured by the invitation, and always:
"Don't change," my host added, "because of course the
professor won't dress!"

Like most females of my class and generation, I only feel
half-educated; less than that, quarter-educated; much less
than a quarter; it may be that that is why I have this over-
whelming and grovelling respect for professors, scientists,
mathematicians, philosophers and scholars of all sizes, sexes,
sorts and nations. One's preceptors in manners and be-
haviour used to say that one should never run after people,
particularly men. I have tried to keep this in mind, but I
do run after professors, impelled by an idiot instinct that
if I can contrive to sit near them for long enough periods,
by their side, at their feet, on the arm of their chair, I shall

myself gradually grow wiser by bodily emanation. Were
it not for this, it would be easier to remain at home and
solidly read. With no hope of competing with them, I
ransack my brains in their company, for odd scraps of in-
formation that might possibly be slipped in unobtrusively
and interest them for a moment:

"At the time when the monks of Chartreuse were sup-
pressed, they had a tremendous quantity of their famous
liqueur ready to ship all over the world. If they could get
it out of France within two days, they could have kept the
profits which otherwise went to the government. So they
looked for a private purchaser, but the risk was too much
for any one man to take. Yet there was a chance of a great
fortune for whoever might have been bold enough——"

That's the sort of thing.

("Indeed," from the professor, measured and benevolent
but never patronising. "Indeed? Chartreuse. Yes. Indeed.
That is most interesting.")

"At a modern French cavalry school, every year, they
first have to eat two large dinners—one forwards and one
backwards, and then they have to gallop for eighteen miles
and then have to drink three magnums of champagne and
then have three mistresses in three hours.

"Among my collection of walking-sticks, I've a rather
curious specimen, the wood knobbled like an Irish black-
thorn, and the top a carved crown in some darker wood.
They say that the crown was a symbol of office that the
Bow Street runners used to carry on their tipstaffs. And
coloured glass walking-sticks like barley-sugar were orig-
inally used as symbols carried by the mayor of a town.
When the stick was shattered in his hand, he was justified
in reading the Riot Act. And I have a stick made of three
thousand love-letters. And Malaccas are proved male by

that firm rib you can feel when you pass a hand down the side of it.

"When a mandarin or some one of high degree is dead in China, they bring in the official portrait painter. He is never allowed to see the corpse, but a family conclave gravely consults his book containing dozens of portraits of other mandarins; and picking out here a nose, here a mouth or an eyebrow or a line of jaw most like the dead person, and no doubt quarrelling violently all the time ('How *can* you say that dear Uncle Chung had an upper lip like that?') they manage to select for him enough ingredients that he can put together a composite portrait. I've seen such a book, and was amazed at the variety of these faces."

("Dear me, that is curious; very curious. You are fortunate in having had a glimpse of that book. They must be exceedingly rare over here.")

Of these items, the professors prefer the one about the French cavalry school, which I offered with some diffidence lest they should be shocked. For this line of professors is unworldly and appreciative. And the greater their fame and erudition, the more one marvels at their simpler qualities. I do not think they wanted to be themselves French cavalry riders on trial, but the test had a lusty smacking sound that no doubt contributed to their illusion that just beyond their ken was a world of physical heroes.

There does exist, of course, quite another kind of professor, possessing, as a matter of course, conventional evening-clothes and ordinary worldliness. I once sat between two of these, at a dinner-party, and found myself well-pleased; for they rippled with fascinating low-down zoological anecdotes which would have called forth murmurs of blue-eyed surprise from the first professor of my childish acquaintance: that Professor Philanderpan invented

by G. F. Farrow, who created the Wallypug and the Dodo: "The Missing Prince," "The Wallypug of Why," "The Little Panjandrum's Dodo," "Professor Philanderpan"—I am trying not to say in senile benevolent tones: "Does any child read them now, I wonder?"

The Wallypug was the dearest simplest most warmhearted little fellow that ever wore a crown; his investigations into the life of the common people, his discomfitures, his trials and joys remind me peculiarly of Soglow's "Little King." He had the same directness of purpose. Wherever the Wallypug went, he was attended by a little court of the Doctor-in-law, the Public Rhymester and A. Fish, Esq. There were four or five Wallypug books, before the author swerved aside into the amusing but less loveable adventures of that very conceited animal, the Dodo. The Dodo was terribly proud of being extinct, and always wore white kid gloves. Conceited animals are great fun. My favourite character in fiction is Mr. Toad: Toad of Toad Hall, my super-dainty Toad.

I seem dimly to remember hearing that G. F. Farrow died poor. I hope that this is not true; that he did not die, and that he is not poor; that somewhere or other, and not in the kingdom of Why, either, but somewhere solid on this earth, he is living in blatant riches earned for him by Wallypugs, Dodos, Panjandrums and Philanderpans; and that every time he leaves the expensive soap to melt away in the pink marble bath, he can say to himself: "What does it matter? I can buy lots more soap, and baths too!" Yet I am faintly nervous about this, for I knew E. Nesbit during her last years. She, too, wrote for children of all ages up till eighty, about the Psammead and the Mouldiwarp. And died poor. This writing and selling of books is a capricious matter.

Professor Philanderpan's good-hearted mission was to teach children how to unprove proverbs; such as "It's a long lane that has no turning." First the children had to explore until they found the long lane; then, exploring further and sometimes dangerously, they would triumphantly discover it *had* a turning. And they rushed off hand in hand to tell Professor Philanderpan. The more absurd their experiments, the more practical and literal was the technique and language by which the author presented them. Experiments in inversion are always fun; many have written stories about the architect who haunts a house, but a far more poignant story could be written about a house that (justifiably) haunts the architect.

Like most other children, I preferred literal transactions in my reading, to misty fantasy; and proverbs, no doubt owing to Nanny's creed and admonitions, played a large part in one's juvenile life. So that Professor Philanderpan satisfied on both these counts.

Proverbs and riddles and "catches." The present generation of children still ask me, their eyes sparkling with the prospect of my discomfiture: "Adam and Eve and Pinchme went out to the river to bathe. Adam and Eve were drowned, so who was saved?" And: "Why does a miller wear a white hat?" "Well—why?" "D'you give it up?" "Yes." "To cover his head!"

These catches from children to grown-ups, unsubtle though they may be, yet have not the nasty quality which animates certain well-known catches from grown-ups to children. Of the two trains, for instance: "Which was nearer to London when they met?" Most of us have tried to work it out in an agony of complicated arithmetic, before we realise that they must be equi-distant from London "when they met." And "Which is heavier, a pound of

lead or a pound of feathers?" "A pound of lead, of course,"
confidently. "My dear child, *think*. A *pound* of feathers,
a *pound* of lead." If we were very intelligent, and if they
emphasised the word "pound" sufficiently, we replied: "Oh,
yes, of course. Of course, they weigh exactly the same.
They must, if they're both a pound." And a mental pic-
ture of a small lead weight, and bulging sacks of feathers
balancing it on the other side, sack after sack, very like
those huge eiderdown pillows laid lovingly on top of your
bedclothes in Germany and Austria. It is, indeed, while
lying beneath one of these that I began to think, about
half-way through a hot night, that under certain circum-
stances a pound of lead, far from being heavier than a
pound of feathers, would be undoubtedly many pounds
lighter. Nevertheless, and in spite of common sense and
mathematics, many of us still believe with the pertinacity
of Galileo's *"E pur se muove!"* that a pound of feathers
cannot be as heavy as a pound of lead, and that really the
Demonstrators of Absolute Truth were talking nonsense.
Of course a pound of feathers is lighter than a pound of
lead.

Oh yes, they may have tripped us up; caused us to
recant; finally, if we were stupid, proved their point by
demonstration. But all the same, there are matters of which
mysteriously we, the spiritual legatees of Galileo and Ein-
stein, know the truth, and know each other who know the
truth: You and you and you and you—but certainly not
one of those standing over there. Mankind is divided, not
straight down the middle in arbitrary fashion, not straight
through the apple, but by a zigzagging invisible line, a tem-
peramental line, between those who calmly know that a
pound of lead *is* heavier than a pound of feathers; and those
who, if they suspected the existence of these rebels in their

very midst, would anxiously begin building a lunatic asylum of enormous dimension, to house them.

I delight in Galileo's handling of the martyrdom situation. His inquisitors were triumphant when obstinacy gave way, as they thought, to reason. His friends and relations must have felt a great deal more comfortable that he was not to be tortured and put to death. He recanted, shrugged his shoulders, murmured a hardly audible recantation of his own recantation, and went on serenely believing in all this newfangled nonsense of his, about the earth moving round the sun.

Martyrdom is, after all, only admirable when someone else is to be benefited by grim constancy. Otherwise, fanatics are so often mere exhibitionists, like hermits. Already as a child I was conscious of impatience even with my well-beloved little Elsie Dinsmore, heroine of the famous series of Elsie books (twenty-eight of them), when she fought her stern father's displeasure for over a year and for over seventeen chapters, because she refused to read to him out of a secular book on a Sunday. The tussle ended by little Elsie nearly dying of brain-fever, and her father turning Christian by her death-bed; which brought her back to life in next to no time; so that for the next twenty-seven volumes every one was happy.

I only had two of the Elsie books on my nursery shelves. In the one I have already mentioned, the heroine was about seven years old; in the other, "Christmas with Grandma Elsie," the same character seemed to be mysteriously widowed, but with children and grandchildren to console her, and her adored father still trying to make up to her for any severity that he may have practised some fifty-five years before. Not knowing, then, the way of family sagas in

fiction, I accepted the perplexing transition and was deeply fascinated by both volumes. Indeed, my taste for sincere, priggish, pious books of "The Wide Wide World" period and for chronicles of several generations like "The Forsyte Saga," "Buddenbrooks" and the "Jalna" books, was to take firmer hold of me as the years went on. And now I have two shelves full of nothing but the Elsie books; green, blue and red. Whatever other shelves must be cleared and their contents sent to hospitals and clubs or the basement box-room, these remain sacred. They satisfy some obscure need in my composition (not, certainly, on the intellectual side, so it must be on the moral side) which can only be satisfied otherwise by Jane Austen; and she, (one of my most sincere griefs) wrote only six, not twenty-eight books. Friends who come to sit with me when occasionally I am ill, remark drily that it might be a lesson in humility to many of the foremost writers of to-day if they could see the indifferent sweep of the arm with which I topple a whole pile of their latest productions off my bed-side table, to make room for eight or nine of the Elsie books. I do not mean to boast of this; for indeed, I cannot see that is is a matter for boasting, nor for shame either, but only for wonderment. However, I have tried to diagnose the case, and without wholly succeeding, can yet produce one or two reasons why they still enthral me.

First of all, I must either be tired or ill before I read them; they do not stimulate the brain, but rest it like knitting, patience or jigsaw puzzles. Secondly, to an adult understanding they really are very funny; the author, Martha Finley (Farquharson) was passionately sincere, and wrote without a twinge of doubt but that whatever she set down would be acceptable to equally sincere multitudes of old and young readers in the 'seventies and 'eighties. Her

confidence was well founded, for a preface to nearly every fresh volume tells how she only continued the chronicle of Elsie Dinsmore in response to an insistent fan mail; a fan mail that showed a curious morbidity in one particular instance, when apparently they demanded, after "Elsie's Wifehood," "Elsie's Widowhood":

> It was not in my heart to give to my favourite child, Elsie, the sorrows of Widowhood. But the public made the title and demanded the book; and the public, I am told, is autocratic. So what could I do but write the story.

When either Captain Raymond or his mother-in-law Elsie, or his mother-in-law's father, Mr. Dinsmore, wanted to buy a carriage and horses, or a beautiful property in a well-wooded district, or some "tasteful present of jewellery" for their loved ones, they always prefixed every purchase by saying: "My dear daughter must remember that I am but a steward entrusted with my Heavenly Father's wealth," and the buying went on merrily. For that was another of my pleasures in the Elsie books. Everybody in them was sumptuously rich, except a few objects dotted about here and there for exercise of benevolence, and the faithful darkey servants who swarmed round every porch and plantation. Carriages and horses, mansions with glorious gardens, rich clothes, suites of grandly furnished apartments, presents of jewellery and silver, cluster on every page. The author wallows; the readers wallow; and only the characters in the book remember that they are but stewards.

And the author of the Elsie books is not afraid to give details, confident that every detail will be interesting. Here, I think, is another reason why I find her style restful but not boring, though it would probably madden ninety-nine people out of a hundred to be told every time Lulu

went upstairs and put on her set of coral ornaments and stood a moment at the window wondering if any girl in the world had such a good kind generous splendid handsome noble father, and then came downstairs again and left her hat in the hall for a moment while she ran in to give her father a hug, and so on. As the family tree spread and spread, replenished by constant marriages, births, and visits of relatives from a distance who settled down and did a bit of intermarrying and bought yet another noble residence with well-watered grounds that happened to be for sale in the neighbourhood, there was no flagging in the description of what every single person in every one of these houses was doing, planning, saying and thinking, at all moments of every day and evening. Among the pelt of events that followed each other down these sixty odd years, I picked up some curious bits of information; for instance, that the telephone was in constant use in America long before I had any idea it had even been invented; and a spirited description of the doings of the Ku Klux Klan and the effects of the war between North and South (all the Dinsmores being in deepest sympathy with both the North *and* the South, which must have immensely simplified circulation). A visit of Captain Dinsmore and his two children to a Mormon settlement was enlightening; and when about eighty of the Dinsmore clan visited the Chicago Exhibition of 1893.

A character who made a strong impression on me was dear old Cousin Ronald from Scotland. He had a gift for ventriloquism, and endeared himself to young and old by such merry tricks as causing Elsie to believe that one of her sons was screaming for help while drowning in the water; or by sending the more timid of the Dinsmore children into fits of tears and hysterics by the impersonation of gruff voices announcing from outside the door and down

the chimney, that they were burglars and murderers, starving and desperate men. Small wonder that whenever Cousin Ronald visited any of the families, his was a warm reception and the most comfortable chair by the inglenook.

No one would be more surprised or grieved than the late Martha Finley, if she were to be informed that, diagnosed by more recent schools of psychiatry, the twenty-eight volumes would reveal some strange matter. The father-fixation motif is so strong between Elsie and Mr. Dinsmore, who is only seventeen years older than his child, that when it reluctantly has to be severed for a book or two, to permit the girl to get married, she is made to refuse all younger suitors and give her heart to her father's college chum, Mr. Edward Travilla. He lives only long enough to be tenderly bending over his wife's bed each time seven delicious bundles wrapped in warm-smelling flannel are brought to her ("Hello, where did you get this?") and then Time the Great Reaper does a bit of scything, and Elsie and her father are drawn even closer together by their common grief. We are not told the private views of Elsie's father's second wife on the subject; outwardly the second Mrs. Dinsmore is all gentleness and devotion, but it is plain that the subconscious of Elsie's author then sat up and roared for madder music and for stronger wine. And roared and roared. So Elsie's second daughter, Violet, while hardly more than a child, was swiftly married off to Captain Raymond, a widower with three children of his own. Captain Raymond's eldest daughter, Lulu, a pretty, dark, rebellious little girl, worships her father though less submissively than Elsie had worshipped hers. So that in the latter fourteen volumes of the series, we get the theme repeated even more glaringly in alternate stripes of rosy sentiment and livid green jealousy. What Captain Raymond goes through when suitors

begin to ask for Lulu's hand, is nobody's business. I thought we had reached fever-point when first Elsie is besought, when she is fifteen or thereabouts:

". . . passing one hand caressingly over her shining hair, 'My darling, how very, very lovely you are!' he said, the words bursting spontaneously from his lips; 'there is no flaw in your beauty, and your face beams with happiness.' "

(My father never talked to me like that.)

But Captain Raymond and Lulu beat them at the post. Captain Raymond, I venture to guess, was the author's "favourite." She could rationalise even his habit of coming quietly into the room in soft slippers and thus comfortably overhear any passionate praises of himself that might happen to be going. He had a way, too, when there were any pretty young girls about, his daughter's friends, of smoothing back the hair from their foreheads and gravely kissing them, with the words: "I claim a father's privilege." Captain Raymond was always claiming a father's privilege all over the place, and very enjoyable it was to all concerned.

Mr. Dinsmore in his earlier stages, "My dear honoured father," as Elsie frequently calls him, should take a place in immortality with Samuel Butler's Mr. Pontifex, Anstey's Mr. Bultitude and Wells's Mr. Pope; with Mr. Barrett of Wimpole Street and Wotan of Valhalla. Between these latter two domestic tyrants, the resemblance is so clearly marked that the analogy hardly needs emphasizing. You have only to remember that Mr. Barrett had a large family of young Barretts, and Wotan had a large family of young Valkyrie; that each had a favourite daughter: Elizabeth: Brunhilde; and that each, deeply resenting the advent or possibility of a suitor for these daughters, shut them up with a large bedroom fire, a much too large bedroom fire, and hoped in this manner to isolate them and keep them safely at home; but that neverthe-

less Browning and Siegfried contrived in their youthful passionate ardour to carry off the beloved and leave the father lamenting. Lord Ullin, too, might well be added to the possessive Papa group:

> "Come back, come back," he cried in grief
> Across the stormy water,
> "And I'll forgive your Highland Chief—
> My daughter, oh my daughter!"

> 'Twas vain. The wild waves lashed the shore,
> Return or aid preventing.
> The waters wild went o'er his child,
> And he was left lamenting!

Peter Pan has given strong indications that he too, if ever he Grew Up, would become a domestic tyrant not dissimilar to Mr. Barrett, Wotan, Lord Ullin, and Mr. Dinsmore. If you are inclined to think that Peter has been dragged in and that the analogy is far-fetched, remember his behaviour when Wendy metaphorically put a beard and whiskers on him and made him papa of the Lost Boys in the Never Never land; jealous of his rights, despotic, sternly refusing to listen to the juvenile side of any argument:

(". . . They are really out pictorially to greet Peter in the way they think he would like them to greet him. . . . The whole island, in short, which has been having a slack time in Peter's absence, is now in a ferment because the tidings has leaked out that he is on his way back; and everybody and everything know that they will catch it from him if they don't give satisfaction.")

A pretty, winsome spectacle is the glimpse of a mature Mr. Dinsmore and Mr. Travilla reading and enjoying "The Wide Wide World." Mr. Travilla brings it in as a present to Elsie:

"A book in two volumes; just published and a most delightful, charming story!" And later, Mr. Travilla again calls on Elsie:

" 'I see you have your book with you. How do you like it?'

" 'Oh, so much! How I pity poor Ellen for having such a father, so different from my dear papa; I can't read about her troubles without crying, Mr. Travilla.'

" 'Shall I tell you a secret,' he said smiling. 'I shed some tears over it myself.' "

However, we must not scoff at Mr. Dinsmore and Mr. Travilla for their susceptibility to "The Wide Wide World," without remembering that Van Gogh reacted in the same way: Van Gogh, when he was a young schoolmaster in Isleworth, used to read "The Wide Wide World" aloud to the little boys, and wept at the sentiment as he read. And Van Gogh was to be a very great artist and a great explorer; an explorer in paint.

A man or woman born without a sense of locality, should immediately become an explorer. For explorers alone have no need to find their way. They lose their way, and by so doing establish once and for all and for ever afterwards a way that other people have to find. I think no one can quarrel with my theory that the true explorer is one of that company born without an invisible compass in their composition; but having instead the wit and good sense to cover up their wayward tracks, their nonsensical trail, by creating both the track and the trail. We call it the "cart before the horse" method.

A sense of locality is one of those gifts that I would mark with my letter "H," white on a blue ground: here lies mystery, mystery as strange as water-divining; out of range of man's five senses, it twitches teasingly at an uncontrollable sixth.

People will say to you: "But surely you *must* know by now

where Palmeira Crescent is? You've been there twice." As
it happens, you have been there seven times; but still your
wakefulness has slipped a cog, and somehow, somewhere, how-
ever hard you concentrate, your bones are not informed
whether to turn to the right or to the left. And if by acci-
dent you do choose the right road, you have learned not to be
reassured by the dream-like feeling of familiarity growing
bolder out of the haze as you near the house you are seeking;
for this dream-like feeling of familiarity is just as likely to
occur if you have taken the wrong road.

It is not that you have no antennæ; merely that your an-
tennæ are treacherous. They have an objective existence; but
a freakish, poltergeist existence; they will trick you with ab-
solute certainty, flattering the pride and power within you
. . . till they bring you up dead, staring at a large corner
house with balconies overlooking the sea, which most defi-
nitely, most surely, ought to have been on the opposite side
of your road, with the sea and the whole landscape twisted
the other way round. Few moments are more disconcerting,
more of a shock to the nervous system, than when you find
suddenly that they've been and gone and taken and moved
the sea, and moved the cliffs and the fields and all the build-
ings; just lifted them up and put them over there on your
left, when indubitably they were *here*, last time, solidly on
your right.

Missing a sixth sense is bound to have an effect on one's
career and character. I am not nearly as shy of people as I
am of houses, unfamiliar houses, houses that I am visiting for
the first time. "I've never been there before," and panic
rises in my throat at the phrase. Panic increases at sight of the
bland front door. When it swings open, I shall not recognise
what lies beyond. The maid will be strange. While I give my
name, take off my coat and give up my stick, I conjecture

wildly which of the doors in sight may be the sitting-room
door? Up the stairs? Down that passage? And the room
itself will be unfamiliar. And after that, more groping about
(this is metaphorical, of course; one need not grope, because
one is shown the way) till one is securely in the dining-room,
seated at the table. Then fear gradually sinks to rest. The
larger the house, the more misery is in the experience. Pan-
dering to this idiot form of shyness, I would rather, as a
transient emotion, visit strange people dwelling in a house I
know, than old friends in a new house.

When I went to parties in strange houses, as a child, I cried
from the first moment to the last. What an asset Little Gladys
must have been at the feast. I cried because I thought I should
never be fetched, and would have to stay there for ever; it
did not strike me that this would be even worse for them than
for me. I was a picturesque child, in sapphire blue velvet
falling from a smocked yoke, big dreaming blue eyes, a wist-
ful tremulous mouth, and long thick appealing brown curls.
And my crying was not howls and kicks, but slow tears rolling
down my cheeks. In vain the grown-ups clustered round,
gave me their laps and their love, gave me the best pink jel-
lies, the best little boys beside me at tea, the best presents and
the best seat for the conjuror or the magic-lantern show.
Perhaps after hours of their concentration on my mysterious
sorrows, I might just begin to show signs of recovery and a
wan smile—when it was all upset again by the first nurse
(never mine) to fetch the first child home from the party.
It was perhaps natural that it should not occur to anyone that
what I urgently needed to carry me over this moment of crisis
was a strong double whisky. As the collection of small over-
excited guests melted away, one by one or in twos and threes,
that forlorn terrified desolate out-of-it nobody-wants-me

what-shall-I-do feeling swelled and swelled and choked me with sobs . . .

They say a woman forgets the pain and misery of child-bearing and is quite ready to go in for it again next time. So from one party to another, I forgot about never being fetched; and every time the invitation came, was eager for the treat.

And nowadays, though I manage not to behave at strange houses as though I were a Melisande heroine fleeing through the misty forest: "I am not happy! I am not happy! Why do they not come to fetch me away?" yet I still feel a some-what disproportionate triumph if I can pass through the hours so gaily as to forget this panic which now and then causes me to leave abruptly, on some dishonest pretext of work or sleep, but really only desiring to reassure myself that I *can* leave, now, whenever I want to. Still, and most of all, do I feel incredulous and deeply touched when sometimes and in a way that compels belief, I am looked upon as an asset to the party, myself a ringleader Rectory Child, knowing my way about the house.

This panic of new places functions most furiously in hotels. Staying in a hotel for the first time, my instinct is to behave like a dog who lies flat with his nose to the crack in the door, and whines and will not be comforted. The only familiar bit of furniture in the building is my own reaction to its strange-ness. I lived for eleven years, between the ages of fourteen and twenty-five, in and out of hotels, boarding-houses and fur-nished flats, in England and abroad; every residence tempo-rary; every settling-down barely preceding a rooting-up.

The first fourteen years of my life had been established so firmly and finally in our house in Holland Park, with just six weeks' holiday at Broadstairs every year, from July 20th till,

roughly, September 8th, that I had not been prepared for any more nomad scheme of existence. Everybody, I thought, lived as we lived, except beggars. The perverse thing about this vehement horror of new houses and new hotels is that when the first few days are overcome, attachment will set in. I am aware from the first moment that this will happen, but it saves me not one quiver of desolation. Where attachment sets in, naturally detachment is the very devil. The more strongly I resist a place on arrival, the more passionately I resist departure. ("She has," said auntie, "such an affectionate nature!") It would seem that it was a nature planned to attract every form of emotional inconvenience.

A very real panic of these eleven years of nomad existence was: "I can't be ill here." You cannot be ill if you are leaving the next day, and have already given notice and packed, and the rooms are let to other people. You cannot be ill if it should be at all likely to prove infectious. You simply must not. Nor staying with friends. Really, you may only be ill in one place, and that is your own home. And if you have had no home for eleven years, panic breeds nicely, like mushrooms in spawn.

Love is supposed to be one of the universal kinships. But you will find a richer difference among people in love than in people who are ill. After all, every man or woman who is the object of every woman or man's passionate tenderness, twists a common emotion a little way this way, a little way that way; dabbles it in never quite the same colours. Love goes out as an explorer into strange places; but illness is no questing beast; it will eagerly come to you where you are, and lodge familiarly in your body, simplifying life, narrowing it, bringing down the sky and drawing in the walls, levelling your interests and cramping your personality. There

may be many illnesses, but meagre variety in our responses.
You may be patient or impatient; you may be stoical or cow-
ardly; you may rage and complain, or radiate sweet grati-
tude and consideration for others. But these are about all
the careers in outward behaviour that are open to you. Within,
under identical stress of pain, monotony and fear, very much
the same thing goes on in everybody, though it is a peculiar
feature of illness that you suppose your inner life to be unique,
until the blinds are once more pulled up and you put on your
boots and go out to join the multitude of your fellow-men;
then, you think, the unique phase is over. Naturally, the
reverse is true. While you were ill and isolated, hardly a
thought you had but was stale with the infinite number of
times every invalid had munched it before. But once well
again, mingling with your fellow-men, working, rebelling, in
love, smiling quietly at a matter which even your best friends
find serious, noticing an arrangement of chimney-pots that
nobody else appears to have noticed, it is then that you begin
again to be unique; to regain your original personality. One
has only to look at a collection of letters by any well-known
writer, to realise the truth of this. Chekhov, D. H. Lawrence,
Katherine Mansfield, Van Gogh, Horace Walpole, Barbellion
and Beethoven did not resemble one another until they were
ill. Alice James occurs to me as an exception, but she was an
invalid nearly all her life and bore it as a matter of course;
her personality developed in spite of it, with a briskness, a
lack of sentiment and self-pity which must have been discon-
certing to her visitors and relations:

. . . So far I have not succumbed to Marie Bashkircheff's *Jour-
nal*. I imagine her the perverse of the perverse; and what so dreary
to read of, or what part so easy to act, as we walk across our little
stage lighted up by our little self-conscious foot-lights? Every hour
I live, I become an intenser devotee to *common sense!*"

With the others I have mentioned, their very optimism, when it comes, is an optimism that leaps up in the same hectic flame, and gutters and mutters down again to the same blotting-paper grey. Illness shunts you on to a single line. And such bravery of conduct as we can assume, is as loosely attached as the three feathers which a child may hold on its head, trying to look gallant for a moment. Mr. Bumble summed up the law for us; and if the law's a h'ass, illness, as colloquially, is a beast. One may just admit, though with a reluctant growl, that trouble and sorrow and war and loss, disappointment and humiliation, may possibly bring out the best in us; form our characters, discipline our desires, create tolerance and nobility and all the rest of it; though if one were writing a Threnody on the Death of a Character Ennobled by Misfortune, one would not be wrong also to slip in Envy, Stinginess and Truculence among the mourners following the hearse. Still, here and there sorrow does make a creditable job. But illness slowly whittles down your resistance; and then fear moves in with all its imprisoning locks, its stocks and its barrels. And fear is a dead loss. Fear thieves your sleep at night; burgles your dignity and decency by day.

When I was living in what is called a Private Hotel, and an air raid began one evening, stopped and then began again after we had all gone to bed, I was surprised and abashed by the behaviour of the bunch of old ladies to be found in nearly every London boarding-house; abashed, because although I had decided beforehand that in the event of an air raid I was going to conduct myself with coolness and reticence and presence of mind, it had never occurred to me that the bunch of old ladies could display not only the same ostensible lack of fear; but the same amount of coolness, reticence and pres-

ence of mind. They folded up their knitting when the alarm sounded; they discussed, without raising their voices, whether they should go up to bed or down to the cellars; and gave firm reasons, some for going up and some for going down. And one very frail and white-haired lady asked a little anxiously: "But is it *safe* to go to bed?" and blushed when her friend, a wag, replied: "Well, my dear, that depends, doesn't it?" And the others chuckled, and chipped her for her naughtiness and her conquests. One or two ruthless ideas were thrown out among them as to what should be done to the Kaiser; but not a soul screamed even when the noise began. In my young arrogance, I had believed that old ladies always screamed with fear, especially boarding-house old ladies with knitting and foolish jokes. Then was this, here in front of me manifesting itself, the much-advertised backbone of England? Or would the old ladies of a French Pension have been equally backbone? Or of a German Gasthaus?

I remember finding myself presently in a bedroom, not my own, on the second floor, with a cheery young couple with whom I had been till now only on staring terms, and their pretty little daughter, Betty, who did not wake up in the excitement. I think they must have called me in because the view was better from their window than from mine; and Billie, the wife, made me put on a pair of Leslie's thick socks as a cure for what were (quite literally) cold feet. Presently we saw a little silver cigar high over the houses; presently we saw it flame and fall. It was so very much everybody's spectacle while it was up in the sky, that it seemed odd that as it fell the drama should be localised, and others, not ourselves, should have heard the actual crash.

My "favourite" air raid did not occur while I was in London, where there was always the fear of being hustled underground into basements and tubes, but sitting in Rebecca

West's house up on the cliff-road at Leigh-on-Sea, above the
Thames estuary, with plenty of space around us and no cellar
for our accommodation even if we had felt like burrowing.
I have spoken of this air raid in the singular, but we had them
every night for a week and more, during the clear September
moon of 1917. First the siren sounded, warning us that "they"
were approaching; usually at supper-time when the mackerel
was brought on the table. Fresh mackerel and sprats were
plentiful and delicious at Leigh, and very much better than
the packet soups, offal and lentils of London boarding-houses.
So there we sat and thrilled and ate our mackerel with relish.
But if the Germans were a little earlier or later than supper-
time, we read while waiting "The Fall and Rise of Susan Len-
nox"; a magnificent fall and an unprecedented rise; and the
case-histories at the back of Havelock Ellis's "Psychology of
Sex."

A few moments after the siren had screeched, the guns be-
gan to make conversation from Shoeburyness, Sheerness and
Canvey Island; for we were situated just behind the first lines
of defence. The menacing dialogue swelled above our heads,
as some of them got through the barrage and made their
staccato barks; "you're-another" sort of barks; "you're-an-
other-you're-another"; that sort of dialogue. It got quieter,
and we knew they were on their way to London and that we
should hear much more of them in half an hour or so, when
they came back and casually dropped such of their bombs
as they had not been able to use effectively over Whitehall
and Westminster. ("A pity, *nicht wahr*, to lug these all the
way home?")

From the window, we could see them following the silver
sash of the river; or, if the tide were out, the bed of shining
mud. One evening a Zeppelin was brought down into the
mud, and fell with a squelch. At about this stage of the pro-

ceedings, when they were on their way to London, but we
could still hear the hum and whirr growing fainter, and won-
dered how long they would take, and remarked what an ex-
cellent fish was the mackerel and what a pity that legend had
been so busy blotting its scutcheon, and the housekeeper was
bringing in the second course of scrambled eggs, at about this
stage, a telegram usually arrived from my father in London,
saying: "Are you all right?"—but in reference to the air raid
of the night before. I still cannot tell why he always waited
so long before sending it; a war of anxiety against common
sense, I suppose; and anxiety eventually won.

Extremely perplexing, under the circumstances, to decide
how to answer it? "They" would be back soon, and then we
might not be as all right as we would have just said we were, in
our reply-paid telegram. And then, too, the German aero-
planes were thrumming busily on their way to London, so
that the logical reply would have been: "Yes, but are
you?" only you cannot use italics in a telegram, and unless
"you" were italicised, the message read with the wrong stress
would be: "Yes, but *are* you?" and my father would not un-
derstand.

About twenty minutes later, the thrum was heard again;
faintly. Then nearer. Our own first line of defence got busy,
and for a brief while it really felt as though chaos had de-
cided to run up a branch line station, covering and including
our house.

We were not frightened, probably because we were seeing
nothing ghastly, nor hearing any agony that could start
imagination. If there were such a thing as sound pure and
simple, this was it.

We thought it wise to stand in the hall under the jamb of
the doors. The majestic housekeeper joined us, and severely
reprimanded her son, a boy of fifteen, for leaning with his

head against a white wall and making a mark. She deserved that we should raise a cheer for the survival of order and cleanliness; but any cheering would have been less than the squeak of the smallest mouse in that hurly-burly. The child's nurse also stood with us, and made a remark which we have ever since incorporated into the language, to an extent to make me wonder how the rest of the English-speaking race could do without it. She was a buxom, kindly sentimental soul, her bosom lush with unexpected sympathies. And suddenly, in a lull that followed a rocking, crashing series of barks and explosions, directly centred above our heads, she remarked: "Oh dearrr me" (in full Scotch), "I'm so sorry for the men at the end of Southend Pier!"

Not sorry for *us*, you observe, but for the men at the end of Southend Pier. Who at that moment were hardly such objects for pity. At that precise moment, they were quite a long way away from the fuss. We echo, now: "I'm so sorry for the men at the end of Southend Pier," whenever somebody displays breath-taking irrelevance in the placing of their sympathies.

No, those air raids at Leigh-on-Sea were really not at all bad, compared with the horror of air raids when boxed up in London and crowds. They were romantic; they were exciting; we saw nothing horrible; yet we were not thrust down into cellars but could look out at any moment we pleased, on to open sky and air, river and horizon.

Nevertheless, with a child in the house, we decided that the men at the end of Southend Pier had better be left to a lonely vigil; so we moved inland to a mill. I cannot remember what mill, or where it was, or why we chose it. It was very silent there, and stuffy and dark; our mattresses were portions of flooring carelessly knotted. There was a lovely collection of damp-smelling novels of the 'seventies and 'eighties, of which

our favourite was "Anna Lee, the Maiden, the Wife and the Mother." Anna Lee was a good maiden, a good wife and a good mother. But she had a frivolous friend who went to the theatre with William Archer. Anna Lee prophesied to her over and over again that no good would come to a girl who went to the theatre with William Archer, but the wilful lass paid no heed to these warnings, and he worked his vile purpose on her.

There are times when foolish coincidences of name seem exquisitely funny. I suppose our brains, exhausted from too many air raids, required the simplest of food.

All air raids were fantastic affairs; an inconsecutive jumble of nightmare, funny adventures and fiction. The most fantastic I experienced was during a sort of nervous breakdown. I was staying with a little soubrette friend who lived a life in Soho which was part Cigarette-the-vivandière, and part Wendy-the-little-mother, with a dash, maybe, of The Cricket on the Hearth. Her flat was full of doors, as a soubrette's flat should be; and when the air raid began, I think at about ten P.M., all these doors flew open, and vociferous Latins came scampering in, either to reassure her or to beg for reassurance; to bring her bottles or ask for drinks; to clutch at her skirts or to kiss the nape of her neck. I remained in bed on the couch in the sitting-room; there was no spare room, and my legs had not been carrying me for the last week or two. And while the bombs fell and the Latins scampered to and fro, she jabbered happily with all of us in several Latin languages; filled hot-water bottles for me; let the kettle run over on the stove or poured steaming water beside the funnel on to the carpet, while more and more of her protégés dashed in and dashed out and made highly individual prayers to the Madonna.

Followed another air raid in London which had the quality

of real horror about it, because I was in the streets and forced
to take cover in the Underground; and the Underground to
me, even when no air raid is on, is definitely under ground.
Agoraphobia or the fear of open spaces, has never come any-
where near me; but I have had hard work to cure myself of
claustrophobia. Another air raid happened at a small dinner-
party in a Soho restaurant. One moment there were waiters,
and the next moment, so to speak, there were not. One of the
men of the party, home on leave with a stiff leg, took us to
his club near by; but there, following orders which were com-
pulsory, we had to go down not only into the cellars, but into
a quite unnecessary set of cellars below the cellars. We were
there a very long time, and we could not rebel because of the
delicate relations of guests to a host, and the fact that ladies
should not have been allowed in that club at all. All sound
was muted; some of us carved our names on the walls; and
I suppose we tamed a spider, and taught a mouse to do its
loveable little tricks. When we came up into the air again,
the club servants looked at us with the same cold disapproval
as their ancestors, years before (was it years?) must have
looked upon us as we went down.

I had been working at St. Dunstan's that summer; at the
same time I tried to read "Pragmatism" by William James.
At the same time there was a heat wave. I am grand in cold
waves, but crumple up in the heat, always.

I went to see Clemence Dane at Sydenham, and had a
nervous breakdown in her front garden. We sat in the rock-
garden all through the night, during flashes of lightning and
rumbles of thunder, because it was too hot to go indoors; and
I was dosed with brandy and black coffee, when I should have
been given bromides and other sedatives; but how could we
know? The next day, I came back on a tram; a jarring inter-

minable journey. The brass rail beside me glittered and burnt my hand.

Call it a nervous breakdown. It was an attack of accumulated hatred of being alive at all, which lasted two years at least. But what directly brought it on, was being allotted a really very light job of taking the St. Dunstan's men for walks in Regent's Park, and being ashamed to explain two things to the authorities; that I had no bump of locality and had to learn by heart a hundred landmarks before I could find my way anywhere; and that I was short-sighted, and ashamed of it. Can you imagine what it was like, taking a blind soldier for a walk? He trusting you utterly, as was reasonable and natural that he should; and you losing your sense of direction; not knowing the way back to St. Dunstan's; nor daring to ask, because he would hear you and get panic-stricken at finding himself with this incompetent guide? Can you imagine what it felt like, this very small-sized job. . . . That path—did not lead back to St. Dunstan's, after all. It looped round and led farther away. . . . And that patch of water which suddenly turned up on your right, should it not have been on your left if you were where you hoped you were? . . . But he must not guess that you had lost your way. He must never guess. They must never guess.

You are curiously ashamed of being short-sighted. The very words "short sight" call up an idea of somebody peering with knitted brows, peering and frowning and staring at the ground. You do not wear glasses if you can help it, because that proclaims your weakness. Instead, you go to a fantastic amount of ingenuity and trouble to camouflage the fact that what you are invited to see, you cannot see. People with normal sight are more slow to grasp the difficulties of moving about in a blurred world, than people are with normal hearing

to remember and allow for deafness. Short-sighted people, though ever so slightly, have to lie their way through life. Long sight, though equally inconvenient to the owner, has no humiliation attached to it. Perhaps because of sailors, far-sighted eyes fixed on the horizon, etc., long sight is more romantic. There is literal reproach in the phrase: "You can't see beyond your own nose!" to a near-sighted person. When I was a very small child, I read in the papers about a French circus dancer, retired from public life, who asked her maid, coming in with the morning *chocolat*, why she did not raise the blinds and draw the curtains. But *la bonne* had already done so. Madame, without realising it, had gone blind in the night.

Why, with this desperate fear of blindness on me, I should have been obstinate in offering service to St. Dunstan's of all places, I cannot tell. A passionate understanding, perhaps, that there, more than in any other assembly of war victims, help was needed; big help; small help; quick help.

Logic and argument have very little effect on fear; yet it must be an accumulation of subconscious logic which prevents youth from going about always in fear of old age and of death; realizing that fear of time is simply a waste of time. Along some lines, fear is of use as a spur to activity: if singly or collectively, for yourself or for others, you fear pain enough, the world eventually produces anæsthetics. Fearing cancer enough, the world will presently discover first the cure for cancer and then the prevention of cancer. Fearing war enough——? A question mark is the only end to that.

Time is an abstraction that should never have been symbolised. Why should that remote, unbelievable, dizzy thing that happens to us, called the "passing of time," materialise as an old man with a long beard and scythe? If I could see time in shape it would be no human conception, but for a brief flying second, like the inside of the Great Observatory

at Mount Wilson; but this is the kind of thought that happens as a bird flies, only visible after it has passed, not while it is still moving towards you.

There are probably as many quotations about age and time as about love; the Americans say: "Aw, be your age!" intending, I believe, to convey deprecation, a sort of "don't mention it!" an odd suggestion that gratitude is a matter of infantilism. Another quotation about time emerges curiously from a series of Chinese-boxes, not directly from its source, but in a story by Harold Nicolson. He quotes a French Vicomte quoting Shelley's "Life like a dome of many-coloured glass . . ." who because he had had a Cockney nurse, misquotes it as: "Toime loike a dom of many-coloured glass . . ." And now, by quoting Mr. Nicolson quoting the Vicomte quoting Shelley, I have thrust it into yet another, smaller box.

"The worst of time," remarked an impatient young woman who had been jilted by her lover and wanted the healing hand to begin its job that very day, "the worst of time is that it takes such a *time!*"

Pirandello has a glorious time fiddling with time, juggling with it, mating it with reality and then divorcing it again; and Max Beerbohm went Pirandelloish in a peerless story called "Enoch Soames."

There is one moment in "Mary Rose," a troubled moment, supreme in all the plays of Barrie, where Mary Rose is once again, as young as she was twenty-five years ago, in her parents' home. And presently the father says to the minister:

"Please don't talk of it to me, sir. I am—an old man. I have been occupied all my life with little things—very pleasant—I cannot cope—I cannot cope."

A hand is placed on his shoulder so sympathetically that he dares to ask a question.

"Do you think she should have come back, Mr. Cameron?"

And this, though it has much to do with death, and a little to do with faery, is most to do with this flickering, teasing question of time and its healing hand.

By "healing hand of time," they mean, of course forgetfulness; not healing at all; obliterating. There is a difference. Equally, there is no such thing as forgiveness, though the word is in constant use; it is nothing more tangible nor generous than forgetfulness; merely another of these words with a glaze on it, that we take for granted. We have a conception of forgiveness as a bending figure (usually our own) raising up some one who droops or crumples: "Will you, can you forgive me?" "Yes, I have forgiven you. I did it, so to speak, about five minutes ago." As though it were an automatic process under our control; a click, and the thing's done. By "forgive," we really mean a temporary act of acceptance; it is implicit that we will make no more fuss and that we will not take revenge. Nothing more spiritual than that. It is not fundamental, but sentimental; a man-made invention; an enjoyable performance that blesseth him that gives and him that takes; for masochists like to be forgiven, and people with a superiority complex like to bend and be gracious.

"You'll forgive and forget?"

"I'll forgive and forget."

But even with "forget," a mental reservation remains; for the whole business of whatever-has-been-done is perforce registered in your mind. And after you have eliminated personal retaliation, registration is still bound to exist: This person (though you have forgiven him) is capable of doing such and such a thing; therefore in future let your actions sensibly take this fact into consideration; you have here a bit of territory covered for future reference.

So you do not forget, either, in a complete sense of forgetting.

Time has thrown up a flotsam of curious phrases about time. "Wasting time," "Keeping good time," "Healing hand of time," "Biding one's time," "As times go," "Before one's time" (as though time were ever "one's"), "Behind time," "In proper time," "In the nick of time," "In high time," "Once upon a time," "Time out of mind," "Beating time," "Killing time," "Losing time," "Doing time."

In Hollywood, nobody keeps time; nobody keeps appointments; they are the connoisseurs of life, out there. No, perhaps I am wrong; they do keep time; they keep it on the shelf, an old-world formula, a graceful decoration of their days, a rococo symbol, but they have discarded its practical use. "What's the time?" exists as an archaic phrase like "Prithee what's toward?" We know that if everybody disarms, we shall have no more use for weapons. In Hollywood, because everybody has discarded the rigidity and limitations of time, they keep it as a man keeps an old mistress, out of sentiment alone.

We make the mistake of confusing time with age, and of fearing them both.

When Shakespeare wrote his lament for the dead boy, Fidele, the sweetest thing he could promise death was freedom from fear; from fear and from fears; for he specifies them, dwells on them as though while he was alive they were the chief despoilers of his happiness:

> Fear no more the heat o' the sun,
> Nor the furious winter's rages. . . .
>
> Fear no more the frown o' the great,
> Thou art past the tyrant's stroke—
> Care no more to clothe and eat. . . .

Fear no more the lightning-flash
Nor the all-dreaded thunder-stone;
Fear not slander, censure rash—

No exorciser harm thee,
Nor no witchcraft charm thee,
Ghost unlaid forbear thee—

Had Shakespeare suffered fear of all these? or had some one young and golden whom he had loved, suffered from them and found fair refuge in death?

Though now our voices
Have got the mannish crack, sing him to the ground,
As once our mother; use like note and words
Save that Euriphile must be Fidele.

It is curious that Shakespeare, a few moments later, should have forgotten that he had given these lines to Arviragus and Guiderius. These are not words by which any boys would have sung their mother to the ground. The note is in lament for some one young:

Golden lads and girls all must,
As chimney-sweepers, come to dust.

Shakespeare simply forgot all that stuff about "Euriphile, our mother." How human, how endearing of him to have forgotten; and how little it matters to us who still have the dirge for company. No one has ever told us so tenderly that, though life is a shadow-pageant of fears, death is the one solid fear of them all; death cannot be combated; and if it comes early, all compassion can say is that at least death slays in his victim the fear of old age.

At about the time when I might have been silly enough to begin fearing this approach of old age, I met Eliza. I met Eliza, and here is her portrait:

She is the loveliest Jewess I have ever known.

And should you think that this introduces an oriental maiden, tall and supple, with soft brown eyes, a shower of ebony hair, and mouth curving upwards like the scimitar of a new moon, you are mistaken; for she has celebrated her seventieth birthday.

She is no more than the height of a man's heart, which Orlando said was perfect, forgetting for a moment that his Rosalind was a goddess, divinely tall. And she moves with grace and dignity, always carrying her head a little lifted, as though she were floating towards you, figure-head of a ship, mischievously bent on some successful piracy. Her eyes are deep, living blue; and her nose has the same delicate integrity as her chin; while her mouth is the most provoking of all her features, for it is like a wave, forever about to break into a smile; an irrepressible, infectious, forbear-from-joining-me-if-you-dare sort of smile.

She is an Edwardian lady, which means that she relishes spontaneous tribute as a wit and a beauty. It means also that she always wears a hat, with a veil falling down behind, when she entertains her friends to amusing little lunches in her own home. She is absurdly fond of compliments: of having her hand kissed: her lips, too, perhaps: a sheaf of appropriate flowers, a basket of rare fruit, a book from the author with an inscription saying that he kneels to the prettiest, bows to the wittiest, and kisses the one he loves best.

Most of all does she adore a box at a first night.

Here she is happy. Here, in fact, will be her special notion of heaven easily fulfilled. The royal box, just raised enough

above the stalls that she may be a little imperious, her fan in her hand, and on her head one of those crowns which we have all grown to recognise with most respectful tenderness: one of them, Persian blue enamel; another, an arrangement of black-and-white lace and bunches of white currants. Her crowns suit her, and the actors have grown to think that they signify good luck. "Which one is she wearing to-night, bless her? Oh, the blue butterflies. Good."

She cares for the stage more than for any other facet of the day's diamond, though as it spins they all sparkle at her, and she sparkles back; not caring that she may be in debt; not caring that she has neither husband nor child to look after her; not caring that she is seventy, and that she has saved no money and keeps no more than one servant; not caring that she is more often in pain than not. No matter what reverses of fortune come along, she remains life's mistress, not its humdrum wife; teasing life, tantalising life, responding to it deliciously. And of all the pies wherein she most enjoys thrusting her pretty little finger, the stage is to her the most succulent, well-flavoured pie of all. Tell her what play you have written, tell her what managers are angling for it, tell her whom you want for this part or that part, and beg her to manœuvre it somehow. She will bid you, in her fascinating husky voice, leave it all to her.

Imagine, then, the heroine of my portrait sitting in her box at a theatre in heaven, at the biggest First Night of the Heavenly Season. At least three or four tall handsome gentlemen of the Edwardian-moustache period are her cavaliers. But because she is also passionately interested in the present, her box is visited from its little door behind, by all the most gay, most insouciant, most devoted of the neo-Georgians, men and girls. And when the curtain goes up, it is only to see more of her friends distinguishing themselves on the stage. In the in-

tervals, the air is spicy with her comments; and at the end, when the applause is over, and the triumphant author has bowed once to the whole audience, and twice in her direction, she will visit the dressing-rooms; and the actors will cluster round her, and thank her for her help and generosity and enthusiasm. And then, I think, she will go home happily, leaning on the arm of the noblest actor of her century and ours.

Search as I will, I cannot quite discover what lends her such grace and quality. It may be her extreme impenitence. Impenitence can be an exquisite failing, though I have never rated it so highly in any one else. She has often good reason to be penitent, for her accuracy is so unreliable as to be reliably inaccurate; and her anecdotes are almost too richly baroque. When she improvises an epigram, it is as though she first steps forward to deliver it, and afterwards curtseys in the grand style to the music of your applause, while her eyes, dear humbug, say in round innocence: "I can't think *why* you're all laughing!"

By her mutinous challenge to old age, she and no one else has made me feel that I need not mind growing old. And what more can a friend do for you than that? I realised this good she had unconsciously bestowed on me, on her seventieth birthday, when her rooms were crowded as any débutante's, with flowers and friends and courtship. She whispered to me, after a reception lasting from 10 A.M. till 10 P.M.: "I'm a little bit tired, m'dear, but it has been *such* fun!"

And she died a week later, swiftly and suddenly, at the theatre, at the biggest first night of the season. It was during the hush just before the curtain went up.

She died, as certain of our more reckless journalists would put it, "literally in her boots." (She had delicious little feet, and her evening shoes were always charming, with paste buckles.) As a rule, I would rather people did not die in their

boots, though in this particular instance it gave no trouble and was no hurt to anybody. But usually the sight of a stoic marching about the house with compressed lips and brow bedewed with agony, grim and obdurate in determination not to give in, is a sight more exasperating than heroic. If only they would realise the kindness and courtesy they can show to those who love them, by allowing their boots gently to be drawn off, Charlotte Brontë's sorrow would have been more endurable while Emily was dying.

It is surprising then, that in spite of his use of the forbidden words, I enjoy Benet's Ballad of William Sycamore:

> *I saddled a red, unbroken colt*
> *And rode him into the day there;*
> *And he threw me down like a thunderbolt*
> *And rolled on me as I lay there.*
>
> *The hunter's whistle hummed in my ear*
> *As the city-men tried to move me,*
> *And I died in my boots like a pioneer*
> *With the whole wide sky above me.*
>
> *And my youth returns, like the rains of Spring,*
> *And my sons, like the wild-geese flying;*
> *And I lie and hear the meadow-lark sing*
> *And have much content in my dying.*
>
> *Go play with the towns you have built of blocks,*
> *The towns where you would have bound me!*
> *I sleep in my earth like a tired fox,*
> *And my buffalo have found me.*

I am aware that Emily went on peeling potatoes long after she could no longer stand; but Anne's death still appears to me the more heroic. Anne was a being whose virtues were a

balanced equation of gentleness and consideration; whereas Emily, dark and noble and fierce, with her capacity for bearing pain in silence and appealing for no one's help, Emily was a typical genius. Her rôle, for it would be unfair to call it a pose, of wild animal at bay, of her back to the wall, of every hand against her was, as Romer Wilson pointed out in "Alone," influenced by the favourite reverie of her times: Byron and the black romantic castles of the Rhine; a form of spiritual diabolism which was of enormous help in bearing a difficult life.

Even now, children say, we have all said, alone and scowling, "I don't care. Everybody hates me. I'm glad." But I wish poor Charlotte, who had to see all her sisters and brother die, had not had to see Emily die in her boots.

Nothing can be further removed from my own reverie of being one of the jolly, swarming, rosy-cheeked crowd of Rectory Children, than the reality of these Parsonage children of Haworth. Their only link, by Emily and Bramwell is that lawless quality which I would so strongly have desired for my own childhood; for to be lawless means to be fearless. You cannot ignore the law while you fear what it can do to you; unless you ignore it truculently so as to shame your own timidity, perhaps shame it out of its habitation for ever.

I am not brave; in fact, I have often silently admitted that I am a coward. But going carefully over my behaviour in perilous instances of my life, I doubt if I am much more or less of a coward than the average person. That is to say, I can and have behaved with conspicuous courage over things that anyhow have not frightened me in the slightest; have forced myself to outward decency and not to betray animal fear, over things that would normally frighten most people; and been an immoderate coward over the individual things that set me shivering with peculiar terror.

Thus, in class one, among the things that do not frighten me, I would put rats and mice; sight of blood; heights; dentists; thunder; caterpillars, tortoises, lizards and frogs; and plunging swiftly into very cold water.

In class two, fairly good behaviour in facing up to fairly normal fears, come earthquakes, spiders, forked lightning, high seas, enemy air raids, and having stitches put in my knee. Perhaps also ghosts and burglars and drunkards and bulls and the dark.

Motor-bikes and wasps make me both angry and afraid; their resemblance is undeniable. When I am recommended by a friend with the Savanorola urge, to take whatever I may be afraid of, crocodiles, let us say, and for discipline's sake put them all over myself, I wonder whether he may not be confusing fear with nausea?

But in class three, among my individual fears, belongs an unreasoning fear of oculists and officials, police and the Law and trespassing and the Mob and unpopularity. Setting aside oculists as something irrelevant (but which would link up with my nervous breakdown after St. Dunstan's, with my feeling about beggars, and far back to that one paragraph read in the papers about the French circus-dancer) one can group all these other terrors under a single heading: fear of persecution. And that is why I pay my Income Tax promptly; never go where it says trespassers will be prosecuted; and would be wildly, despairingly convinced from the beginning that I had no chance but to lose and be condemned, if any civil or criminal case were ever lodged against me. I derived an exaggerated satisfaction and sense of safety and the law-on-my-side-for-a-bit-anyway, while I once had for cook the wife of a mounted policeman; I pretend that my firm decision never to infringe the law, springs from good manners and good taste—from anything but what it really is: blue funk. I

shudder at crowds, avoiding them from knowledge of what my panic would certainly be if a mob came howling and hurling itself on my track, with directed rancour. They would sound, in the distance, and then closer, in the next street and tearing round the corner, like the London paper-boys shouting bad news of the Boer War; stunted boys with faces drawn by Hogarth, Rolandson and Cruickshank.

While I was living in Cornwall, and later on for five years in Italy, I never forgot the danger of being a foreigner. "They mustn't be antagonised." And "they" did not mean the individual; I have never feared individuals, but, like Cedric Lord Fauntleroy, would march up boldly to the most beetle-browed gouty-tempered Earl and slip my little hand with full confidence into his. Perhaps my behaviour and actions (not my opinions) may be all the time and all my life, a little as though I were secretly conscious of being Wanted by the Police. The mythical Rectory Children never thought about it; they laughed heartily when they saw a Bobby; and Bobbies and Beaks were indulgent to them, even if they had been trespassing. No wonder they could break down gates, climb forbidden apple-trees, and cheek game-keepers, without any selfconscious annotations.

My love of popularity might well be an extreme reaction from the same causes; for its opposite, stretched out beyond reason, could loom first as a menace and then as a howling mob, that mob which Saki's "Clovis" called "the jacquerie" when he tore through the morning-room screaming: "The jacquerie! They're on us!" followed by an astonished band of the mildest servants, gardeners and chauffeurs carrying their trade equipment.

For mobs make pogroms.

Yet my childhood was a sanctuary perfectly free from pogroms or rumours of pogrom. We had wealth in moderation;

and no strict religious upbringing. In my school was a family
of Jewish sisters so severely cramped within religious rules
that their life seemed to us full of the most curious taboos:
things they might not eat, things they might not do, feasts
and traditions that must be scrupulously and literally observed.
I understood little of what this family was about, and their
conduct appeared to me far stranger than that of my Gentile
friends. It did not occur to me for years that there were dis-
advantages in being a Jew, and that they were in any way and
by any society, looked at askance. My cousins and the daugh-
ters of old friends of the Rakonitz family all had the same sort
of upbringing, lax yet secure, as myself. One cousin used to
fast on the Day of Atonement (and always fainted) but we
looked on her as a strange animal indeed. Later, nearly all my
friends happened to be Goyem. Their friendship proved in it-
self that they had no anti-Israelite prejudices; so that my fears
of the "jacquerie" could not have come from them. Yet I
never cared for the word "Jew"; and even on this page, as on
so many others, whenever I write "Jewish" I have to restrain
myself, not each time successfully, from crossing it out and
putting "Israelite" instead. "Israel" is a lovely name. I called
my first family-chronicle book, "Tents of Israel," though the
choice of title was not my own, but an inspiration of W. L.
George who was himself half a Jew. I would never have con-
sented to call the book, "Tents of the Jews." Kipling wrote
a fine poem on Israel:

> A Ruler without a Throne,
> A Prince without a Sword,
> Israel follows his quest.
> In every land a guest,
> Of many lands a lord,
> In no land King is he.

But the Fifth Great River keeps
The secret of Her deeps
For Israel alone,
As it was ordered to be.

It is a word of pride: A Jew can cringe; an Israelite never. Shylock was each in turn.

So my early secret reactions to persecution can only have been dim racial apprehensions, linking with the secret fascination and secret fear of my childish interest in the Dreyfus Case.

Perhaps it stood for me, early and late, as a symbol of unfairness, of undeserved things; things that can suddenly happen to you, and you are helpless when they happen; a very Bridge of Fears that you cross over and over again long before you need. If Dreyfus had made a noble voluntary sacrifice, and some one were the better for it, one could have borne to contemplate what happened to him. But it happened to him out of the blue; out of the black. He was living inconspicuously, satisfied with his work, and happy with his wife and two children; a good man at his job, they say, and probably with no more and no less petty human faults and small boastings than the rest of us. No romantic hero and no crafty villain. What leapt out upon him and led to the martyrdom of Rennes and Devil's Island might occur at any moment to any one of us. He did no harm, but suddenly they got him and the law got him and the mob got him, and justice did not get him for a long long time. And he had to submit only because there was no way out. This is the very reality of suffering, compared with that other suffering, heroic and for the sake of friend, father or country, which we meet in fiction, in fable and in reverie. Dreyfus was not even ultimately the picturesque hero of his own terrible story. He was the

bewildered scapegoat, and Picquart was the hero. Picquart whose integrity, bare of other motive, forced him to stand against his own class and military creed.

All the defenders are dead: Labori, Peguy, Picquart, Zola, Clemenceau. . . . I was talking of this to a friend, the editor of an American magazine, down in the South of France this summer. I said: "Isn't it strange, the way everybody said Dreyfus couldn't survive, and yet he survived them all, and walked behind the coffin at Zola's funeral. I wonder what he thinks about in the evenings?" She suggested: "Why don't you go and see him and talk to him and find out?" I shook my head, and went on wondering, though I had not thought of Dreyfus for many years. An old man now, they said. They said his one desire was to be left alone.

What does he think of, in the evenings? Is it impertinent to wonder? I hope not. Does he think in bitterer deeper lines than we do? or does he merely muse on to-day's quiet happenings and yesterday's doings? Does he recall the horror of that moment when he first realised they were accusing *him*, saying that the writing in the *bordereau* was *his* handwriting? or that ghastly moment when he woke up in his hut on "L'Ile du Diable" to find a boa-constrictor near his bed, and shouted for help, and the guard rushed in and slew it only just in time? Or of that moment which should have been glorious but was surely more painful, at Rennes, when he was reinstated and his medals restored to him?

Or did he only think, now, in the same way as might old white-haired men who had not been to Devil's Island, who had not suffered on a big scale, who had not been Dreyfus in the Dreyfus Case, of small local troubles, of small daily pleasures?

His good housekeeper—how excited she had been to-day— her son had come in fourth in the Grand Concours de Bicy-

clettes; how she had jabbered and wept, especially when the
boy had been invited into the *salon* and they had drunk his
health in wine from Monsieur Jean's vineyard.

Kind of him always to remember his old friend, Dreyfus,
and send him a dozen cases of his vintage, though last year's
was a little thinner, a little sourer than it had been before;
did not linger as fragrantly on the tongue.

Tiens, that rheumatic pain, there it was, back again in his
left shoulder.

The price of *charbon* had gone up; prices were always going
up; one must be philosophical and not grumble.

He was getting tired of *courgettes farcies* every day for
déjeuner; surely there were other vegetables?

One of the grandchildren had broken his glasses; trouble-
some to have to make do for a day or two without glasses . . .

Dreyfus, left still alive when all his defenders were dead,
ruminating in the evenings.

The next morning I read in the *Eclaireur de Nice,* on the
13th July, 1935, that Dreyfus had died.

So I suppose the Dreyfus Case is my King Charles's Head.

It is honestly a surprise. I began this book telling myself
that I was not going to cheat, and that whatever got itself
shut up in the triangle should not have been placed there
deliberately beforehand. To change the metaphor, I was not
going to salt that mine. All the same, I could not help guess-
ing, guessing before I began, what would probably prove
to be my King Charles's Head; the persistent idea to which

I should be led on a chain of association from each of the
random small objects by which I started. I believed that my
pencil, subconsciously wanting to make a neat job of it,
would three times be pushing my thoughts in that privately
indicated direction. I believed, in fact, that my own particu-
lar King Charles's Head would reveal itself as a passionate
revolt against Peter Pannery; an aversion which included
scorn and fear and a sort of hopelessness; a racial refusal to
accept the male as an eternal small boy shouting aloud his
irresponsibility from the tree-tops; for was he not husband
and father and patriarch and head of the family? I have
never succeeded in this quest for a man so much surer, wiser,
stronger than myself; and a quest that has never ended in
fulfilment was bound to have worked its way down into
those very bones which have no marrow but wishing.

So, though I set out three times on a voyage of discov-
ery, I did not doubt but that I knew whither I was going.
I argued with some sophistry that this was not being dishonest
to my readers, to whom I had promised to give myself no
special facilities in the search. I argued that one could not
help guessing a little; and that guessing, like jettison and
barratry and other Acts of God, was, so to speak, outside
one's Insurance Act. Besides, I argued further, what was to
prevent *them* from guessing, either, if they wanted to? The
trend of my sentences, the whim of the pattern, the invol-
untary bend of the branches in the wind, the compass
urgency of the ship's figurehead in the bows, must be un-
doubtedly even more visible to them than to me.

It was gratifying and yet peculiarly disconcerting, to
find truth getting the better of nearly dishonest intention.
The King Charles's Head which came up again and again,
the obsession, the thing on my mind, the deep-down fear,
the infantile memory which had influenced so much of my

mental gesture, was not Peter Pannery; although that came
to the surface, too, once or twice; and so did a powerful
wish not to be excluded from belonging to a company which
from childish reading I apparently named the Rectory Chil-
dren, but which obviously, stripped of symbol, meant
the genial confident majority; a normal majority who were
not afraid of policemen, and who had good times in a
fraternity that was never embarrassed, but sang "For Auld
Lang Syne" in chorus all over the world; the Rectory Chil-
dren, who occupied the Promised Land while we were still
hankering for a sight of it; who had inherited the earth long
long before the meek. Yes, I am still delighted and flattered
when the Rectory Children claim me as one of themselves;
swap hats with me; allow me to gallop on their ponies; join
in their good times; when, above all, they notice no incon-
venient difference between their outlook and mine. One has
to enlighten them, of course; but not at first, not quite at
first. Truth is an unholy nuisance. Truth is a nuisance and
holy.

But even this business of the Rectory Children proved
fundamentally to be not quite my King Charles's Head.
My King Charles's Head was the Dreyfus Case. There it is,
indisputably rising to the surface in Part I, when we started
from the little blue and white striped glass dragon on the
mantelpiece. There it is again at the end of Part II; the
twenty-five-cent fragment of the Grand Canyon had led
me, not straight up to the Dreyfus Case, certainly, but round
to it on an incorrigible swirl. And when I started Part III
with a picture found on a rubbish-heap under the olives in
the South of France, a picture of a little white dog fading
from the wood on which it had been painted, that too, after
various wanderings, planted me beside the Dreyfus Case and
finally left me there.

The man himself had not much to do with it, I think; nor the countries which were involved, nor the race to which he belonged, nor any significance in time and politics and history. But it made me see early in my childhood, and, oddly enough, by impersonal and not acutely individual experience, by a photograph in an illustrated weekly, not by Nanny's smacks, that safety and happiness and virtue were precarious and dependent; that at any moment something might happen to you from outside, some dark and arbitrary smash; and heaven would not interfere; and it would not be your fault nor the logical consequences of anything you had done; and it would not be that you were sacrificed to save another (for that would be bearable) nor that you were silently nobly suffering in the service of all mankind. No, this thing that might suddenly smash down on you, wrecking art, career, health, love; above all, wrecking coherence and faith and belief in kindness, this thing had no *sense* in it. You might shout with all your lungs "It isn't fair," and injustice would not take the slightest notice.

Calamity might happen to you, I suppose, even if you were one of the Rectory Children. But they would never foresee it, nor watch with apprehension and blind sickening rage while it happened to others; so when they escape it altogether, they do not breathlessly give thanks for the miracle, for they will never have realised that existence is in itself perilous. Better, always, be born one of the Rectory Children; but that is a matter of luck, not of choice.

The mind cannot cure itself of an innocent and juvenile habit of making pictorial notes. Calamity, in the pack of fortune-telling cards whose symbols, because they are so gay and naïve, have gradually become almost too firmly tattooed on one's mind as the thing which they are primarily meant only to typify, Calamity is a dancing grey devil

covered in scales, with a sort of javelin in either hand ready to hurl; Success is a round yellow sun with waving rays; Jealousy, a green eye; Scandal, a tea-table prettily prepared with blue and white china; the sight of a round tea-table with blue and white china on it will ever cause me to glance with sharp suspicion at my hostess: have they been talking Scandal about me before I arrived? There is a funny silly fascination in letting oneself return, if only for a moment, to the infantile style of learning that the cat sat on the mat, by a picture of the cat on the mat, instead of by the more mature method of reading it in cold uncoloured print.

Some authors, indeed, have the gift of splashing effective colour onto their pages; but they are, severely speaking, not the best authors. We must beware of "purple patches," Tyrian purple, imperial purple dyed like a Roman Emperor's cloak, when we write our austere masterpieces; or if, yielding to temptation, we have allowed them to seep in, we must forthwith cut them out again.

Did I remember to italicise "purple patches" at the beginning of this book, among the list of things to avoid in autobiography? And a warning not to be high-minded and priggish? and (more insidious) not to leave a thing half-said, for very fear of being priggish?

"For one must avoid, to begin with, dullness, crowding, bad taste, anecdotes, a cargo of I's, whimsicality and over-intimacy."

Probably I have been guilty of all these crimes, over and over again; and, in addition, I forgot to enjoin a Spartan attitude towards quotation. The pages are leaping with quotations. Quotations gurgle among the reeds; quotations are thrust into all the smaller crevices of the interlocking pattern. I lapse too easily into quoting, both aloud and in writing. It must be that I am proud of my fluency and

arrogant of my memory. Yet humility and laziness may also be responsible: for why not lay hands on what others have put into words so much better than you could ever hope to, yourself? And why ever make the effort to do it yourself, when you can quote? I find sensuous pleasure in apt allusion: because the quotation just fits in there, and adds a sentimental rounding-off, down it goes.

Will there be any sympathy, perhaps, with my longing to add at the end of Part III, after the line "I read that Dreyfus had died," just those four lines again from Shakespeare's dirge:

> *"Fear no more the lightning-flash*
> *Nor the all-dreaded thunder stone.*
> *Fear not slander, censure rash,*
> *Thou hast finished joy and moan."*

For you see (do you see?) how it beautifully completes the whole thing? washes the sunset over the sea, drags slow tears to the eyes, tolls the bell full fathom five . . . for the man who had suddenly been seared by lightning and struck by a thunderbolt. How hard it was to resist the temptation to repeat just this once more (and echo is itself a drugging delight) what I had already cited over and over again throughout the book; my first childish memory of poetry.

Still, I left it out. And if it should be unpardonable guile to bring it in now, in the plausible form of a temptation resisted, then obviously I am possessed of an evil spirit that will not be overcome by the most severe self-criticism; by the most fastidious knowledge of what is right in literature, and what is weak and foolish and redundant and Tyrian-purple and tricky and vulgar and cheap and borrowed and bad taste. I shall have to employ an exerciser to rid me of this evil spirit. Why did Shakespeare

say "No exorciser *harm* thee," in the last verse of the
threnody spoken over the dead Fidele? I thought exorcisers
were well-meaning people whose function was to drive out
demons and other inhabiting spirits. But perhaps Shakes-
peare was getting old and incredulous, when he wrote Cym-
beline. Perhaps at the Mermaid, there were hot discussions
on whether or not exorcising were of any *real* benefit to the
patient? whether it did not do more harm than good? ("I
tell thee, Will, I knew a fellow with just a simple nervous
breakdown, and his friends insisted on taking him to an
exorciser, and now he's shot all to bits. I told his mother
that what he needed was to be taken *out* of himself instead
of encouraged to talk about his evil spirits. Besides, so many
quacks set up as qualified exorcisers. It's just a fashion, and
in four hundred years, maybe they'll have something
else!")

Nevertheless, one last quotation. Jane Austen remarks in
a letter to Cassandra:

"Heaven forbid that I should ever offer such encouragement to
explanation as to give a clear one on any occasion myself."

So, with yet another cause for gratitude to my favourite
author, who offers me her perfect excuse for wherever I may
have failed in that shining lucid quality that she so admirably
possesses, I want to return for a few moments to this King
Charles's Head of mine. I have only so recently learned about
it, that until now, my sole reaction is disappointment: This
passionate recognition of injustice, this despair at injustice,
is this, finally, all that I can produce? is this the last word?

I seem to get my answer three times, and again in those
ingenuous terms of coloured symbols: Zola; Father Damien;
a yellow chair.

For after all, and here is sudden reality beyond the last word, Dreyfus did *not* die on Devil's Island, with his innocence unacknowledged. Dreyfus died more than a quarter of a century later, in his own bed in his own country. He had suffered unfair calamity, but Calamity with its javelins had not been the winner in that story. They had brought Dreyfus back from Devil's Island and reinstated his honour at Rennes. He outlived most of his persecutors and defenders alike. He walked behind the coffin at Zola's funeral.

But for Zola, injustice would have won.

I have forgotten what I read of Zola, in a biography; but a hazy impression remains that like the rest of us, he was not in every essential a good and stainless man. Yet he wrote "J'accuse"; and risked his liberty, his fortune and his career. He risked all that, with exile and obloquy thrown in, because of that fiery desire for truth which burnt up every consideration of self. He took risks, not out of local patriotism nor in any flamboyant display of courage (though it had to be done sensationally to be effective) but simply because he was a lay brother serving justice. Have you heard authors fussing about their flame and their holy vocation? Lay brothers in mediaeval abbeys, you will remember, could not afford the expenses of having a true vocation; so they did the hard and humiliating drudgery; waited on the monks and abbots, scrubbed floors and washed dishes, and sat in seats of the chapel allotted to the lay brethren a very long way down the nave from the altar and the Cross.

Father Damien spent a large part of his life looking after lepers on Molokai. He was so occupied in looking after lepers, that he did not bother overmuch about his own private reputation; so that when he died, he was attacked by saintlier men who had stayed at home or comfortably

in Honolulu, and had not gone to nurse lepers. Instantly, Robert Louis Stevenson wrote a burning attack on the injustice of these attacks. R.L.S. has often played the exuberant youngster, but this time his voice did not crack in schoolboy indignation.

But I am still perplexed as to why my unreasonable imagination should have added a yellow chair to Zola and Father Damien? a plain kitchen chair with sturdy legs and a straw seat. Though of course I know that chair, and so do you. Vincent Van Gogh painted it, the essence and spirit of all chairs; not beautiful nor decorated nor softly cushioned; nor a period piece; not a chair for a rich man's drawing-room; nothing spiritual about it; just solid wood and straw; a chair to sit on when you are tired and your legs can support your body no longer.

It is a thrilling picture; no less thrilling than "J'accuse"; no less thrilling than the account of Father Damien's services to the lepers, as they flamed out in Stevenson's defence of him. But Van Gogh could never have survived years of hard lonely apprenticeship and incipient madness, ultimately to paint that chair, but for his brother, Theo, who recognised his genius and subordinated his own life to serve it, however and wherever he could. And when Theo married, so that one might have feared his wife would have distracted his attention from Vincent's service, she, understanding, devoted herself to Theo with all encouragement of his devotion towards Vincent; lay brother to Theo's lay brotherhood. And Vincent Van Gogh, that single-minded man who lost his chance of priesthood for literally interpreting the Gospels and stripping himself of his clothes to give them to naked miners of the Borinage, he was himself passionate lay brother to truth, if you care to call it truth.

"The next morning I read in the *Eclaireur de Nice* that

Dreyfus had died." If this were the last word, it remains topical merely because injustice always was and always will be the only topical theme. But perpetual injustice has one perpetual compensation which must be highly irritating to the cruel and the careless: that the very injustice of injustice, will create rescuers. Not nearly enough exactly to match the need; statistics would be on the side of pessimism; but single spontaneous acts of rescue, here and there, every now and then, to cause in us that strange exultation when we hear of new instances or reflect on the old: Dreyfus died, but in his own bed, not dishonoured on Devil's Island. Nor was Van Gogh allowed to sink into starvation or total insanity, before his hand could paint the yellow chair. Nor did a clear anger fail to justify Father Damien against the Pharisee.

"If I mayn't be father and I mayn't be Baby," says Tootles in Peter Pan, "may I be a twin?" "No," shout the Twins, "it's awfully difficult to be a twin!" It is, indeed; I have tried and failed. And it's awfully difficult to be a lay brother; ironically, much more difficult than to have a vocation. For they do things that are beautiful, moving, courageous; but all the while, in front of the world and to their own households and to themselves, they seem undramatic and unheroic. That quality is not strained; it is elusive; it cannot be gained by prayer; nor by knowing it to be, like kindness and with kindness, the most exciting, the most satisfying quality in all the world. Listen to the quiet beat of it through this story:

Driven from his country, Einstein has settled at Princeton University, where a special fund exists to give him every facility for study and research at his leisure and according to his inclination. When he and his wife first arrived, a party was given to welcome him; and Frau Einstein, talking to one of the other ladies and wishing to illustrate some

casual point, said: "My husband always says—You know my husband?"

The lady, thinking she meant "Do you know him personally?", replied: "No, I'm afraid I don't."

"Well, he is a physicist."

THE END